KEYGUIDE TO INFORMATION SOURCES IN

Museum Studies

SECOND EDITION

KEYGUIDE TO INFORMATION SOURCES IN

Museum Studies

SECOND EDITION

Peter Woodhead and
Geoffrey Stansfield

MANSELL

FITZROY DEARBORN

First published 1994 by
Mansell Publishing Limited, *A Cassell imprint*
Villiers House, 41/47 Strand, London WC2N 5JE

Published in the United States of America by
Fitzroy Dearborn Publishers,
70 East Walton Street, Chicago 60611

© Peter Woodhead and Geoffrey Stansfield 1994

British Library Cataloguing-in-Publication Data
Keyguide to Information Sources in Museum
Studies. - 2 Rev. ed
 I. Woodhead, Peter II. Stansfield, Geoffrey
 016.069

 ISBN 0-7201-2151-5

Library of Congress Cataloging-in-Publication Data
Woodhead, Peter.
 Keyguide to information sources in museum studies/Peter Woodhead
and Geoffrey Stansfield. — 2nd ed.
 p. cm.
 Includes bibliographical references and index.
 ISBN 1-884964-11-7
 1. Museums—Administration. 2. Museums—Information services.
3. Museum publications—Bibliography. I. Stansfield, Geoffrey,
1931- . II. Title.
AM5.W66 1994 93-37246
 CIP

Typeset by Colset Pte. Ltd., Singapore
Printed and bound in Great Britain by
Biddles Ltd, Guildford and King's Lynn

3070

A (WOO)

Contents

Introduction to the Second Edition

The first edition was well received and achieved the distinction of being listed as an outstanding reference book for 1990 by *Choice* (a publication of the Association of College and Research Libraries – a division of the American Library Association).

For the second edition, considerable updating of the text has been carried out. Details of some 14 new periodicals, nearly 100 new monographs, some 20 new directories and some 11 new organizations have been added. Many entries have been updated, and some outdated publications and periodicals which have ceased publication have been deleted. Monographs are arranged in the same way as in the first edition, using the format previously adopted by the Department of Museum Studies, University of Leicester, but no longer in use.

The rapid growth in the number of museums referred to in the introduction to the first edition has declined because of the world recession, but the number of visitors to museums has continued to grow. There has also been a growth in training opportunities for museum personnel and in the literature relating to museum studies.

Introduction to the First Edition

Museums play a central role in the study, preservation and interpretation of the world's cultural heritage. As society places increasing importance on the documentation and preservation of this heritage, so museums have experienced a surge of public interest. New museums are being set up almost daily and the number of visitors grows year by year. It is also becoming clear that museums are having a significant economic impact on the communities they serve.

The growth in the museum industry, as it has come to be called, has focused attention on how museums are organized, the functions they perform and the setting of performance standards, and this, in turn, has led to increased opportunities for research and for professional training.

There has been a corresponding growth in the literature relating to museums and museum studies. However, this literature is not particularly well organized, and information about some aspects of museums is often difficult to trace.

CONTENTS AND ARRANGEMENT

This book has been planned to help alleviate this situation. It is seen very much as a first source of information about museums and museum studies. It aims to provide an integrated guide to the documentation, reference aids and key organizational sources of information about museums and museum studies worldwide.

Part I provides an overview of museums and the literature about them. Chapter 1 begins by discussing definitions of the term 'museum', with a brief

history of the origins and development of museums. It then looks at museums today – their increase, diversification and administration (with emphasis on five countries). There is discussion of the term 'museum studies', the arrangement of the subject field, and its relationship with other subjects. Organizations closely involved with museums at both international and national level are examined, along with the museum profession, recruitment, training and careers. Chapter 2 looks at the nature and origins of museum studies information, the role of documentation centres and libraries, and the way in which museological literature is organized in different countries. Chapter 3 gives advice on tracing information about particular museums, their collections and staff, individuals and current research. Chapter 4 discusses ways of keeping up to date with current publications, developments and events, while Chapter 5 examines non-current bibliographies. Chapter 6 looks at the primary literature, first by form of publication – periodicals, theses, monographs (along with dictionaries and encyclopaedias) – and secondly by subject. Chapters 7 and 8 discuss audio-visual materials and trade suppliers respectively.

Discussion in Part I covers a high proportion of the works listed in Part II; numbers within square brackets refer the user to the full bibliographical details given in Part II. Part I also refers to some publications which are not included in Part II because they are too general or because they are used to illustrate particular points. References to many of these may be found at the end of some chapters.

Part II is an annotated bibliography of reference sources. It is subdivided by forms of material, e.g. general bibliographical guides, bibliographies of publications by museums, periodicals, etc. The arrangement of the monographs is based on the format used by the Department of Museum Studies, University of Leicester, for its syllabus and associated bibliographies. Almost all the publications listed have been inspected by the authors. The choice of entries has necessarily been selective although it is hoped that most major sources have been included.

The languages in which periodical articles appear are given in abbreviated forms as part of the bibliographical information supplied for periodicals; explanations of these abbreviations are listed on p. xv. For publications other than periodicals, the language in which they appear can be assumed to be that of the title. Translations of titles in 'difficult' languages appear in round brackets after the original.

Part III is a list of selected museum organizations, beginning with international organizations, followed by organizations arranged alphabetically by country. This list is explained more fully at the start of Part III.

Acknowledgements

We would like to record our thanks to all who have helped with the compilation of this work. While it is not possible to thank everyone individually, there are some who deserve special mention.

We would particularly like to thank Geoffrey Lewis, Director of the Department of Museum Studies at the University of Leicester until 1989, who read the full manuscript of the first edition and made many helpful and constructive suggestions. Also, we would like to thank Ralph H. Lewis, formerly Head of the Branch of Museum Operations of the United States National Park Service, who read and commented on the first edition, and who has continued to supply us with a wealth of material relating to museums in the United States. Thanks are also due to Susanne Peters (previously Head of the UNESCO–ICOM Museum Information Centre in Paris) and her colleagues for their painstaking and detailed replies to our questions and for their help when one of us (GS) visited the Centre during Easter 1988, and Jane Sledge (present Head of the Centre) for her extremely helpful and prompt replies to our many queries.

We would like to record our thanks to Pamela Dixon for her typing and word-processing skills; to Leicester University Library and the Department of Museum Studies, University of Leicester, for providing facilities in preparing the first edition; and to Leicester University Library and the Institute of Archaeology, University College London, for facilities in preparing the second edition.

Geoff Stansfield is pleased to record financial assistance received from the

University of Leicester Research Board towards the cost of the visit to the UNESCO–ICOM Museum Information Centre.

Geoff Stansfield

Peter Woodhead

List of Abbreviations Used for Languages

Af	Afrikaans		Fr	French
Ar	Arabic		Gr	Greek
Bu	Bulgarian		It	Italian
Ca	Catalan		Ja	Japanese
Ch	Chinese		Nd	Dutch
Cr	Croatian		No	Norwegian
Cz	Czech		Pl	Polish
Da	Danish		Pt	Portuguese
De	German		Rm	Romanian
En	English		Ru	Russian
Es	Spanish		Sl	Slovak
Fi	Finnish		Sw	Swedish
			Th	Thai

PART I

Overview of Museum Studies and its Literature

1 The History and Scope of Museum Studies

WHAT IS A MUSEUM?

The term 'museum' derives from the Greek *mouseion*, a place of contemplation or a shrine of the Muses. The Romans used the term to describe a place of philosophical discussion. Lewis [179] notes that the word 'museum' was revived in the fifteenth century to describe the collection of Lorenzo the Magnificent, a member of the Medici family in Renaissance Florence. By the seventeenth century, 'museum' was used to describe collections of curiosities, and by the eighteenth century the term had come to mean an institution set up to preserve and display a collection owned by and open to the public.

Since the late eighteenth century, 'museum' has come to mean a building used for the storage and exhibition of objects relating to the cultural heritage rather than the collection itself. More recently the emphasis on the building has become less dominant with the advent of open-air museums and 'ecomuseums' comprising series of buildings as well as objects (Lewis [179]). In present-day usage, the term 'museum' is usually considered to embrace also 'art galleries', and in this book is used in its broadest sense to include all types of museum and art gallery irrespective of the nature of their collections or the nature of their administration.

Several other terms have been used, often synonymously with 'museum'. The term 'gallery' was used from the sixteenth century to denote a place, often a long room, where paintings and sculpture were exhibited, the word being derived from the Italian *galleria*, in contrast with *museo* which was used to describe a place where bronzes, carvings and other precious artefacts were displayed. The term 'cabinet' was used to describe either a collection of curiosities or a place where decorative

art material was housed. In German the terms *Kammer* or *Kabinett* were used, often in the form of *Naturalienkabinett* or *Wunderkammer* (normally containing natural specimens), *Kunstkammer* (an art collection), and *Rüstkammer* (historical objects or armour). The term *pinakotheke* was used in Athens in the fifth century BC to describe an art gallery and may still be found in the name of some art galleries today.

The variety of public institutions which describe themselves as museums is such that it is sometimes difficult to see what they have in common. The most widely accepted current definition of a museum is that incorporated in the Statutes of the International Council of Museums (ICOM) [447] and adopted at the Eleventh General Assembly of ICOM in Copenhagen in 1974 and modified at the Sixteenth General Assembly of ICOM which took place at the Hague, Netherlands in 1989 (International Council of Museums, 1990). This defines a museum as:

> a non-profitmaking, permanent institution, in the service of society and of its development, and open to the public, which acquires, conserves, researches, communicates, and exhibits, for purposes of study, education and enjoyment, material evidence of people and their environment.

Definitions serve a number of purposes. Those adopted by professional associations are primarily intended to clarify eligibility for institutional membership. More recently, more precise definitions have been adopted, often by the same professional associations, to clarify the functions of museums in Codes of Practice and for the purposes of the accreditation and/or registration of museums, designed in part to promote minimum acceptable professional standards. The British Museums Association's [540] definition of a museum in current usage was adopted as its annual general meeting in 1984:

> A museum is an institution which collects, documents, preserves, exhibits and interprets material evidence and associated information for the public benefit.

This definition has also been adopted for the Museums and Galleries Commission National Registration Scheme set up in 1991.

The definition used by the American Association of Museums [543] was adopted in 1962:

> A nonprofit permanent establishment, not existing primarily for the purpose of conducting temporary exhibitions, exempt from federal and state income taxes, open to the public and administered in the public interest, for the purpose of conserving and preserving, studying, interpreting, assembling, and exhibiting to the public for its instruction and

enjoyment objects and specimens of educational and cultural value, including artistic, scientific (whether animate or inanimate), historical and technological material. Museums thus defined shall include botanical gardens, zoological parks, aquaria, planetaria, historical societies, and historic houses and sites which meet the requirement set forth in the preceding sentence.

The American Association of Museums used a slightly different definition in its Museum Accreditation scheme launched in 1970 (American Association of Museums, 1970).

It should be noted that the above definitions are frequently accompanied by explanatory notes which further define the terms used, and the interested reader is referred to the original documents. Also, definitions are frequently modified to reflect changes in museums and changing circumstances. For a fuller discussion on museum definitions, see Hudson [165], Lewis [179] and Teather [195].

It should also be made clear that most of the definitions referred to above relate to museums which are public institutions, supported from public funds. Many private and 'independent' museums also fall within these definitions. It is important to remember that such public museums are a relatively recent phenomenon and that many present-day public museums had their origins in private collections, set up primarily for the gratification of their owners.

BRIEF HISTORY OF MUSEUMS

The museum most frequently cited as the forerunner of the present-day museum was the museum at Alexandria, founded *c*. 280 BC by Ptolemy Soter as an institute for advanced research and populated by scholars from the whole of the Greek East and supported later by Roman emperors. Lewis (1992a) notes that, although there is little doubt that the Alexandrian Museum contained some objects and that it was associated with a botanical and zoological park, its primary function was as a centre for philosophical learning. Lewis also describes other examples of collecting in classical antiquity, in Islam and in the Orient. During the Renaissance, the revival of interest in classical material led to a great increase in collecting; the collections developed by the Medici family in Italy, for example, are well documented (Lewis, 1992a). Many art collections were established by rich Europeans, some being opened to the public, often on payment of a small fee. Lewis (1992a) notes that the gallery erected between 1563 and 1567 by Albrecht V, Duke of Bavaria, to hold paintings is probably the oldest surviving purpose-built 'museum'.

Many early collections were assembled in a very haphazard fashion with little attempt at organization. The concept of 'ordered' collections owes much to individuals like Caspar F. Neickel, whose *Museographia* (Neickel, 1727) provided a guide for the amateur collector giving advice on how to deal with problems of

classification, and the naturalist Linnaeus (1707–78). The latter published a classification of the three realms of nature *Systema Naturae* (1735) and a list of the known species of plants *Species Plantarum* (1753). Linnaeus' system of classification was widely adopted by museums and is still used in a modified form today.

The systematic arrangement of collections was also a necessary prerequisite for the publication of catalogues. Early catalogues included *Museum Wormianum* (Worm, 1655), a catalogue of the collection of the Danish physician Olaf Worm (1588–1654), an assortment of specimens of natural history and prehistoric archaeology; *Musaeum Tradescantianum* (Tradescant, 1656), a listing of the contents of the famous collection (stuffed animals, dried plants, minerals, coins and medals, etc.) assembled by the Tradescants (father and son) as a result of their extensive travels (a collection later to become the nucleus of the Ashmolean Museum in Oxford); and *Museum Petiverianum* (Petiver, 1695–1703), a catalogue of the collection of James Petiver (*c.* 1665–1718), botanist and entomologist.

From the sixteenth century onwards, corporate bodies began to acquire or assemble collections with the intention of making them available for the public, an important step towards the public museums of today. In England, the first public museum was the University of Oxford's Ashmolean Museum in Oxford, based upon the Tradescants' and Ashmole collections, which opened in 1683, followed by the British Museum, opened in 1759 by the British Government to house the collections of Sir Hans Sloane, Sir Robert Cotton and the Earl of Oxford (Robert Harley).

A number of influences can be identified in the development of public museums. In Europe, royal collections (in Austria, France, Spain, Germany and Russia) often formed the basis of the first public museums. The Musée du Louvre in Paris, for example, came into being following the French Revolution in 1789 and the creation of the Republic in 1792. The museum was based on the confiscated and nationalized royal collections which were made accessible to the public with the opening of the Louvre in 1793. Lewis (1992a) suggests, however, that it was not until the beginning of the nineteenth century that the role of museums in contributing to national consciousness began to be recognized in Europe. He cites as examples the national museum in Budapest, opened in 1802 and financed from money raised by voluntary taxes, and a museum in Prague, founded in 1818 specifically to foster cultural identity and the study of Czech and Slovak peoples. In Denmark, the National Museum of Antiquities in Copenhagen was established in 1819 by the Danish Government, and in Sweden, the Swedish state collections were transferred to the Statens Historiska Museum in Stockholm which opened in 1847.

Another major influence in museum development was that of the learned and scientific societies, many of which accumulated collections and set up their own museums (e.g. the Royal Society of London and the Literary and Philosophical Societies in Britain's towns and cities). The ownership of many of these collections was transferred to public bodies, including local authorities, from the nineteenth century onwards.

In the United States, the early museums tended to be either society museums like the Charleston Museum of the Charleston Library Society of South Carolina, which began collecting in 1773, or private museums like Charles Willson Peale's Museum in Philadelphia, opened in 1786. The origins of the United States National Museum can be traced to the bequest of James Smithson (1765–1829), a son of the first Duke of Northumberland: 'to the United States of America, to found at Washington, under the name of the Smithsonian Institution, an establishment for the increase and diffusion of knowledge among men'. In 1846 the US Senate approved an Act establishing the Smithsonian Institution which included the Smithson material. The United States National Museum was not, however, formally established by Congress until 1879, although collections had been displayed in the Smithsonian building, 'the Castle', since 1858.

In Canada, the National Museum dates from 1843 when a collection was established in Montreal as an adjunct of the Geological Survey of Canada (later to become the Geological and Natural History Survey of Canada). The museum was officially designated the National Museum of Canada in 1927. In 1880 the museum was moved to Ottawa. Other Canadian museums were set up by almost every city and town and by each of the provincial governments. In the maritime provinces, many community museums owed their origins to the Mechanics' Institutes.

Hudson [166] remarks on the concentration of museums in France, Germany, England and Italy until the 1880s. By the late nineteenth century, there were remarkably few museums outside Europe and the United States, although the influence of the major colonial powers – Britain, France, Portugal, Belgium and the Netherlands – led to some expansion of museums in their territories.

In Africa, the major influence in setting up museums was that of European settlers. Lewis (1992a) records the first museum as the South African Museum in Cape Town in 1825. Similarly in Australia, museums were founded on European patterns with the first in Sydney established by the Philosophical Society of Australasia in 1821 (Lewis, 1992a). Others were later set up in each of the states. The earliest museum in New Zealand was the Nelson Provincial Museum at Stoke, founded about 1841. In Asia, perhaps the first museum was that of the Asiatic Society of Bengal, opened in 1814 (Lewis, 1992a). In China and Japan, the earliest museums date from the second half of the nineteenth century.

More detailed histories of museums worldwide can be found in 'Museums and their precursors: a brief world survey' (Lewis 1992a), from which much of the above has been taken, and also in Lewis [179], Bazin [149], Hudson [168], Murray [185] and Wittlin [203].

MUSEUMS TODAY

Details of individual museums in particular countries can be obtained from the directories listed in Part II [375]–[444] or from organizations listed in Part III

[447]–[546]. This section of the *Keyguide* is concerned first with the increase in numbers and diversification of museums, and secondly with their administration, using five countries – the United Kingdom, France, Denmark, the USA and Canada – as examples. It must be stressed that museums in these five countries have been developed to a high degree, and the detailed administration which has evolved should not be regarded as typical worldwide.

An ICOM study in 1982 (De la Torre and Monreal, 1982) estimated that there were some 26,700 museums worldwide, two-thirds of which were in the industrialized countries. Hudson and Nicholls [375] claimed to have tracked down nearly 35,000 museums worldwide. In 1977 Hudson [165] estimated that in the 1960s new museums were being opened in the USA at the rate of three a week, and he also calculated that the number worldwide increases by 10 per cent every five years. The survey carried out by the American Association of Museums in 1989 [145] gives details of the number of museums established in ten-year periods and shows that the highest number of new museums was established between 1960 and 1970 (2,390), with a fall in 1970–80 to 889. In Britain, the steady growth year by year, often without the necessary resources, is giving cause for professional concern and has been one of the factors that has led to the Museums and Galleries Commission National Registration Scheme. The Museums and Galleries Commission reported (1987) that the number of museums in Britain had nearly doubled since 1971, and that almost half of the new museums were in the private sector, collecting in 'new' areas such as transport, technology, and social and industrial history.

Recent years have shown a tremendous diversification in museums. There are now, for example: art museums (fine art, applied art, modern art and museums devoted to specific artists); archaeology, anthropology and ethnography museums; history museums (social history, industrial history, history of particular towns and regions, and museums of the history of the armed forces); museums of science and technology (including the relatively new phenomenon of science centres); transport museums devoted to railways, road transport, aircraft and ships (maritime museums); natural history museums (zoological, botanical and geological, zoos, aquaria and botanic gardens); agricultural museums, site museums, ecomuseums, open-air museums and regional museums; and museums serving the needs of ethnic minorities ('black' museums, and American and Canadian 'Indian' museums). Few of these designations are clear-cut and many museums can be regarded as hybrids.

As far as the administration of museums is concerned, most fall within one of four main categories: national (in which museums are state or federally supported); local authority; university; or private (often termed 'independent' museums in Britain).

Different patterns of museum administration have developed in different countries, the main variables being the degree of public or private control and, in the public sector, the degree of central government control. In many socialist countries (e.g. China), museums are administered centrally, often by the country's

ministry of culture, but sometimes by the ministry of education or the ministry of tourism, and this is also the case in some European countries (e.g. Sweden). In some African countries, the administration of museums is combined with that of archaeological and historic sites and monuments in departments of museums and monuments (e.g. Ghana [515]).

United Kingdom

In the United Kingdom, the major national museums, including the British Museum, the Natural History Museum, the National Museum of Science and Industry, the Victoria and Albert Museum and the national art galleries, are to be found in London, Edinburgh, Cardiff, Belfast and Liverpool. Each has its own administration, and many now have branches and outstations in other parts of the country. The National Museum of Wales in Cardiff, for example, administers a series of branch museums throughout Wales, and the National Museum of Science and Industry embraces the Science Museum in London, the National Museum of Film and Photography in Bradford, the National Railway Museum in York, and the Science Museum at Wroughton. Most of the national museums have been authorized by individual Acts of Parliament which give them separate legal identities. There have been recent moves towards greater standardization between the national museums. The Museums and Galleries Act of 1992, for example, established Boards of Trustees for the National Gallery, the Tate Gallery, the National Portrait Gallery and the Wallace Collection and repealed some of the earlier individual acts. At the county and town level, museums are mainly the responsibility of local authorities which may set up and maintain museums under the Libraries and Museums Act 1964. Most of the older universities (Oxford, Cambridge, London, Manchester, Glasgow) have their own museums, some of which fulfil an important community function. In recent years there has been a vigorous growth in independent museums, most of which tend to specialize in a particular site, theme or industry. Private and independent museums are governed by a trust deed, or the Companies Act 1985, and may be registered under the Charities Act 1960.

The Museums and Galleries Commission [539], established in 1931 as the Standing Commission on Museums and Galleries, was originally set up to advise the Government on matters relating to national museums. In 1981 it was renamed and given wider responsibilities to include non-national museums. Through the nine Area Museum Councils (and a Museums Advisory Committee in Northern Ireland) it now administers schemes for capital and conservation grants to English museums and it also operates the Local Museum Purchase Grant scheme through which non-national museums receive grants towards the cost of purchase of museum objects and collections.

France

In France, museums have been the responsibility of two ministries.

The Ministry of Culture and Communication (Ministère de la Culture, des Communications et des Grands Travaux) has been responsible for museums of art, history and archaeology through two principal departments. The first, the Direction des Musées de France, oversees individual national museums (35 in 1989), the Réunion de Musées Nationaux, and the Musées Classés et Contrôlés (state classified and registered museums). The second, Direction du Patrimoine, oversees archaeology, heritage (buildings and objects) and the ethnology of France, centred on the Musée des Arts et Traditions Populaires in Paris.

The Ministry of National Education oversees four national museums – the Musée de l'Homme, the Palais de la Découverte, the Musée d'Histoire Naturelle and the Musée National des Techniques – as well as important science museums in Dijon, Lyon and Nancy. In 1984 the Ministry of Research and Technology opened the vast Cité des Sciences et de l'Industrie at La Villette.

Until 1991 the Ministry of Culture also sponsored the only training institute for curators, the Ecole du Louvre, which has been combined with the Ecole du Patrimoine, various research councils, training for conservation and traditional manual skills, a conservation research laboratory and national conservation workshops, and the Beaubourg (which is run separately from other national museums and galleries). In 1992, however, the activities of those working in museums, archives, field archaeology, historic building and monument curatorship, and the national cultural inventory were merged into a single profession. High-level professional training is provided by the Ecole Nationale du Patrimoine, established in 1991, under the Ministry of Culture (de Lee and Boylan, 1992).

In 1992 it was announced that the Ministry of Culture was to be dismantled and merged with the Ministry of Education but the implications of this move are not yet clear (Boylan, 1992a).

Another organization, the Réunion de Musées Nationaux, was originally set up in 1895 to acquire works of art, archaeology and objects of general historical importance for the national museums. It is financed in part by the Ministry of Culture, but it also receives all the income from entrance charges to national museums. It organizes major exhibitions of international scope and is responsible for the publishing and distribution of books, catalogues and other publications for all the national museums.

Recent developments in France are described in more depth in Wright (1989) and Boylan (1992b).

Denmark

In Denmark, the tradition of public subsidies towards the cost of running museums dates from 1887. The Museum Subvention Act 1958 introduced a

system of state grants to museums which were directly related to non-state (mostly local authority) grants. Originally, subsidized museums were required to submit to an inspection by the National Museum, but by 1976 the administration of the Museum Subvention Act was left to the subsidized museums themselves through the media of the National Council of Museums (Statens Museumsnaevn) and the County Museum Councils. In 1984 a new Museum Act brought together under the Ministry of Culture all museums, state and subsidized, to operate under the same provisions (Lundbaek, 1985).

The stated purpose of the 1984 Act is:

> to secure the Danish cultural heritage and to promote the work and collaboration of the museums . . . The task of the museums is, by collecting, registration, conservation, research and mediation (i.e. all kinds of relating to the public, including displays, lectures, educational service, publishing, etc.), to work for the securing of the Danish cultural heritage . . . to illustrate the history of culture, nature and art . . . to enlarge the collections within their respective fields of responsibility . . . to make the collections accessible to the public . . . to make collections available for research and disseminate the results of that research.

USA

The US museum community of over 14,000 organizations includes diverse institutions with very diverse collections. Annual budgets vary in size from a few hundred dollars to over $200 million. Organizational structures of US museums include public and private institutions, corporate entities and university affiliates. Museums in the United States are essentially not-for-profit charitable institutions administered by Boards of Trustees for the general benefit of the public. Museums must be organized on a permanent basis for essentially educational or aesthetic purposes, utilize a professional staff, own or utilize tangible objects, and care for and exhibit them to the public on a regular basis.

The national museums are located in Washington and are administered by the Smithsonian Institution, a quasi-federal agency of the US Government receiving approximately 80 per cent of its funding from the federal government. Museums under the Smithsonian include the National Museum of American History, the National Museum of American Art, the National Air and Space Museum, and the National Museum of Natural History. The Smithsonian recently acquired the collections from the George Heye Foundation-Museum of the American Indian, and in 1993 was planning construction for the National Museum of the American Indian, in Washington.

The National Gallery of Art, also located in Washington, has its own Board of Trustees and is administered separately from the Smithsonian Institution. The National Park Service, an agency of the US Department of the Interior, administers historic and natural park sites throughout the United States. The

Armed Forces branches also administers museums and historic fort and military installations around the country.

The United States does not have the kind of national museum system found in other countries that provide financial support. Museums in the United States, including those administered by the Smithsonian, National Park Service and other federal agencies, may receive funding from private donors, foundations, and corporations. Government funding for US museums not operated by the federal government is through competitive application to various national agencies, such as the National Endowment for the Arts, the National Endowment for the Humanities, and the National Science Foundation. Another federal agency, the Institute of Museum Services, also provides funding, through competitive grant applications, for general operation support. State and local governments also provide funding, either through direct support or through competitive application to state arts and humanities agencies or councils.

Current issues facing museums in the United States include: the Native American Grave Protection and Repatriation Act (NAGPRA); the Americans with Disabilities Act (ADA); ethics, education and public service; and strengthening multicultural representation in museum staff, exhibitions and collections. All museums, regardless of their funding sources, are contending with a relatively poor economy which inhibits appropriate growth in the public service mission. Innovative funding strategies are being tested and more museums are collaborating to maintain services to a diverse audience.

Canada

Canadian museums and museum-related activities have developed for more than a century. At the national level, four federal museums in Ottawa were originally established to improve public knowledge and to preserve important collections of artefacts. The National Museums Act of 1968 brought these four federal museums – the National Gallery of Canada, the National Museum of Man (now the Canadian Museum of Civilization), the National Museum of Natural Sciences, and the National Museum of Science and Technology – into the National Museums Corporation.

During a period of prosperity through the 1960s, the establishment of museums across the country was accelerated. Provincial governments, municipal councils, historical societies, and other non-profit groups sponsored museum development. The celebration in 1967 of the centennial of Canada's confederation helped to inspire this growth.

In 1972 a dramatic departure from previous federal direction was taken with the adoption of the National Museum Policy. This initiative was based on the principles of 'decentralization and democratization'. The National Museums Corporation assumed a second set of responsibilities involving making grants to Canadian museums outside the National Capital Region. These grants were

intended to assist in the upgrading of physical facilities, to promote better care of collections, and to encourage inter-regional exchange of exhibits.

In 1986 the National Museums Task Force recommended the dismantling of the National Museums Corporation. The four major federal museums became administratively autonomous, free-standing institutions. The existing Museum Assistance Programme, the Canadian Conservation Institute [500], the Canadian Heritage Information Network, the Mobile Exhibits Programme and the International Programme were restructured to take into account provincial government priorities and the changing needs of the museum community.

In 1988 the policy paper 'Challenges and Choices' was released. This document reflected responses from wide public consultation, and proposed objectives promoting access, awareness and understanding, representation of diversity and excellence. In response to these recommendations, a new National Museums Policy was announced in 1990. This document encouraged the development, management and preservation of significant and representative museum collections in all regions of the country. Financial and technical support for conservation, information and documentation, research, professional training and the development of First Nations and small and medium-sized museums was offered.

Museum policies have also been developed by numerous Canadian provinces and territories, including Saskatchewan, Prince Edward Island, Quebec, the Yukon and Ontario. In Ontario, a statutory regulation and associated guidelines and standards have been developed for over 200 community museums. An annual operating grant, and capital and non-capital funding programmes from lottery dollars are available to eligible museum clients.

Canadian museums are active witnesses to Canada's past, present and future. Government support at the municipal, provincial and federal levels will assist these museums to attain their objectives as public institutions.

For a discussion on these and other issues, see the publications of the Government of Canada [291] and the National Museums of Canada (1986).

WHAT IS MUSEUM STUDIES?

The study of museums may be traced back to prescriptive works in the eighteenth century, notably C. F. Neickel's *Museographia* (1727), which dealt with the problems of classification, collection care and sources to supplement collections.

Although a definitive history of museum studies still has to be researched and written, some research has been undertaken into the early history and development of museum studies in different countries. Teather [195] in the first PhD in Museum Studies to be awarded by the University of Leicester – *Museology and its traditions: the British experience, 1845–1945* – traced the development of museum studies in Britain, and Cushman (1984) and Malt (1987) did the same in the USA. It is clear that the early history of museum studies has been very

much influenced by individual museum workers, and there are a number of studies (e.g. Alexander [141]) that have examined and described these personal initiatives.

The use of the term 'museum studies' is relatively recent, and dates from the setting up of university departments in this field of study in the 1960s. 'Museum studies' is a general term which embraces both museology and museography (see below) and may be defined as the study of all aspects of the theory and practice of the museum operation. As Lewis [179] points out, the terms 'museology' and 'museography' have long-established usage. He notes, for example, reference to 'museographists' in *Elements of conchology* by Mendes da Costa (1776), and a German journal *Zeitschrift für Museologie und Antiquitätenkunde sowie verwandte Wissenschaften* devoted to museology which commenced publication in Dresden in 1878. ICOM (1972) has defined the terms as follows:

> Museology is museum science. It has to do with the study of the history and background of museums, their role in society, specific systems for research, conservation, education and organization, relationship with the physical environment, and the classification of different kinds of museums. In brief, museology is the branch of knowledge concerned with the study of the purposes and organization of museums.
>
> Museography is the body of techniques related to museology. It covers methods and practices in the operation of museums, in all their various aspects.

For further discussion on the nature of museology, see Sofka (1980), a series of papers by eminent museum curators and museologists.

Museum studies today reflects the two primary but related functions of museums. The first is to collect and care for objects relating to the natural and cultural heritage. Closely associated with this is the service by which these collections are made available for public education and enjoyment through exhibition, and educational and interpretive programmes.

The theory and practice of caring for collections (collection management) is now a well-established field, which is becoming more complex year by year as museums respond to the growing number of national and international laws, agreements, conventions and codes governing collecting and the transfer of cultural property. This increasing emphasis given to collection management also reflects the move towards greater public accountability of institutions that are financed directly or indirectly from public funds (for a discussion of this, see Malaro [238], National Audit Office [246] and Audit Commission [285]).

The application of sophisticated scientific techniques is also making its impact on collection management to the extent that the conservation of collections, although an integral part of collection management, has now become a field in its own right with its own specialized staff, training courses, institutions and literature. Within conservation, there has been a change of emphasis from

restorative conservation to preventive conservation, and the control of the museum environment (light, climate and atmospheric conditions) to minimize the deterioration caused by environmental factors. Conservation itself has become increasingly specialized: for example, in 1987 the ICOM International Committee for Conservation [454] had twenty-five working groups concerned with different kinds of object and different aspects of conservation.

The documentation of collections and the retrieval of data relating to them is being revolutionized by the use of computers. This is another area of museum work in which there is increasing specialization and which is developing its own specialist organizations, training courses and periodical literature.

As far as the museum service to the public is concerned, the growing pressure for public accountability, referred to above, has led to mounting interest in the museum visitor and visitor reaction to museums and museum programmes. Current work includes demographic studies, studies into the motivation and behaviour of museum visitors (and non-visitors) and attempts to measure the effectiveness of design elements and architectural features on visitor enjoyment, learning and motivation. Apart from some early studies in the USA (Melton, 1935; Robinson, 1928), serious interest in this field was not revived until the 1960s, when work was focused on commercial and temporary exhibitions and carried out by independent consultants. Now, many museums carry out evaluation on their exhibitions and programmes as a routine procedure, and many also employ in-house evaluators. An indication of the growing interest in evaluation was the establishment in 1985 of the International Laboratory for Visitor Studies.

All the functions of the museum depend upon sound management, and the management of museums embraces the management of collections, the management of museum buildings and plant, and the management of personnel. The study of museum buildings has attracted attention over many years and the first monograph on the subject was published in 1950 (Coleman, 1950). Recent work on museum buildings has been dominated by architectural considerations, but there is growing interest in the functional aspects of museum buildings and how effective they are in providing a safe environment for collections, and suitable facilities for the public and for the multitude of activities which now take place in museums.

ARRANGEMENT OF THE SUBJECT FIELD

It is difficult to find one completely satisfactory way of arranging the museum studies subject field. ICOM [447] produced its first scheme for the classification of museum documents in 1946 as an extension of Class *AM* (Museums) of the Library of Congress Classification. This scheme has been modified and extended a number of times. The classification, adopted and used in the ICOM annual bibliography *International Museological Bibliography* [38] until it ceased publication in 1988, used eight main headings for the organization of literature:

General museology
Protection of the cultural and natural heritage
Museums and society
The museum (management, personnel, building design and equipment)
Collections (acquisition, documentation, research, conservation and security)
Museums, communication and interpretation (the public, the exhibition,
 education and cultural action)
Different types of museum
Activities of national and international associations

Arrangements of the subject field have developed also from the planning of training courses. The ICOM Training Unit and the ICOM International Committee for the Training of Personnel [473] prepared a Common Basic Syllabus for professional museum training (ICOM Common Basic Syllabus, 1980). This syllabus, widely adopted (often in slightly modified form), comprises nine main headings:

Introduction to museology: history and purpose of museums
Organization, operation and management of museums
Architecture, layout, equipment
Collections: origin, related records, set-up and movement
Scientific activities, research
Preservation and care of collections
Presentation: exhibitions
The public
Cultural and educational activities of the museums

In the 1980s the Department of Museum Studies of the University of Leicester organized its syllabus *Learning goals for museum studies training* and associated bibliographies in a simpler format (adopted for the monographs listed in Part II of this volume), as follows:

The Museum Context – deals with the philosophical, historical and contemporary context of museums, including the organizational, legal, clientele and professional contexts.

Collection Management – covers the many aspects of caring for and managing collections, including policies for acquisition, legal aspects of acquisition, acquisition methods, documentation, storage, security and insurance, research and use.

Museum Management – embraces the nature and role of governing bodies of museums, museum personnel, buildings and sites, equipment and materials, and finance.

Museum Services – is concerned with the service which the museum provides to the public, including exhibition policy and practice, museum education services, museum information services, 'Friends' of museums, volunteers and trading activities.

RELATIONSHIP WITH OTHER SUBJECTS

Because different individuals see museums from different perspectives, it is important that museum studies should reflect these views. For example, some people see museums as part of the arts movement, having their closest affinities with theatre and music. This is reflected in the number of courses in arts administration which embrace museums. However, museums may also, with equal justification, be regarded as part of the heritage movement, having their closest affinities with organizations concerned with the management of natural and historic sites, buildings and monuments. It is certainly true that museum collections can often be fully understood and appreciated only in the context of the sites from which they originated. Other views are that museums, particularly those which attract large numbers of visitors, should be seen as part of the tourism and leisure industry, or that museums with well-developed educational functions should be regarded as a specialized form of education.

Museum studies has close links with individual subject disciplines such as art, archaeology, zoology, botany and geology. A curator of archaeology, for example, might regard himself as primarily an archaeologist who happens to be working in a museum. In the same way, an art curator might regard himself primarily as an art historian rather than a museum curator.

In many of its branches, museum studies draws heavily on other academic disciplines. The study of the conservation of collections is rooted firmly in the sciences of chemistry and physics and the study of museum buildings in architecture, while the study of museum exhibitions draws on design theory and educational psychology. The difficulty in delineating the parameters of the subject had led some writers to suggest that museum studies is not a full academic discipline in its own right. Whether this is so, or not, does not concern us here. What is important is the recognition that museum studies has an interface with many other disciplines and cannot be isolated from them.

ORGANIZATIONS

There are a number of types of organization closely involved with museums. These include: international organizations, official national bodies, professional associations, regional bodies, specialist groups and academic institutions. The roles of international and national organizations are described by Lewis (1992b).

International and supra-national organizations

The United Nations Educational, Scientific and Cultural Organization (UNESCO) is an independent international governmental agency of the United Nations. Its Division of Cultural Heritage [490] administers a programme concerned with the preservation and presentation of cultural property which is of direct concern to museums. There are also intergovernmental agencies such as the International Centre for the Study of the Preservation and the Restoration of Cultural Property (ICCROM) [487] (sometimes known as the Rome Centre), and the non-governmental Commonwealth Association of Museums [486].

The only international body specifically concerned with museums is the International Council of Museums (ICOM) [447]. A precursor of ICOM was the International Museums Office (1922–46) which was set up following the First World War under the auspices of the Committee for Intellectual Co-operation, which in turn owed its origin to the League of Nations. ICOM is a non-governmental, professional organization representing museums and the museums profession. ICOM receives some financial support from UNESCO, with which it maintains strong links (it has advisory status to UNESCO and to the United Nations Economic and Social Council). It also has close links with the International Council on Monuments and Sites (ICOMOS) [488], with the International Centre for the Study of the Preservation and the Restoration of Cultural Property (ICCROM) [487], and with the International Institute for Conservation of Historic and Artistic Works (IIC) [489]. ICOM is concerned primarily with international issues facing museums, and these issues are the main items on the agenda of the conferences which take place every three years.

Most of the larger countries have their own ICOM national committees (some with their own periodical publications), which usually work closely with the national associations (see below) in their respective countries, sometimes performing the functions normally carried out by national associations. There is also a series of international committees, currently twenty-three in number [451]–[473], which are concerned with the issues relating to different types of museums, collection and museum activity. These committees vary greatly in size, activity and publications; the largest (e.g. the International Committee for Conservation [454]) issue regular and substantial newsletters and some publish occasional monographs, including directories (e.g. the International Committee of Musical Instrument Museums and Collections [469]). In most cases the ICOM international committees are the only bodies working at an international level in their respective fields, although occasionally they may be paralleled by other international bodies: for example, the ICOM International Committee for Conservation exists together with the International Institute for Conservation of Historic and Artistic Works [489] (although they now work closely together). There are also two ICOM regional organizations [449]–[450], and in addition a series of international organizations, currently ten in number [474]–[483], affiliated to ICOM. These are concerned with promoting particular kinds of

museum (e.g. agricultural, architectural, maritime) and fostering links between them and other interested organizations.

Other organizations have links with museums at a supra-national level. The Council of Europe, for example, was responsible for the European Convention on the Protection of the Archaeological Heritage (ratified by the United Kingdom in 1973), for work on the problems of the underworld cultural heritage, and on prevention and control of illicit trafficking in cultural property. The European Community operates a fund for regional development in economically weaker areas, and certain museum projects (e.g. Merseyside Maritime Museum and Beamish Open Air Museum) have benefited from it.

Official national bodies

At a national level there is much variation between countries, but in most there is some kind of official national body. Such bodies may be responsible for museums throughout the country (see earlier discussion in this chapter), but others serve to advise governments on matters of national concern and some function as agencies for distributing central government funds to museums. Examples are: for Britain, the Museums and Galleries Commission [539]; for Canada, the National Museums Corporation; and for France, the Direction des Musées de France [511] (all of which have been mentioned earlier).

Professional associations

Examples of professional museums associations are the Museums Association (Britain) [540], founded 1889, the American Association of Museums (1906) [543], the Japanese Association of Museums (1928) [521], and the Canadian Museums Association (1947) [501]. Most of the national museums associations are open to membership by both museum institutions and museum staff, and their primary function is to provide a service for their members. This entails keeping members informed of museum developments through periodicals and other publications; making representation to government and other bodies on museum matters; and setting and monitoring professional standards. Some professional associations are also involved with professional training.

As the museums profession has grown, and as the influence of the professional associations has increased, there have been moves towards the establishment of codes of practice and codes of ethics. An Acquisitions Code was adopted by ICOM in 1971 and a Code of Professional Ethics in 1986 which has since been updated, most recently in 1990 (ICOM, 1990); and the Museums Association Code of Conduct for Museum Curators was adopted in 1983 and amended in 1987, and its Code of Practice for Museum Authorities in 1977. The codes may be seen as a move towards increased professionalism, defining the responsibilities of professional curators and museum authorities in relation to their collections and to the public which they serve, as well as such issues as the restitution or

return of cultural property, the disposal (deaccessioning) of collections and the display of culturally sensitive material.

Regional bodies

In the developed countries, there are also regional museum organizations. In Britain, for example, there are nine Area Museum Councils, ten Regional Federations and a growing number of *ad hoc* county or other regional groups. In the United States, the American Association of Museums [543] has six Regional Conferences (associations), and there are many state and local associations. A similar regional organization may be found in Australia. In Canada, there are provincial museum organizations in most of the provinces. Regional associations are particularly important in large countries where the distances involved prevent museum staff from travelling to national meetings. Some of the larger regional associations operate on the same scale as smaller national ones and some (e.g. the Ontario Museum Association in Canada) have full-time professional staff, a journal and a training programme.

Specialist groups

Apart from the ICOM international committees referred to earlier, there are many specialist museum groups within individual countries. In Britain, there are more than twenty such groups, almost all of which have come into being in the past twenty years, and most in the past ten years. They tend to be subject based (e.g. Group for Costume and Textile Staff in Museums), or service based (e.g. Group for Museum Publishing and Shop Management). Similar groups exist in many other countries, particularly North America. Their main function is to provide the opportunity to examine some of the more specialized aspects of museum work through meetings and seminars and to disseminate information and ideas through reports and periodicals. Details of the groups are available from the national organizations.

Academic institutions

There are few institutions of museum studies to parallel the institutes in other professions (such as the Institute of Archaeology in London). An exception is the Institut für Museumskunde [514] of Germany. The term 'institute' is sometimes used to describe periodic programmes such as that of the Museum Management Institute, an annual programme of the J. Paul Getty Trust, administered by the American Foundation of Arts at Berkeley, California.

The growth of museum studies departments within academic institutions is discussed below.

THE MUSEUM PROFESSION: ITS NATURE, RECRUITMENT, TRAINING AND CAREERS

The first museum curators had no formal training in museum work. Some were private collectors, and others were able to indulge their interests because they had private means. Some were academics who combined responsibility for teaching with that of running a museum. Others were appointed to museum posts because of their social standing.

George Brown Goode, assistant secretary of the Smithsonian Institution in charge of the United States National Museum, suggested in 1895 that success in the museum field could be attained only after years of study and experience in a well-organized museum (Cushman, 1984). Cushman noted that the first museum training programme in the United States was at the Pennsylvania Museum's School of Industrial Art (now Philadelphia College of Art) in 1908, and the first programme to train museum professionals for natural history museums was at the Museum of Natural History at the State University of Iowa, also in 1908. She recorded how a discussion on training initiated by the American Association of Museums in 1910, and the *Report of the Committee on Training Museum Workers* (AAM, 1917), led to early initiatives in training for museum work by Paul Sachs at Harvard's Fogg Museum in 1921 and John Cotton Dana at Newark Museum. Further details are given by Malt (1987).

In Britain, the University of London Courtauld Institute introduced in 1932 a diploma and degree course intended to train art museum curators. In October 1932 the Museums Association published regulations governing the award of its in-service Diploma, a scheme which until 1989 was run in co-operation with the University of Leicester. A major reorganization of the Diploma scheme took place in 1989. The University of Leicester Graduate Certificate/Master's course in Museum Studies dates from 1966, and new courses were introduced in 1989. The University of Manchester Postgraduate Diploma course in Art Gallery and Museum Studies dates from 1971, and in 1986 the Institute of Archaeology (University College London) set up a course leading to an MA in Museology. Full details of these courses may be found in the relevant prospectuses.

Early university departments in other parts of the world include the Department of Museum Studies at St Paul's University, Tokyo (1951) and the Department of Museology at the University of Baroda, India (1952).

The first world directory of museology training courses was published in 1970 (Sabourin, 1970). The directory *Museum studies international* [369], in its 1988 volume, lists 460 training programmes for museum curators in thirty-eight countries. A revised directory is to be published in 1993. These range from undergraduate to postgraduate courses in which museum studies may be a minor or major element. Many courses specialize in curatorship in specific fields of study such as art or history, and only a few offer a common core of museum studies training with the opportunity to specialize in one of several subject areas. New courses are often described in the periodical *It*, published by the ICOM

International Committee for the Training of Personnel [473]. For the UK, courses in museum studies and related subjects are listed in the *Museums yearbook* [399], and an annual list is published in the *Museums Journal* [99] ('Museums Journal's guide to long courses in museum studies, conservation and related subjects'). A 'Training supplement' (a guide providing the latest training news and a list of short courses) is also published quarterly in the *Museums Journal*, in January, April, July and August.

Advice on financial assistance for those wishing to embark on a training course can be found in *The grants register* [364], which includes a brief bibliography listing further sources.

Recruitment of curatorial staff by museums is at various levels, and qualifications needed depend to some extent on the type of museum and the nature of the post. Most of the larger research-orientated museums recruit staff on the basis of their academic qualifications and specialization, usually at postgraduate level. A qualification in museum studies is not normally required. The profession is changing, however, and as museum studies courses become more widely available, and competition for jobs greater, museums (and particularly local authority museums) are increasingly expecting new staff to have a professional museum qualification. Many employing authorities, particularly in Britain, also give financial recognition to such qualifications by awarding salary increments. The primary qualification demanded by employers, however, is still an academic one, and most employers look for a degree in a subject field relevant to the museum field in which the applicant will be working. For appointment to more senior posts, relevant museum experience is also needed.

First appointments in British museums, for example, are normally at the research assistant or curatorial assistant level or at assistant keeper level in smaller museums. A small number of museums offer trainee posts. Professional development over a period of years is typically from museum assistant or assistant keeper (or curator) to keeper, then principal or senior keeper, assistant director and director. It is unusual for this progression to take place within the one museum. The curator in charge of a small museum may have a salary in the same range as that of a keeper of a department in a large museum, and the salary of a keeper of a department in a national museum is often equivalent to that of a director of a large local authority museum. Movement of staff between national and non-national museums, once rare, is now becoming more common in Britain.

Few studies have been undertaken to determine the training requirements of the museums profession. Exceptions are *Professional directions for museum work in Canada* (Teather, 1978) and the Museums and Galleries Commission's report *Museum professional training and career structure* (1987). In 1988 a special issue of the journal *Museum* [90] was devoted to training. There is confusion about the responsibilities and terminology of job titles and designations, particularly those relating to director, curator and keeper, and there are often differences between countries. At the collection level, posts may be designated curator or keeper (UK) of par-

ticular collections (art, archaeology, history, zoology or botany, etc.). Staff with responsibility for the conservation of collections usually have 'conservation' in their job title. Education staff may be variously called keeper of education, education officer or keeper of extension services. There tends to be a much wider range of job titles in North America, but such positions as registrar, collection manager and keeper of documentation are now becoming more common in Britain.

As the museum movement grows, there is a tendency for museum jobs to become more specialized and for special training courses to develop, with the result that movement between different areas of museum work becomes more difficult. The Museums and Galleries Commission's report *Museum professional training and career structure* (1987) provided a timely assessment of training needs in the UK and has had a major impact on training. It noted, for example, that an expansion of the museums service in Britain had led to a multiplication of staff and increased complexity of management and administration. It identified the need for a common core of general museum studies to be undertaken by all museum workers, and proposed a progressive training programme which would allow curators to increase their qualifications and experience throughout their career.

In 1989 the Museum Training Institute (MTI) was established in Bradford 'to approve, promote and provide museum education and training in the United Kingdom'. The MTI is a national organization supported by the Office of Arts and Libraries, the Museums and Galleries Commission, the Museums Association and the Training Agency.

The museum profession is still quite small. It was estimated that in 1985 there were some 10,000 full-time paid staff in British museums, of whom perhaps two-thirds (6,600) were professional staff (Prince and Higgins-McLoughlin, 1987). Nor is the museum profession a very cohesive one. Many curators are not members of any professional museum association (ICOM has a personal membership of only 8,000) and, as noted earlier, many regard themselves primarily as subject specialists who happen to be working in museums.

There are a number of publications which give advice about careers in museums. Paine's *Careers in museums* (1991) relates specifically to posts in British museums, and Canham's *Museum careers: a variety of vocations* (1987) to museums in the United States.

REFERENCES

American Association of Museums. 1917. *Report of the Committee on Training Museum Workers*. Washington (DC): American Association of Museums.

American Association of Museums. 1970. *Museum accreditation: a report to the profession*. Washington (DC): American Association of Museums. 46 pp.

Boylan, P. J. 1992a. France dismantles its culture ministry. *Museums Journal* [99], 92: 6, 9.

Boylan, P.J. 1992b. Museum policy and politics in France, 1959–91. In: S. Pearce (ed.), *Museums and Europe 1992*, pp. 87–115. London: Athlone Press.

Canham, M. 1987. *Museum careers: a variety of vocations*. Washington (DC): American Association of Museums, Technical Information Service. 16 pp. (Resource Report/American Association of Museums, Technical Information Service, 2.)

Coleman, L.V. 1950. *Museum buildings*. Washington (DC): American Association of Museums. 298 pp.

Cushman, K. 1984. Museum studies: the beginnings, 1900–1926. *Museum Studies Journal*, 1: 3, 8–18.

De la Torre, M. and Monreal, L. 1982. *Museums: an investment for development: study prepared by the International Council of Museums for the 'International Seminar on the Financing of Culture' (Madrid, 22–24 March, 1982)*. Paris: ICOM. 106 pp.

de Lee, M. and Boylan, P.J. 1992. A well-qualified success. *Museums Journal* [99], 92: 5, 18–19.

ICOM Common Basic Syllabus for professional museum training. 1980. In: *The professional training of museum personnel: a review of the activities and policies of ICOM, 1947–1980*, pp. 25–30. Leicester: Leicestershire Museums, Art Galleries and Records Service for the ICOM International Committee for the Training of Personnel. Reprinted in *ICOM News* [69], 41: 2 (1988), 5–8.

International Council of Museums. 1972. *Professional training of museum personnel in the world*. Paris: ICOM.

International Council of Museums. 1990. *Statutes/Code of Professional Ethics*. Paris: ICOM. 35 pp.

Lewis, G.D. 1992a. Museums and their precursors: a brief world survey. In: J.M.A. Thompson and others (eds.), *Manual of curatorship* [137], pp. 5–21. London: Butterworth-Heinemann.

Lewis, G.D. 1992b. The organization of museums. In: J.M.A. Thompson and others (eds.), *Manual of curatorship* [137], pp. 47–57. London: Butterworth-Heinemann.

Lundbaek, M. 1985. Organization of museums in Denmark and the 1984 Museum Act. *International Journal of Museum Management and Curatorship* [92], 4: 1, 21–7.

Malt, C. 1987. Museology and museum studies programs in the United States: Part one. *International Journal of Museum Management and Curatorship* [92], 6: 2, 165–72.

Melton, A.W. 1935. *Problems of installation in museums of art*. Washington (DC):

American Association of Museums. 276 pp. (Studies in Museum Education; Publications of the American Association of Museums, new series, 14.)

Mendes da Costa, E. 1776. *Elements of conchology: or, an introduction to the knowledge of shells*. London: White. 318 pp.

Museums and Galleries Commission. 1987. *Museum professional training and career structure: report by a Working Party*. London: HMSO. 157 pp.

National Museums of Canada. 1986. *Museums in Canada: the federal contribution – response from the Board of Trustees of the National Museums of Canada to the Report of the Task Force on National Museums submitted to the Standing Committee on Communications and Culture of the House of Commons*. Ottawa: National Museums of Canada. 41 pp. En. Fr.

Neickel, C.F. 1727. *Museographia oder Anleitung zum rechten begriff und nützlicher anlegung der museorum, oder raritäten – kammern* . . . Leipzig: Hubert. 464 pp.

Paine, C. 1991. *Careers in museums*. London: Museums Association. 16 pp.

Petiver, J. 1695–1703. *Musei Petiveriani centuria prima (-decima) rariora naturae* . . . London: Smith and Walford. 93 pp.

Prince, D.R. and Higgins-McLoughlin, B. (compilers) 1987. *Museums UK: the findings of the Museums Data-Base Project*; Steering Group: Phipps, M.D. and others. London: Museums Association. 235 pp. Supplemented by *Update 1* (1987; 32 pp.).

Robinson, E.S. 1928. *The behavior of the museum visitor*. Washington (DC): American Association of Museums. 72 pp. (Publications, new series, no. 5.)

Sabourin, A. 1970. Répertoire des cours de muséologie dans le monde. In: International Council of Museums, *Training of museum personnel* [295], pp. 155–237. Hugh Evelyn for ICOM.

Sofka, V. (ed.) 1980. Museology – science or just practical museum work? *Mu Wop – Museological Working Papers*, 1, 14–51.

Teather, J.L. 1978. *Professional directions for museum work in Canada: an analysis of museum jobs and museum studies training curricula – a report to the Training Committee of the Canadian Museums Association*. Ottawa: Canadian Museums Association. 412 pp.

Tradescant, J. 1656. *Musaeum Tradescantianum; or, a collection of rarities preserved at South-Lambeth neer London*. London: Grismond. 179 pp.

Worm, O. 1655. *Museum Wormianum seu historia rerum rariorum* . . . Lugduni Batavorum: Ex officina Elseviriorum. 389 pp.

Wright, P. 1989. Museums and the French State. *Museums Journal* [99], 89: 5, 23–31.

2 Museum Studies Information: Its Origins and Utilization

It has been made clear in Chapter 1 that the serious study of museums is a relatively new phenomenon, and this is reflected in the age of the literature. A very high proportion of museum studies literature is post-Second World War, one of the main features being the increasing number of periodicals and newsletters emanating from the numerous specialist groups that have developed in recent years. This chapter discusses the various channels of communication in museum studies, with notes on data about museums and on writing and publication, and looks at the repositories of literature – documentation centres and libraries.

CHANNELS OF COMMUNICATION

Periodicals

Information relating to museum studies is communicated primarily through the journal or periodical (these terms are used interchangeably to indicate a publication issued at regular or irregular intervals, each issue normally numbered consecutively, with no pre-arranged termination date). They include such publications as, for example, bulletins, proceedings, transactions, etc. of organizations as well as the increasingly popular newsletter.

The majority of journals and newsletters are published by international and national museum organizations (e.g. *ICOM News* [69], *Journal of Indian Museums* [77]), and by regional museum associations (e.g. *Museum Quarterly* [96]). More

specialist periodicals are produced by organizations concerned with particular aspects of museum work (e.g. *Journal of Education in Museums* [76], *Studies in Conservation* [122]), or with particular subject areas (e.g. *Geological Curator* [61], *Journal of Biological Curation* [75]). Some, however, are published by individual museums (e.g. *Curator* [58]), and others by academic institutions (e.g. *Reinwardt Studies in Museology* [113]). A few are published by different kinds of museum administration (e.g. *AIM* [46]) or user groups (e.g. *Museum News* [94]). Journals published by commercial publishers are less common (e.g. *Museum Management and Curatorship* [92], *Museum Development* [89]).

The authors of the large majority of the articles in the periodical literature are practising museum workers, but a growing number are teaching and research staff of academic and related institutions.

Museum studies journals date from 1878 with *Zeitschrift für Museologie und Antiquitätenkunde sowie verwandte Wissenschaften*. In 1890 the Museums Association published the first volume of its *Report of proceedings, with the papers read at the annual general meeting*. This was succeeded by the *Museums Journal* [99], which began publication in 1901. *Museumskunde* [100], the journal of Deutscher Museumsbund (Museums Association of Germany), was first published in 1905, and the *Proceedings of the American Association of Museums* in 1907 (followed by *Museum Work* in 1918 and *Museum News* [95] in 1924).

Journals published by museums are devoted mainly to matters relating to their collections, but may be of wider interest. The Natural History Museum, for example, publishes the *Bulletin of the Natural History Museum*, which has separate series for Botany, Entomology, Geology and Zoology, and *Occasional papers on systematic entomology*.

As well as the scholarly research journals, some museums publish more popular journals aimed at the general public; examples include *Natural History* (American Museum of Natural History, 1919–. Monthly) and *Smithsonian* (Smithsonian Institution, 1970–. Monthly).

The oldest form of museum periodical is probably the annual report, which was at one time produced by most museums and circulated on an exchange basis. Financial constraints have forced many museums to discontinue the publication of such reports, exceptions being those museums which have a statutory responsibility to do so (many national museums), and those which are supported by membership subscriptions and regard the reports as an important service to members.

Theses

Research undertaken for a higher degree in museology and submitted in the form of a thesis is relatively uncommon; for example, a computer search of DISSERTATION ABSTRACTS ONLINE [130] under 'museum(s)' produced a list of 388 North American theses covering the period 1861 to 1993. A manual search

of *Index to theses* . . . [132] gave seventeen British theses with 'museum(s)' or 'museology' in the title.

Monographs

A notable feature of museological literature is the reports emanating from numerous committees and other bodies associated with museums. Examples of major publishers of such reports are UNESCO [490], ICOM [447] and its international committees [451]-[473], and, at a national level, the professional museum associations (e.g. the Museums Association's *Biological collections UK* (1987)). Reports containing data useful for museum studies are also published by individual museums (e.g. *A survey of visitors to the British Museum (1982-3)* (Mann, 1986), published by the British Museum) and by non-museum organizations (e.g. *Arts for everyone* (Pearson, 1985), published by the Carnegie United Kingdom Trust and the Centre on Environment for the Handicapped).

Museums, especially large ones, can be major producers of literature, much of it in monograph form. Bassett [26] examined in detail the most important types of museum publications and provided a bibliographical guide to the literature on them. The same author (Bassett, 1986) examined the range and nature of British museum publications over the period 1975-85. Twelves (1992) discussed the development of retailing in museums and gave practical advice on the setting up of museum shops (further information on this aspect of museum activity can be found in the *Newsletter of the Group for Museum Publishing and Shop Management* [64]). Detailed lists of the publications of nearly 1,000 museums in Britain can be found in Roulstone [30], while on a world scale *World museum publications* [31] fulfils a similar purpose.

Other monographs take the form of textbooks, treatises or handbooks/manuals. The majority of these are published by museum organizations (e.g. the American Association of Museums [543] and the American Association for State and Local History [542]); others by commercial publishers, individual museums and university presses.

Much of the information in monograph form is a synthesis of material previously published. This process of synthesis takes place again at a later stage to produce various kinds of reference work such as bibliographies, indexes and abstracts (see later chapters).

Other channels

Current research is also reported in papers presented at seminars and conferences, and many such papers find their way into print either in conference reports or as papers in journals. Other reports are circulated within the 'invisible college' of the museum world as 'preprints' – preliminary, tentative reports, sometimes modified in the light of criticism – which by their very nature cannot be subject to bibliographic control.

Another, and related, problem is that important work is frequently published by small organizations, in journals of poor quality and limited circulation, so that it is not as widely available as it deserves.

Unpublished material

As with many disciplines, much work is carried out which is not published. Some new initiative is needed to rectify this situation, and any future strategy should recognize the need to encourage individuals working in the museum studies field, and with significant contributions to make, to publish their work.

The press and media

The wide interest in museums is reflected by the large number of feature articles about museums and museum collections which appear in the press, for example in daily newspapers and tourist and leisure magazines. Museums are often the subject of radio programmes and television documentaries, and the present public interest in museums has been stimulated in Britain, at least, by television series like 'Museum of the Year Award' and 'Antiques Roadshow'.

DATA ABOUT MUSEUMS

There is a pressing need to collect and organize the data which are the raw material for museum studies research. To date, few attempts have been made to tackle this, although the Museums Association's project *Museums UK: the findings of the Museums Data-Base Project* (Prince and Higgins-McLoughlin, 1987), financed by the Office of Arts and Libraries, was an important development. The Institute of Museum Services in Washington, DC (discussed in Chapter 1) maintains a database relating to applicants and recipients of grants awarded by the Institute. In 1989 the American Association of Museums carried out a survey of museums in the United States which provided up-to-date information [145]. Other data of relevance to museum studies may be found in the surveys carried out by official organizations such as the Office of Population Censuses and Surveys (e.g. Smyth and Ayton (1985); Harvey (1987)), and by tourist and cultural organizations such as the English Tourist Board (e.g. English Tourist Board (1982)), Australia Council for the Arts (1991), and the Arts and Culture Branch, Department of the Secretary of State, Government of Canada [156], and by individual museums (e.g. Prince and Higgins, 1992).

WRITING AND PUBLICATION

Bassett [26], in a section on 'Preparation and publication', considered several general guides to research writing and publishing which researchers in museum

studies might find useful. The *Newsletter of the Group for Museum Publishing and Shop Management* [64] has included several papers on museum publishing and museum book sales (e.g. Silvester (1979, 1980)).

As with all subjects, researchers intending to submit articles to museological journals will find guidelines for authors included in some of the journals themselves (e.g. *Museum Management and Curatorship* [92], *Geological Curator* [61]).

DOCUMENTATION CENTRES AND LIBRARIES

The two main repositories of museum studies literature are documentation centres and libraries. Documentation centres tend to play a wider role than libraries: in addition to receiving and processing material and making it available to researchers, they may be involved in summarizing publications and indexing them; they may conduct research, and prepare and distribute bibliographies and bulletins or periodicals (e.g. *Muzejní Práce* [108], *Muzealnictwo* [105]). Unlike libraries, however, they do not usually provide a lending service.

The development of documentation centres may be seen as a response to the growing need for information about museums and museum studies, the specialized nature of the subject field, and the need to concentrate resources in national centres. Relatively few libraries have the resources to provide or exploit such specialized material.

The following notes about individual documentation centres and libraries are drawn partly from information supplied by the Director of the UNESCO–ICOM Information Centre, from whom the latest information may be obtained. More details about particular libraries/documentation centres are given in Part III.

International documentation centres and libraries

There are two international documentation centres in Paris which constitute the UNESCO–ICOM–ICOMOS documentation network. The UNESCO–ICOM Museum Information Centre [447] was established by UNESCO in 1946 and entrusted to ICOM in 1948. It covers the field of museology and museum operations and provides a range of services (for full details, see [447]). It shares a bibliographic database (ICOMMOS) with the UNESCO–ICOMOS Documentation Centre [488], which contains literature concerning monuments and sites, shortly to be made available on CD-ROM. The International Centre for the Study of the Preservation and the Restoration of Cultural Property (ICCROM) [487] in Rome also has a large collection of literature on all aspects of the preservation and conservation of cultural property.

There are plans for a network to facilitate the sharing of bibliographic materials between museum information centres. Initially, the UNESCO–ICOM Museum Information Centre is co-operating with the Museological Resource Centre of the Canadian Conservation Institute [500] and the Canadian Heritage Information

Network (CHIN) to establish a database structure. When museological bibliographic data are loaded into the database, it is planned to remove duplicate and overlapping records. Eventually, other museum reference centres will be invited to contribute data. The long-term goal is to offer an online museological reference database to the museum community and to support museum information/reference centres by saving a duplication of cataloguing effort. It is also intended that the results of this project will be available in a CD-ROM format. Further details may be obtained from the UNESCO–ICOM Museum Information Centre [447].

Museum libraries

However small a museum, or whatever its type, its activities usually require the support of a library. Many of these museum libraries (a particular type of special library) are simply small collections of a few books and periodicals, most of which relate to the collections housed in the museum (with poor coverage of museum studies) and are intended as working libraries for staff, with no lending facilities. Some, however, are of considerable size, and libraries in many major museums, such as those in the United Kingdom national museums, are of international importance. Large libraries such as these often include, in addition to books, special forms of material, such as photographs and slides, manuscripts, memorabilia and other types of archive material; for example, the library of the American Museum of Natural History in New York contains nearly half a million volumes, countless archives and nearly one million photographs.

There is a brief discussion of museum libraries and their nature, operations, staffing and stock in Kenyon (1992). Detailed advice on running a museum library is given in Larsen [296], while certain aspects of museum libraries are discussed in *The role of the library in a museum* [302]. Articles and other publications about museum libraries can be traced through *Library and Information Science Abstracts* (London: Library Association, 1969–. Monthly. Available online through DIALOG and BRS) and *Library Literature* (New York: H.W. Wilson, 1931/32–. Bi-monthly. Available online through WILSONLINE). Some libraries serving museums which emphasize science and technology (mainly in the USA) were described in a special issue of the periodical *Science and Technology Libraries* (6(1/2), 1985–6), also published in monograph form (Mount, 1985).

Museological literature in other libraries

Few of the professional associations such as the Museums Association [540] and the American Association of Museums [543] have more than working libraries (the main library of the Museums Association has been transferred to the City University in London), although the American Association for State and Local History [542], for example, has a very extensive library.

The specialized nature of the subject and the small number of users mean that

museological collections in public and academic libraries are, generally speaking, not large. In Britain, there are significant museum studies collections at the University of Leicester (see below), and in the libraries of the Institute of Archaeology of the University of London, the City University, London, and the National Museum of Wales in Cardiff.

Directories of libraries

Information about major libraries, including those in museums – address, number of volumes, etc. – can be found in directories. On an international scale, the *World guide to libraries* (Munich: Saur, 1966–. Irreg.) is the most comprehensive; the tenth edition (1991) listed over 40,000 libraries (including museum libraries) with holdings of over 5,000 volumes. Other directories of libraries can be traced in the latest editions of the two most comprehensive guides to reference works in general, Walford [3] (emphasis on British publications) and Sheehy [2] (emphasis on US publications).

Details of bibliographical services generally, including schemes for interlibrary lending, in most countries of the world, are given in Beaudiquez [1]. In Britain, only a few of the national museum libraries lend material through the interlibrary lending service.

MUSEOLOGICAL LITERATURE IN SELECTED COUNTRIES

It will be clear from what has been said already that museological literature will be found in many different places: museum libraries; national, public and academic libraries; libraries of professional associations; and libraries and documentation centres of the various other museological organizations discussed in Chapter 1. The following section looks briefly at the situation in seven countries; for information about other parts of the world, the UNESCO–ICOM Museum Information Centre [447] should be consulted.

United Kingdom

There is no national museum documentation centre, but some of the Area Museum Councils fulfil some of the functions at a regional level and all can provide information. The Scottish Museums Council [541], for example, has an information centre with a comprehensive range of museological literature, established in 1981. It publishes *Museum Abstracts* [39] and, until 1993, *Museum abstracts international* [13]. The Museum Documentation Association [538] maintains a library on object documentation, collection management, and automation in machine-readable format, with abstracts for the most recent publications.

The Department of Museum Studies at the University of Leicester, in co-operation with the University Library, has been collecting material relating

to museum studies since 1966. At present (1993) the University Library houses about 2,000 relevant monographs and some 400 periodical titles of which just less than 100 are current. A particular strength of the holdings is the long series of journals and annual reports. The Library also houses the theses produced by Museums Association Diploma students during the years 1932–73, and theses submitted by the students in the Department of Museum Studies for (or as part of) their higher degrees. This collection is the most complete of its kind in the United Kingdom.

The Department of Museum Studies of the University of Leicester maintains a Museum Documentation Centre at 105 Princess Road East, Leicester. The Centre holds runs of museum-centred periodicals (some of them in foreign languages) together with files of museum catalogues, newsletters, flyers and similar material. The Documentation Centre is being developed through grants awarded by the Museums and Galleries Commission [539], and the material is in process of entry on to a computer database using ISIS software.

Libraries in British national museums were studied by Draheim (1976), who examined their provision of services to members of the public and to administrative and curatorial staff in his thesis *Libraries in British museums*.

USA

In addition to the many substantial museum libraries, there is one museological collection of particular importance. The Museum Reference Center [544], a branch of the Smithsonian Institution Libraries, maintains a comprehensive collection of technical literature relating to museum management and museum studies in general. All the monographic material has been put online.

The American Association of Museums [543] has developed an information service for its member institutions in connection with the Museum Assessment Program. The purpose of this service is to share existing material from a broad range of sources on museum operations and activities and to develop comprehensive new materials where appropriate.

The Clearinghouse project of the Metropolitan Museum of Art in New York is both a directory and an indexed resource collection comprising information dealing with computerization as it applies to art history and related research projects; museum and visual resource collection documentation; bibliographic and information systems; and vocabulary control and other aspects of library and information sciences.

Canada

The Library of the Canadian Conservation Institute [500] of the Department of Communications houses the Museological Resource Centre and the conservation collection. The Museological Resource Centre houses material on museology,

museums and heritage, intended to serve the needs of the Canadian museum community. Publications include *Acquisitions list* and *Index to museological literature*. The whole collection of museological and conservation information is the largest of its kind in Canada.

France

The Bibliothèque de l'Ecole du Louvre serves approximately 3,000 students over a four-year programme, and houses a collection on museology as it relates to France. The Office de Coopération et d'Information Muséographiques [512] in Dijon has documentation in the field of natural history. A new school for the training of curators, Ecole du Patrimoine, has also been created, and a documentation centre, created at the Ecole du Patrimoine and at the Bibliothèque de l'Ecole du Louvre, develops collections related to the curriculum.

Netherlands

The Library of the Reinwardt Academie in Leiden covers the whole field of museology, including general, theoretical, historical, special and applied museology. Special attention is paid to bibliographies and directories concerning museums from all over the world. The Library primarily serves the needs of students and teachers of the Academy.

Denmark

The Museologisk Bibliotek (Library of Museology) at Lyngby is part of the Danish Museum Training Institute. It aims to serve the staff of Danish museums as well as the general public with information and literature in the field of museology.

Germany

The Institut für Museumskunde, Staatliche Museen zu Berlin, Preussischer Kulturbesitz [514] houses worldwide museological literature with special emphasis on Germany and Europe, mainly in De. En. and Fr.

REFERENCES

Australia Council for the Arts. 1991. *Art galleries: who goes? A study of visitors to three Australian art galleries with international comparisons.* Chippendale (Australia): Australia Council for the Arts. 125 pp.

Bassett, D.A. 1986. Museums and museum publications in Britain, 1975–85. Part 1: The range and nature of museums and their publications. *British Book News* (May), 263–73.

Biological collections UK: a report on the findings of the Museums Association Working Party on Natural Science Collections based on a study of biological collections in the United Kingdom. 1987. London: Museums Association. 597 pp.

Draheim, M.W. 1976. Libraries in British museums. MLib thesis, University of Wales. 333 pp.

English Tourist Board. Market Research Department. 1982. *Visitors to museums survey, 1982: report, by English Tourist Board Market Research Department and NOP Market Research Ltd*. London: Planning and Research Services Branch, English Tourist Board. 60 pp.

Harvey, B. 1987. *Visiting the National Portrait Gallery: a report of a survey of visitors to the National Portrait Gallery*. London: HMSO. 51 pp. (Office of Population Censuses and Surveys. Social Survey Division. SS 1237.)

Kenyon, J.R. 1992. Museum libraries. In: J.M.A. Thompson and others (eds.), *Manual of curatorship* [137], pp. 585–89. London: Butterworth-Heinemann.

Mann, P.H. 1986. *A survey of visitors to the British Museum (1982–3)*; ed. by M. Caygill and G. House. London: British Museum. 58 pp. (British Museum Occasional Paper, no. 64.)

Mount, E. (ed.) 1985. *Sci-tech. libraries in museums and aquariums*. New York; London: Haworth. 218 pp.

Pearson, A. 1985. *Arts for everyone: guidance on provision for disabled people*. Dunfermline: Carnegie United Kingdom Trust; London: Centre on Environment for the Handicapped. 116 pp.

Prince, D.R. and Higgins, B.A. 1992. *Leicestershire's museums: the public view*. Leicester: Leicestershire Museums, Art Galleries and Records Service. 166 pp. (Leicestershire Museums publication, no. 123.)

Prince, D.R. and Higgins-McLoughlin, B. (compilers) 1987. *Museums UK: the findings of the Museums Data-Base Project*; Steering Group: M.D. Phipps and others. London: Museums Association. 235 pp. Supplemented by *Update 1* (1987; 32 pp.).

Silvester, J.W.H. 1979 and 1980. The small museum's publishing function. *Group for Museum Publishing and Shop Management – Newsletter* [64], 2 and 3.

Smyth, M. and Ayton, B. 1985. *Visiting the National Maritime Museum: a report of a survey of visitors to the National Maritime Museum, Greenwich*. London: HMSO. 46 pp. (Office of Population Censuses and Surveys. Social Survey Division. SS 1226.)

Twelves, M. 1992. Retailing. In: J.M.A. Thompson and others (eds.), *Manual of curatorship* [137], pp. 702–9. London: Butterworth-Heinemann.

3 Who, What, Where?: Tracing Organizations, Collections, Individuals and Research

Part III of this *Keyguide* gives information about many important organizations concerned with museum studies. This listing cannot, of course, be comprehensive, and it is important to know where to look to find further information. The purpose of this chapter is to identify those bodies and publications which can help to trace particular organizations/individuals such as museums, museum collections and staff, university departments of museum studies, and current research.

ORGANIZATIONS

International Council of Museums (ICOM)

One of the main keys to finding out who does what and where is the International Council of Museums [447], with its 8,000 members in 120 countries in five continents. A major source of information is *ICOM News* [69], which in each issue lists the staff of the ICOM Secretariat, the UNESCO–ICOM Museum Information Centre [447], the ICOM Executive Council and the ICOM Foundation [448]; it also lists over eighty national committees (for which ICOM functions as an umbrella body) including the names and addresses of the chairpersons. Individual members of ICOM are automatically members of the ICOM national committee of their country of residence. ICOM also supports some twenty-four international committees and two regional organizations, and has affiliated to it some ten international organizations; a full list of all these is given in Part III [451]–[483]. The names and addresses of the chairpersons and

secretaries of these international committees and organizations are given in *ICOM News* [69].

The ICOM *Directory* [366], published for the first time in 1992, includes almost all the information described above, usually in more detail. It also lists for each country institutional members of ICOM, institutions with ICOM members, and individual members.

Professional associations

At a national level, the professional museum associations in particular countries can be the first source of enquiry. Most of them are included in Part III. They are conveniently listed, worldwide, in some museum directories such as the *Museums yearbook* [399], *Museums of the world* [376], *The official museum directory* [443] and *The official directory of Canadian museums and related institutions* [401]. Such directories may also include details of regional and specialist associations in the countries concerned.

DIRECTORIES OF MUSEUMS

There have been a number of attempts at world directories of museums, notably Hudson and Nicholls [375], which lists some 35,000 museums, and *Museums of the world* [376], which lists nearly 24,000. The third edition of Hudson and Nicholls was extended to include living displays, and also included useful brief summaries of the organization of museums in each country; the second edition, published in 1981, included a select bibliography of national museum directories and articles, arranged under countries. The second edition of *Museums of the world*, published in 1975, included a shorter bibliography based on similar lines. The directories listed in the second editions of both these works have been largely superseded by those in Part II of this *Keyguide*.

At continent level, there are selective directories for Africa [386]–[387] and Asia [389], and those published by the UNESCO–ICOM Museum Information Centre include bibliographies of museum directories and articles for most of the countries in each volume. For German-speaking countries, the *Handbuch der Museen* [409] covers over 3,400 museums. At a national level, many countries regularly produce some form of museum directory (see [386]–[444]), some published by professional associations, others commercially. In addition, more popular guides are available for the general public – for example, *Museums and galleries in Great Britain and Ireland* (East Grinstead: British Leisure Publications).

Another type of directory covers a particular kind of museum; for example, *Art museums of the world* [377], *International directory of musical instrument collections* [382] and *Directory of the natural sciences museums of the world* [383]. Further examples are given in Part II [377]–[385]. The 'Geographic guide to museums' section of *World museum publications 1982* [31] lists some 10,040 art museums by country.

The amount of information included in these directories varies greatly. Some attempt to be comprehensive listings for a country or subject, others are more selective. A typical directory is usually arranged geographically and includes at least some or all of the following: name, address and telephone number; name of curator/director; opening hours; admission charges; a brief summary of collections; and any publications by or about the museum.

MUSEUM COLLECTIONS WITHIN MUSEUMS

Some directories of museums include brief details of the collections held by individual museums. On a world scale, Hudson and Nicholls [375], *Museums of the world* [376] and (more selectively) *The world of learning* [372] give summaries of museum holdings; *Museums of the world* has the advantage of excellent indexes – by museum, person and subject – which guide the user to specific entries. For Europe, Hudson and Nicholls [410] summarize the holdings of selected museums. At a national level, some of the more popular guides give details about collections and exhibitions (e.g. Hudson and Nicholls' *The Cambridge guide to the museums of Britain and Ireland* [398]).

At a more detailed level, it is often very difficult to discover which named collections are housed in individual museums and where specific kinds of collection, or collections made by particular individuals, may be found. International directories covering particular kinds of museum (mentioned earlier and listed in Part II [377]–[385]) may help.

Perhaps the most important source of information about collections is the published catalogues, many of which may be located in *World museum publications 1982* [31] and (for Britain) Roulstone [30]. Because of the size of some collections (e.g. in the natural sciences) it is now only really practical to produce catalogues of the smaller and more specialized collections, such as those of fine and decorative arts or those of temporary exhibitions. This was not always the case; attempts were made to produce complete catalogues of many early collections (discussed in Chapter 1). As recently as 1904 the British Museum (Natural History) (now the Natural History Museum) published what amounts to a catalogue of its collections in *The history of the collections contained in the natural history departments of the British Museum* (London: Trustees of the British Museum, 1904 and 1906).

The use of computers has, however, facilitated the production of catalogues by making the process more economical. Both the National Maritime Museum (London) and National Army Museum (London), for example, have produced catalogues in which data for the collection have been drawn from computer databases. There is also a move towards making catalogues of collections more widely available on microfiche (e.g. the Sedgwick Museum of Geology in Cambridge has a fiche catalogue of its entire collection which it can make available to researchers). It is worth noting that it is also possible to obtain

microfilms of important herbaria from certain museums, the microfilm being made up of photographs of individual herbarium sheets.

Some of the larger museums are now using videodiscs to store photographic images of certain collections (Nyerges, 1982). The National Air and Space Museum of the Smithsonian Institution in Washington, for example, has put most of the museum's collection of archival photographs – over one million in total – on a series of five videodiscs, copies of which are available for sale (Cipalla, 1985). There is also an exciting project at the Canadian Museum of Civilization (Granger and Alsford [226]) which involved recording images of every artefact in its collection on an interactive laser-read optical disc system. Some catalogues of museum art collections are including fiches of photographs of the collections within the catalogues themselves.

Some periodicals (e.g. *ASC Newsletter* [48], *Biology Curators' Group Newsletter* [52], *Geological Curator* [61]) include descriptions of particular collections (as well as staff and research in progress). The *Geological Curator* [61] also runs a regular feature on collections 'lost and found'. In Britain, a series of *ad hoc* Collection Research Units has been set up to compile directories of natural science and social history collections at a regional level, with the long-term aim of a national catalogue. A number of catalogues have been published to date (e.g. Davis and Brewer (1986), Schumann (1986), Stace, Pettitt and Waterston (1987)).

For tracing the history of collections and individual items, important sources of information are the sale catalogues produced by the commercial auction houses. Sotheby Parke Bernet have published a directory of auction catalogues involving natural history collections (Chalmers-Hunt, 1976).

There have been many proposals for a union catalogue of collections, but few have progressed further than the idea. The National Inventory Programme (NIP) of the National Museums of Canada, conceived in 1972 and subsequently renamed the Canadian Heritage Information Network (CHIN) (1985) in 1982, is one of the few schemes which aims to produce a national inventory of collections. The computer facilities and the programme have been made available by the National Museums Corporation, and terminals sited in the major museums throughout the country.

One problem in producing national and international catalogues of collections has been that of standards in nomenclature and recording formats. The Museum Documentation Association (MDA) [538] has spent many years developing a set of data standards which has now been adopted by a substantial number of museums in Britain and also some abroad. The launch of the MDA's museum object data entry system (MODES) by MDA in 1987 ([Light], 1987) – a microcomputer package incorporating the data standards and the upgraded MODES-PLUS in 1992 – has brought computer documentation of collections within the range of small museums for the first time.

OTHER USEFUL DIRECTORIES

Many museums and museological organizations can be traced in *The world of learning* [372], a major international guide to educational, scientific and cultural institutions of all kinds. As an annual publication and therefore up to date, it can sometimes confirm (or otherwise) details of an organization originally traced elsewhere. The same is true of the *International directory of arts* [367], which gives addresses and other information worldwide on all aspects of art, the fine art trade and museum organizations, although there are no indexes. Of the many useful directories for individual countries (traceable through Sheehy [2] and Walford [3]), the most noteworthy is the *Encyclopedia of associations* [362], which includes numerous museological organizations in the United States (where there are about one-fifth of the world's museums), with details of activities and publications.

INDIVIDUALS AND CURRENT RESEARCH

There is no comprehensive international directory of museum workers. The *ICOM Directory* [366] lists individual members of ICOM for each country, with an index of all names. Personnel working in museums can be traced through some museum directories, although not the two international ones – Hudson and Nicholls [375] or *Museums of the world* [376]. However, on a worldwide scale, the 'Museums and public galleries' section of the *International directory of arts* [367] includes names of staff in many of its entries. At a national level, some lists are produced by professional museum organizations. The *Museums yearbook* [399], for example, includes lists of personal members; *The official directory of Canadian museums and related institutions* [401] includes names of personnel; and *The official museum directory* [443] lists directors and department heads.

Lists of members are produced periodically as separate publications by specialist organizations such as the International Institute for Conservation of Historic and Artistic Works [489], and the American Institute for Conservation of Historic and Artistic Works includes a list of members in its annual *Directory*. Other lists of members may be found in the periodicals of specialist groups (e.g. *Biology Curators' Group Newsletter* [52] and *MPG News* [80]). It should also be noted that museums which publish annual reports often include lists of staff.

Names of senior staff in academic institutions worldwide are listed in *The world of learning* [372] but only down to Reader level. The best source for staff in Commonwealth universities is *Commonwealth universities yearbook* [360], which has a name index, while for North American academics it is the *National faculty directory* [371]. Calendars of individual institutions naturally give more detail. Directories in other fields of study can be useful: for example, the annual publication *Guide to departments of anthropology* (Washington: American Anthropological Association) contains a section on museum departments of anthropology in North America

which includes details of staff, research facilities, collections, facilities for visiting scholars, instructional programmes and publications.

Well-known people currently working in the museum field may appear in international biographical works such as *International who's who* (London: Europa, 1935–. Annual) or national works such as *Who's who* (London: Black, 1849–. Annual). Former workers can be found in retrospective publications such as (for Britain) the *Dictionary of national biography* (London: Oxford University Press, 1885–) or *Who was who* (London: Black, 1920–). For tracing biographies of museum workers pre-1950 on an international scale, Hyamson's *A dictionary of universal biography of all ages and of all peoples* [365] is invaluable. Obituaries appear in some journals (e.g. *ICOM News* [69]), and well-known museum workers have obituaries in 'quality' newspapers such as *The Times*.

For current research, the most up-to-date and detailed information appears in the appropriate periodical(s). There are also national registers maintained by certain countries listing current research in all or some subjects. For Britain, current research being undertaken by museums, universities and other institutions is listed in *Current research in Britain* [361]. For the USA and Canada, museological research in university-related and non-profit research organizations is summarized in *Research centers directory* (Detroit (Michigan): Gale, 1960–. Biennial); its companion volume *International research centers directory* (Detroit (Michigan): Gale, 1982–. Irreg.), covering the rest of the world, includes some museological research.

Other more general directories, some for individual countries, can be traced in Sheehy [2] and Walford [3]. It should be remembered that many directories depend upon replies by individuals to questionnaires, and therefore can be only as good as their response rate.

REFERENCES

Canadian Heritage Information Network, National Museums of Canada, Ottawa. 1985. In: D. A. Roberts, *Planning the documentation of museum collections* [264], pp. 499–504. Duxford: Museum Documentation Association.

Chalmers-Hunt, J. M. (compiler) 1976. *Natural history auctions 1700–1972: a register of sales in the British Isles.* London: Sotheby Parke Bernet. 201 pp.

Cipalla, R. 1985. The video-disk advantage. *History News* [67], 40: 8, 18–20.

Davis, P. S. and Brewer, C. (eds.) 1986. *A catalogue of natural science collections in north-east England: with biographical notes on the collectors.* Durham: North of England Museums Service. 333 pp.

[Light, R. B.] 1987. MODES: the museum object data entry system. *MDA Information*, 11: 2, 10–12.

Nyerges, A. L. 1982. Museums and the videodisc revolution: cautious involvement. *Videodisc/Videotex*, 2: 4, 267–74.

Schumann, Y. (ed.) 1986. *Survey of ethnographic collections in the United Kingdom, Eire and the Channel Islands: interim report.* [Ipswich]: Museum Ethnographers' Group. 2 vols. (Museum Ethnographers' Group Occasional Paper, no. 2.)

Stace, H. E., Pettitt, C. and Waterston, C. D. 1987. *Natural science collections in Scotland (Botany, Geology, Zoology)*; ed. by D. Heppell and K. J. Davidson. Edinburgh: National Museums of Scotland.

4 Keeping Up to Date with Current Publications, Developments and Events

One obvious way of keeping up to date successfully is to scan individual publications. This is, of course, an important activity, but the increasing amount of museological literature of all kinds has necessitated the development of specialized guides to the literature – annual bibliographies, and indexing and abstracting journals. Indexing journals list the authors, titles and other bibliographical details of publications. Abstracting journals give the same information but also include abstracts (i.e. summaries) of publications; the abstract may be in the language of the original or be translated into some other language. Some bibliographies include abstracts, others do not. A bibliography is, strictly speaking, a list of books, but its scope is usually extended to include periodical articles and other publications in addition to books. In fact, many annual bibliographies as well as indexing and abstracting journals concentrate on periodical literature in particular. This chapter looks at the various services provided, making comparisons where possible, examines computerized online services and discusses other ways of keeping up to date.

MUSEUM STUDIES BIBLIOGRAPHIES AND ABSTRACTS

The most extensive coverage worldwide is given by the *International Museological Bibliography* [38], published by the UNESCO–ICOM Museum Information Centre in Paris until 1988 and now available on CD-ROM. The listing is not exhaustive; volumes 1–14 included bibliographical references from other

museum documentation centres as well as the UNESCO–ICOM Centre, but later volumes listed only documents received by the Centre.

There are often substantial delays between the appearance of a publication and its listing in an indexing or abstracting service such as those discussed above. Such a delay does not apply in the case of *Museum Abstracts* [39], published monthly by the Scottish Museums Council and based on material (mainly British and North American) arriving at the Council's Information Centre.

An extensive listing of primarily English-language publications can be found in the bibliographies produced periodically by the Department of Museum Studies of the University of Leicester, the most recent (1991) being *Museum studies bibliography* [40]. A listing of Czech and Slovak museological literature is given in *Bibliografie Muzeologické Literatury* [37]. A more specialized listing covering the behavioural, educational and communication aspects of museum and exhibition planning is provided by the International Laboratory for Visitor Studies' *Visitor Studies Bibliography and Abstracts* [42].

OTHER BIBLIOGRAPHIES, INDEXES AND ABSTRACTS

There are various other services not primarily concerned with museum studies but containing important references on some aspect(s) of museums. The technical and conservation side of the literature is well covered, worldwide, by *Art and Archaeology Technical Abstracts* [33]. This is an excellent source for references on such topics as lighting, climate control, storage, packaging and handling, health hazards, pest control and fumigation. Its annotated bibliographies on specific topics, published as supplements, are a particular feature.

Several services cover the art and architecture aspects of museums and art galleries. *Art Index* [34] lists periodical literature worldwide with minimum delay, although only about 200 periodicals are indexed. Wider coverage for the twentieth century, including exhibition catalogues, is given by *ARTbibliographies Modern* [35]. There is also *BHA: Bibliography of the History of Art* [36], which covers European art from late antiquity to the present, and American art from the European discoveries to the present, and includes separate sections on museums and museology, private collections, and exhibitions. For references on all aspects of the architecture, design and planning of museum buildings, *Architectural Periodicals Index* [32] appears with minimum delay.

UNESCO publications on museum studies are conveniently brought together in the comprehensive *UNESCO List of Documents and Publications* [41], a complete listing of everything published by UNESCO.

Important publications may well be found in several major indexing and abstracting services that include only a small number of references to museums: *Bibliography and Index of Geology* (Alexandria (Virginia): American Geological Institute, 1969–. Monthly); *Biological Abstracts* (Philadelphia (Pennsylvania): BioSciences Information Service, 1926–. Twice a month); *Chemical Abstracts*

(Columbus (Ohio): Chemical Abstracts Service, 1907–. Weekly); *Historical Abstracts (A: Modern history abstracts, 1450–1914; B: Twentieth-century abstracts, 1914–present)* (Santa Barbara (California): ABC-Clio, 1955–. Quarterly). There are also the two archaeological sections of *Bulletin Signalétique – 525: Préhistoire et Protohistoire* (1970–. Quarterly) and *526: Art et Archéologie* (1970–. Quarterly) – both published by the Centre National de la Recherche Scientifique in Paris.

Many of these services are available online (see below).

ONLINE SERVICES

Many indexing and abstracting services are now produced by computer, and the databases for these are being made available so that literature searches can be done using a computer terminal for online access. These developments began in the fields of science and medicine and have extended to other subject areas, and it is now possible to perform online searches on various aspects of museum studies.

Databases of literature on conservation are available through the Conservation Information Network, developed by the Getty Conservation Institute and the Department of Communications, Canada in collaboration with several institutions which have significant information holdings in the field of conservation. The Network consists of several databases and an electronic mail system. The bibliographic database BCIN was created from the merged holdings of major institutions such as the Canadian Conservation Institute [500], the Conservation Analytical Laboratory of the Smithsonian Institution [544], the Getty Conservation Institute, the International Centre for the Study of the Preservation and the Restoration of Cultural Property [487], and the International Council on Monuments and Sites [488]. Various publications are produced from this database, including *Art and Archaeology Technical Abstracts* [33]. More information about the Network can be obtained from Conservation Information Network, Canadian Heritage Information Network, 365 Laurier Avenue West, Ottawa, Ontario K1A 0C8, Canada.

The art and architecture aspects of museum studies are well covered by the online versions of some of the indexing and abstracting publications discussed earlier: ARCHITECTURE DATABASE [32], ART LITERATURE INTER-NATIONAL [36] and ARTBIBLIOGRAPHIES MODERN [35]. Literature on the education functions of museums can be traced through ERIC (available through DIALOG, 1966–. Updated monthly), the database of educational materials collected by the Educational Resources Information Center of the US Department of Education.

The major indexing and abstracting services mentioned earlier that include only a small number of references to museums are all available online. The corresponding online databases are: GEOREF (1785–. Updated monthly), the database of the American Geological Institute, which covers geology and

geophysics worldwide; BIOSIS PREVIEWS (1969–. Updated twice a month), which covers the biological and biomedical sciences worldwide; CA SEARCH (1967–. Updated every two weeks), produced by Chemical Abstracts Service; HISTORICAL ABSTRACTS (1973–. Updated six times a year). All these are available through DIALOG. The two archaeological sections of *Bulletin Signalétique* are products from the database FRANCIS, searchable online through QUESTEL/TELESYSTEMES.

Because these online files are regularly updated at very frequent intervals, they naturally give more up-to-date information than corresponding printed versions. A list of 250 principal English-language online bibliographic databases in all subjects (about 10 per cent of what was available at the time) can be found in J. L. Hall's *Online bibliographic databases: a directory and sourcebook* (4th ed. London: Aslib, 1986). It is possible for many major libraries, especially academic ones, to perform online searches. This is a complex and rapidly changing field and expert advice from a librarian or information officer is usually necessary.

The databases discussed above are all publicly available. Some, however, are not so easily accessible – for example, the ICOMMOS database shared by the UNESCO–ICOM Museum Information Centre [447] and the ICOMOS Documentation Centre [488], and the database at ICCROM [487]. In cases such as these, a direct approach to the organization concerned is necessary.

CITATION INDEXES AND *CURRENT CONTENTS*

Citation indexes are a rather different kind of indexing service. They work on the principle that, if there is one reference known to be relevant for the search in hand, it can be looked up and the citation index volume will list details of other publications citing it. These in turn can be looked up in the source index volume, leading to more references. Publications on a specific topic can be traced through the permuterm subject index volume. There are three major citation indexes: *Arts and Humanities Citation Index* (Philadelphia (Pennsylvania): Institute for Scientific Information, 1976–. Three times a year. Available online as ARTS & HUMANITIES SEARCH); *Social Sciences Citation Index* (Philadelphia (Pennsylvania): Institute for Scientific Information, 1966–. Three times a year. Available online as SOCIAL SCISEARCH); and *Science Citation Index* (Philadelphia (Pennsylvania): Institute for Scientific Information, 1961–. Every two months. Available online as SCISEARCH). All these publications are available online through DIALOG. They include very few museological periodicals in their coverage, but researchers may well find them useful because of the scattering of articles of relevance to museum studies throughout periodicals of all kinds.

Similar considerations apply to the *Current Contents* series of publications (Philadelphia (Pennsylvania): Institute for Scientific Information, 1961–. Weekly. Available online through DIALOG as CURRENT CONTENTS

SEARCH) which reproduce the contents pages of particular periodicals. This series is currently published in seven sections; the sections of most relevance to museum studies are *Arts and Humanities*; *Social and Behavioral Sciences*; and *Physical, Chemical and Earth Sciences*.

BIBLIOGRAPHIES WITHIN JOURNALS

From time to time, bibliographies relating to museum studies are published in museum studies periodicals. Examples are those on architecture (Glaeser, 1972), and exhibitions and information centres (Screven, 1986). Such bibliographies were at one time a regular feature in *ICOM News* [69] but have now been discontinued.

BOOK REVIEWS AND BOOKS RECEIVED

Book reviews are an important feature of major museological journals. Of particular note are those in *Museum Management and Curatorship* [92] ('Publications digest'), *Museums Journal* [99], *Museum News* [95], *Muse* [82] and *Studies in Conservation* [122]. Briefer reviews appear in *ICOM News* [69] ('Publications'). Many newsletters carry book reviews (e.g. *Biology Curators' Group Newsletter* [52]) or lists of recent publications (e.g. *Social History Curators Group News* [119]). There is often a delay between the publication of a book and its review.

Some publications are listed in the *Museums Journal* [99]. Recent acquisitions to the ICCROM [487] library are listed (with abstracts) in *ICCROM Newsletter* [72].

Another source for reviews of some museum studies books is the *Times Literary Supplement* (London: Times, 1902–. Weekly), which carries book reviews on all subjects; reviews of individual books are traceable through the *Times Index* (Reading: Research Publications Limited, 1790–. Monthly), which covers the *TLS* and other *Times* supplements as well as *The Times*. Like other 'quality' newspapers, *The Times* is itself a useful way of tracing museological news of general interest.

FORTHCOMING BOOKS

For books about to be published, some journals carry publishers' advertisements and announcements. Publishers' catalogues and leaflets are also important sources. For British books recently published, the *Bookseller* (London: Whitaker, 1858–. Weekly) contains a full list of British books as they are published in a classified arrangement. The Spring and Autumn Books numbers of the *Bookseller* are devoted to new books scheduled to appear over the next few months. All

titles in print subsequently appear in *Whitaker's Books in Print* (London: Whitaker, 1965–. Monthly (microfiche); annual (hard copy)), which includes books scheduled to appear during the following months. From 1988 Whitaker has offered a BOOKBANK CD-ROM Service which includes all British books in print, forthcoming titles and provisional titles.

For the USA, *Forthcoming books* (New York: Bowker, 1966–. Every two months) includes titles announced for publication over the next few months. Details of similar works for other parts of the world can be found in Sheehy [2].

NOTES AND NEWS, CONFERENCES, EXHIBITIONS, ETC.

Current information on matters such as forthcoming meetings and conferences, exhibitions and professional appointments can be found in the periodicals and newsletters of the various museum organizations. Examples are *ICOM News* [69] (on a worldwide scale), *Museums Journal* [99], *Museum News* [95], *Aviso* [50] and *Museogramme* [87].

For published conference proceedings, the most helpful source in terms of coverage and ease of use is the British Library Document Supply Centre's *Index of conference proceedings received* [359]. The 1964–88 microfiche cumulation included about 130 entries under 'museum' and related headings.

Announcements about current and forthcoming exhibitions can also be found in tourist literature and 'quality' newspapers, the latter sometimes including reviews of exhibitions. There is an international network for information on available museum travelling exhibitions in the arts, humanities and sciences – The Humanities Exchange (P.O. Box 1608, Largo, Florida 34649, USA; tel: 813-581-7328; fax: 813-585-6398. European address: Postfach 603, CH-4010 Basel, Switzerland) – which acts as a clearing house for information. It publishes a bi-monthly newsletter on available exhibitions, an annual *Guide to organizers of traveling exhibitions*, and a newsletter, *Artworld Europe*, that features information on museums and art exhibitions in Europe.

REFERENCES

Glaeser, L. 1972. Museum architecture: publish or perish. *Museum News* [95], 51: 3, 39–42.

Screven, C.G. 1986. Exhibitions and information centers: some principles and approaches. *Curator* [58], 29: 2, 109–37.

5 Retrospective Bibliographies

Many of the annual bibliographies and indexing and abstracting publications discussed in Chapter 4 will help with retrospective as well as current searching. Most, however, are of relatively recent origin and put the emphasis on periodical publications. To obtain a more complete picture of museum studies literature, other types of bibliography and bibliographical guide are needed in addition. This chapter discusses the various forms of retrospective bibliography that exist to help the researcher who wants to trace older literature.

Good bibliographies can, of course, be found at the end of significant periodical articles and books (for example, there are about 300 references in Roberts's *Planning the documentation of museum collections* [264], and forty-four references in the article 'Exhibitions and information centers: some principles and approaches' (Screven, 1986)). Other bibliographies have been published in book form. Their coverage is obviously restricted to works published before a certain date, and they must therefore be updated by reference to the types of work discussed in Chapter 4.

LIBRARY CATALOGUES AND NATIONAL BIBLIOGRAPHIES

The most comprehensive retrospective bibliographies covering all subjects, including museum studies, are the catalogues of the world's larger libraries, several of which have been published in book form. Examples are (for Britain) the *General catalogue of printed books* of the British Library (formerly the British Museum Library) and (for the USA) the *National union catalog* (formerly the *Library*

of Congress catalog). Details of such catalogues, and also of national bibliographies such as the *British national bibliography* and the *Australian national bibliography*, can be found in Beaudiquez's *Bibliographical services throughout the world* [1]. Comprehensive works such as these are invaluable for tracing older monograph publications by author or subject or (frequently) by title as well.

BIBLIOGRAPHIES OF MUSEUM STUDIES LITERATURE

There have been few attempts at worldwide bibliographies. Some bibliographies relate to the museological literature of specific countries and others are restricted to the literature in specific subject areas. Some areas of museum work such as the documentation of museum collections are changing so quickly that bibliographies produced only a few years ago are already of limited use. Other areas, such as the history and philosophy of museums, are not subject to the same changes.

One of the earliest attempts at a major museum studies bibliography was *Bibliography of museums and museology* produced by Clifford in 1923 [8], an unannotated listing of some 1,500 publications of all kinds, worldwide. On a larger scale is Smith's *A bibliography of museums and museum work* published in 1928 [23], which again is worldwide in coverage, but with emphasis on the USA. More recent is *A bibliography of museums and museum work 1900–1960* by Borhegyi and Dodson [5], continued by *Bibliography of museums and museum work 1900–1961: supplementary volume* [5], which together list some 2,200 publications worldwide, with a bias towards the USA. The Canadian Museums Association's *Bibliography* [7] listed major source materials, with emphasis on North America, over a ten-year period ending in 1985.

An extensive listing, the *Selected Bibliography of Museological Literature* [20], was published annually until 1990 by the Central Administration of Museums and Art Galleries in Bratislava, Czechoslovakia. It was particularly strong on Eastern European publications. It overlapped to some extent with the *International Museological Bibliography* [38]. Its abstracts in English were valuable for English-speaking researchers wishing to locate literature published in Eastern European languages.

A most valuable general museological bibliography is the UNESCO *Basic museum bibliography* [25], the most recent edition of which was published in 1986. It lists essential literature of all kinds, with excellent worldwide coverage. Its 'General resources' section usefully covers bibliographies, directories, manuals and periodicals. Another work of about the same size but limited to basic books on the history, philosophy and function of museums published between 1918 and 1985 is the *Museum studies library shelf list* [14], based on a list originally published in the *Museum Studies Journal*.

Museum Abstracts International [13], the international equivalent of *Museum Abstracts* [39], began publication in 1990 but unfortunately ceased in 1993.

For publications on historical organization practices, an extensive listing is given in Rath and O'Connell's six-volume work *A bibliography on historical organization practices* [17], published over the period 1975–84. There are individual volumes on *Historic preservation*; *Care and conservation of collections*; *Interpretation*; *Documentation of collections*; *Administration*; and *Research*. The bibliography is restricted to English-language publications and is heavily weighted towards North America. Although it is limited to references relating mainly to historical museums and historical societies, it should be noted that the practice in one type of museum may be similar to the practice in others. A particular feature of each volume is the 'Basic reference shelf' section – a list of essential publications in the field.

Other bibliographies covering particular parts of the world or specific areas of museum work can be traced (until 1985) through the subject index (under 'Bibliographies') of the *International Museological Bibliography* [38] or (until 1990) in the 'Museological literature and bibliography' section of *Selected bibliography of museological literature* [20]. Examples are: 'Bibliografiya po muzeyevedeniv 1945–1977 gg.' [11] (a bibliography on museum practice in the Soviet Union); 'Bibliografia muzealnictwa polskiego za lata 1972–1982' [16] (a bibliography of Polish museology); and *Bibliografia museològico–museogràfica a Barcelona* [18] (a limited bibliography mainly of monographs, with worldwide coverage but an emphasis on literature in Spanish).

Covering education in museums is the *GEM museum education bibliography 1978–1988* [6], an unannotated list of museum education publications produced over a ten-year period, continued by Supplements in the *Journal of Education in Museums* [76], and *Bibliographie – Report 1987 zu den Gebieten Museologie, Museumspädagogik und Museumsdidaktik* [15], an unannotated list of national and international publications in museology, museum education and didactics in museums (with an English summary). For geology in museums there is *Geology in museums: a bibliography and index* [22], and for visitor studies there is *Studies of visitor behavior in museums and exhibitions: an annotated bibliography of sources primarily in the English language* [10] (largely superseded, however, by the International Laboratory for Visitor Studies' *Visitor Studies Bibliography and Abstracts* [42]). For natural history museums, Stansfield's article in *Curator* [24] discusses relevant literature.

The UNESCO–ICOM Museum Information Centre [447] has published a series of bibliographies on certain topics, for example 'History of museums', 'Museums in the Third World' and 'Museums and research', listed in *ICOM News* [69] vol. 36 (2/3) (1983, p. 9), and is able to supply bibliographies on request.

BIBLIOGRAPHIES OF PUBLICATIONS BY MUSEUMS

An early attempt to produce a substantial bibliography of publications by museums was the two-volume work by Clapp [27], a classified listing of

the publications available from some 276 museums in the United States and Canada.

As indicated earlier, the extent and range of publications by museums have greatly increased in recent years. Bassett [26] provides an extensive survey of the different types of publication produced by museums and examines particular forms of publication, with detailed examples.

Worldwide in scope is *World museum publications 1982* [31], which lists the permanent collections of over 10,000 art museums and major art galleries and the publications and audio-visual material available from them. Roulstone [30] provides a similar source of reference for publications and audio-visual aids produced by 955 British museums and art galleries.

Examples of such bibliographies for particular countries are *Bibliografia zawartości wydawnictw muzeów w Polsce za lata 1945–1972: druki zwarte i ciągłe* (Bibliography of the contents of museum publications in Poland for the years 1945–1972: monographs and series) [28]; and the four-volume *A magyar múzeumok kiadványainak bibliográfiája* (Bibliography of Hungarian museums' publications) [29].

OTHER BIBLIOGRAPHICAL GUIDES

The standard guides to reference material in all subjects including museum studies are those two major works already mentioned: Sheehy [2] and Walford [3]. Museological material is scattered throughout both works and is best traced through the indexes, which are valuable starting points also for subjects related to museum studies.

Beaudiquez's survey *Bibliographical services throughout the world* [1] is an invaluable guide to bibliographical services such as national bibliographies, specialized bibliographies and interlibrary co-operation in 121 countries worldwide.

REFERENCE

Screven, C. G. 1986. Exhibitions and information centers: some principles and approaches. *Curator* [58], 29: 2, 109–37.

6 The Literature of Museum Studies

This chapter provides an overview of the literature relating to museum studies –
first by form of publication and then by subject.

The growth of the literature of museum studies reflects the growth in the
number of museums as described in Chapter 1 and the growth in the number
of museum organizations, many of which have come into existence only in the
past twenty years. This is well illustrated by an analysis of the more than eighty
periodicals listed in Part II, only seven of which were in existence in 1940, twenty-
two in 1960 and sixty-one in 1980.

The literature of museum studies appears in many languages. The absence of
comprehensive bibliographies makes an accurate analysis impossible, but it is
clear that most of the literature is in English, originating in Britain and North
America, followed by literature in other European languages where the museum
tradition is strongest, for example Eastern Europe and Scandinavia.

PERIODICALS

As indicated in Chapter 2, a large part of museological literature is in the form
of articles in periodicals. The more significant titles are listed in Part II of this
Keyguide. No comprehensive list of museum studies periodicals is available but,
taking into account the many regional organizations and the publications of
individual museums, the total number is certainly many hundreds (the
UNESCO/ICOM Museum Information Centre [447] listing of periodicals
received in 1981 numbers in excess of 1,000). It is important to emphasize,

however, that many articles relating to museum studies can be found in non-museum periodicals. Articles about new museum buildings, for example, often appear in architectural journals (e.g. *Architectural Review*, *Architects' Journal*); articles about exhibitions appear in design journals (e.g. *Design*); and articles about collections in art journals (e.g. *Town and Country*).

Lists of museum and museum studies periodicals can be found in most of the indexing and abstracting publications and annual bibliographies listed in Part II of this *Keyguide*. The *Serials directory* [44] and *Ulrich's international periodicals directory* [45] include full, but by no means comprehensive, listings. A brief listing of thirty-two 'core' titles is given in UNESCO–ICOM's *Basic museum bibliography* [25]. A special issue of *Museum* [90] vol. 168 (4) in 1990, 'Spreading the word: national museum periodicals at work', lists and describes national museum periodicals from thirty countries. A number of periodicals appear in microform as well as hard copy; these can be traced in *Serials and newspapers in microform* (Michigan: University Microfilms International), the 1992/93 edition of which had thirty-three entries under 'Museums and Art Galleries'.

Museum studies journals fall into three main categories which are not, however, well defined. There are journals aimed at an international readership; those directed mainly at a national readership; and those devoted to a specialized area of museum work and which may be international or national.

Museum International [90], published by UNESCO, is a truly international journal, the organ of an international organization (UNESCO) and published in English, French, Spanish, Russian and Arabic. One of the most useful features of this journal is the individual issues devoted to particular topics. Comprehensive cumulative indexes for volumes 1–25 (1948–73) and for volumes 26–35 (1974–83) are invaluable searching aids. Unfortunately, there are no annual indexes, and articles since 1983 can be located only after a laborious search.

Museum Management and Curatorship (formerly *International Journal of Museum Management and Curatorship*) [92], a commercial journal of recent origin, is also international, although it is only published in an English-language edition. It fills a useful role in that it is the only journal which accepts articles of a size that allows an in-depth treatment of a subject. It is wide-ranging in subject content but is slanted towards the art gallery.

Curator [58] is a journal of a different character. It has been published by the American Museum of Natural History since 1958, and early issues were very much concerned with natural history and anthropological museum policy and practice in North America. Recently, however, it has become wider in scope both in subject matter and in geographical coverage. It is a particularly good source for articles on the description of new techniques for the treatment and conservation of biological and geological collections and also on the evaluation of exhibitions and educational programmes, and it may, by virtue of its wide readership, be considered an international journal. Its value is very much enhanced by the publication of frequent indexes, the most recent covering volumes 1–30

(1958–87), with author, title and a seventy-five-category subject index (which does not, however, meet all needs).

There are many journals which are national in character and mainly concerned with museum practice in the country of origin, although they may include material of interest elsewhere. An example is *Museums Journal* [99], published by the British Museums Association. Articles tend to be fairly short (about 2,000–4,000 words) and are mainly descriptive or concerned with matters of current concern. Of a similar nature are the following examples: *Museum News* [95] (United States); *Muse* [82] (Canada); *Museum National* [93] (Australia); *Journal of Indian Museums* [77]; *SAMAB* [116] (Southern Africa); and *Musées et Collections Publiques de France* [83]. With a few exceptions, the usefulness of these national journals is limited by their lack of cumulative indexes; this applies particularly to long-running journals such as *Museums Journal* [99]. In Britain, the United States and Canada, there are regional museum journals (e.g. *Museum Quarterly* [96]), some of which compare favourably with national journals.

Another important type is the special subject journal, devoted to a particular kind of museum or museum collection (e.g. *Geological Curator* [61]); to techniques (e.g. *Studies in Conservation* [122]); to services (e.g. *Journal of Education in Museums* [76]); and to museums characterized by the type of administration (e.g. *AIM* [46]).

Since the first edition of this *Keyguide* a number of new journals have been published, for example *Journal of the History of Collections* [79], *Journal of Biological Curation* [75], *International Journal of Cultural Property* [73] and *Museum Development* [89].

Periodical title abbreviations

A frequent difficulty with periodicals is abbreviation of titles. Museum workers often need to know how to abbreviate a particular title when preparing a manuscript for publication. Advice on this can be found in the *List of serial title word abbreviations (in accordance with ISO 4–1984)* (Paris: International Serials Data System International Centre, 1985). This lists words and their abbreviated forms used for the establishment of abbreviated periodical titles.

Deciphering periodical title abbreviations can be a problem. Some publications adopt their own system of periodical abbreviations, often explained in the publications themselves. General works such as *Acronyms, initialisms and abbreviations dictionary* (Detroit (Michigan): Gale. 3 vols.) include some museological titles.

THESES

As indicated earlier in Chapter 2, theses on museological topics are relatively few in number.

British theses can be traced through the *Index to theses with abstracts accepted for higher degrees by the universities of Great Britain and Ireland and the Council for National Academic Awards* [132], the standard work covering all subjects. As mentioned in Chapter 2, theses produced by Museums Association Diploma students during the period 1932–73 are housed in the University of Leicester Library, which also has theses submitted by the students in the Department of Museum Studies for (or as part of) their higher degrees. Regulations for higher degrees in museum studies were introduced by the University of Leicester in 1975, and to date several hundred MA/MSc theses and a small number of PhD and MPhil theses have been submitted.

For North America, a definitive listing of almost every doctoral dissertation on all subjects including museum studies and related fields accepted in North American universities since 1861 can be found in *Comprehensive dissertation index* [129]. Concise summaries of these dissertations can be found in *Dissertation abstracts international* [130], which includes theses from selected European universities. The theses listed are available in hardback, paperback or microform from the publisher, University Microfilms, which also produces free subject catalogues of doctoral dissertations on selected topics (e.g. Fine arts, Archaeology).

Useful lists of United States theses relating to museum studies have been published in two journals [131], [133].

A number of university departments of museum studies, including those of the University of Leicester and the University of Toronto, provide handlists of museological theses accepted by their respective institutions.

Guides to theses for other parts of the world can be traced in Sheehy [2] and Walford [3].

MONOGRAPHS

Monographs on museological topics are mostly of recent origin, notable exceptions being Neickel (1727), Greenwood [161] and Murray [185]. As noted in Chapter 2, reports published by museum committees and other bodies constitute a sizeable proportion of the literature. Another very well-represented type of monograph is the manual or handbook: a few comprehensive ones (Lewis [135], *Museumshåndboka* [136], United States Department of the Interior National Park Service [138]) and many more specialized ones (e.g. Bostick [209], Burke and Adeloye [211], Chenhall [216], Rixon [262]). Thompson [137] is a standard work of reference, a comprehensive text designed for museum professionals involved in the diversity of activities which characterize museums in the 1990s. There are historical surveys (e.g. Alexander [142], Hudson [168], Wittlin [203]); textbooks (e.g. Burcaw [152], Thomson [275]); treatises (e.g. Malaro [238], Organ [253]); and conference publications, in particular those of ICOM (International Council of Museums [170]–[175]). A detailed and critical examination of the literature on museums (with emphasis on the USA) is given in Shapiro [21].

Many of these monographs form individual volumes in series. The longest running is UNESCO's Museums and Monuments series (e.g. Stolow [270], Sykes [274]), concerned with the protection and preservation of monuments and works of art. UNESCO also publishes: Protection of the Cultural Heritage: Technical Handbooks for Museums and Monuments (e.g. Bostick [209], Johnson and Horgan [232]), a series giving practical and technical guidance on the conservation and restoration of cultural property, aimed particularly at those museums and monuments services whose resources are limited and which must find solutions to their conservation problems more suited to the means available; Studies and Documents on Cultural Policies, which shows how cultural policies are planned and implemented in various individual member states of UNESCO; Protection of the Cultural Heritage: Research Papers, which explores in some depth the value and significance of various aspects of the cultural heritage; and Studies and Documents on the Cultural Heritage. There is also Butterworths' Series in Conservation and Museology (e.g. Stolow [269], Thomson [275]); The Heritage. Care – Preservation – Management series published by Routledge (e.g. Boylan [151], Ambrose and Runyard [283]); and the American Association for State and Local History's Management Series (e.g. Phelan [192], Adams [306]).

DICTIONARIES AND ENCYCLOPAEDIAS

Useful summaries and overviews of museums may be obtained from encyclopaedias (notably the article in *The New Encyclopaedia Britannica* (Lewis [179]). *Dictionarium museologicum* [446] provides a vocabulary in twenty languages of the major technical terms used in museum studies.

SUBJECT FIELDS

The following section gives an overview of the literature in the main subject areas. It is arranged first by the format used for monographs in Part II (described in 'Arrangement of the subject field' in Chapter 1), and secondly by type of museum (history, science, etc.).

The museum context: a world view

Philosophical and historical context

There are a number of monographs devoted to the closely related subjects of the philosophical and historical context of museums. The standard works are the two volumes by Wittlin [202], [203], which adopt a sociological approach. The first volume covers the period up to the outbreak of the Second World War and the second is an extended and enlarged version which also covers the period 1945–70.

A more recent work which gives a good general overview is Alexander [142]. Bazin [149] is concerned particularly with the development of the art museum; and Hudson [168] is concerned with the social history of museums. The history of museums has been very much influenced by individual museum directors, and Alexander [141] examines the impact of twelve prominent museum 'masters'. Hudson [166] looks at museums which have had a wide international impact. There are many histories of individual museums (see University of Leicester, Department of Museum Studies' *Museum studies bibliography* [40]).

Contemporary context

The contemporary context of museums is the subject of a wide forum of professional and public debate, with numerous periodical articles. It is the subject of two monographs by Hudson [165], [168]. Monographs concerned with contemporary issues include a survey commissioned by the African American Museums Association [193], Boylan [151], Karp and Lavine [329], Karp, Kreamer and Lavine [328], van Zoest [197], Vergo [198] and Weil [199] and [200]. The contemporary context is a recurring theme in the reports of the triennial conferences of the International Council of Museums [170]–[175]. Specific aspects are addressed by Hewison (1987) and Lumley [181] (United Kingdom), and by the American Association of Museums [146].

Clientele context

The clientele context of museums is also a subject of growing interest as museums seek to show that they are performing an important service in society and as they rely more and more on income generated from admission fees. Most of the literature reports visitor studies for individual museums and there is little concerned with visiting museums in general. Exceptions are Bourdieu, Darbel and Schnapper, first published in French in 1969 and which has now been translated into English [150], Falk and Dierking [317] and Merriman [183]. Australia Council for the Arts (1991) looks at visitors to art galleries in Australia. Dixon, Courtney and Bailey [156] look at museum visiting in the context of visits to other cultural facilities in Canada. Examples of studies of visitors to individual museums include Abbey and Cameron [139], Harvey (1987), Prince and Higgins (1992) and Mann (1986). Chadwick [314] looks at museum visitors from the viewpoint of the role of the museum and art gallery in community education, and several publications consider the ways in which museums respond to the needs of the disabled or disadvantaged (e.g. Fondation de France [318], Groff and Gardner [321], Kenney [332], Majewski (1987), Snider (1977) (United States), Attenborough (1985) and *After Attenborough* (1988) (United Kingdom)).

Organizational and legal context

There are very few monographs dealing with the organizational and legal context of museums in general, but there are some concerned with specific geographical areas or subject areas. Phelan [192] looks at the legal context of museums in the

United States; and a number of monographs consider the particular legal problems arising from the acquisition and transfer of cultural property, including Malaro [238], who examines legal problems affecting the management of collections, mainly in the USA. International and national laws governing the protection and movement of cultural property are addressed by Burnham [213], O'Keefe and Prott [252], and UNESCO [259]. Williams [279] provides valuable discussion on the issues and principles involved. Ethical aspects are covered by Greenfield [227] and Messenger [241]. There are many articles in the periodical literature dealing with specific countries and specific cases, particularly in the journal *Museum International* [90], which in 1979 devoted a special issue to the subject of return and restitution of cultural property. The American Law Institute and the American Bar Association hold annual seminars on 'legal problems of museum administration', the proceedings of which are published. In Canada, since 1989 there has been an annual Legal Affairs Symposium on the lines of the ALI–ABA in the United States (Legal Affairs Symposium. Ottawa: Canadian Museum of Civilization and Canadian Museums Association in co-operation with the Canadian Bar Association).

Professional context

The professional context of museums is discussed in the various manuals (e.g. Thompson [137]), and in articles in periodical literature, particularly the journals of the professional associations. The nature of the museums profession is a subject for continuing debate (e.g. Kavanagh [177]; van Mensch [196]). Many professional associations have produced codes of ethics and codes of practice (e.g. American Association of Museums (1991)). The training of museum personnel has been the subject of reports by government bodies (e.g. Museums and Galleries Commission (1987)) and by the professional associations. The International Council of Museums International Committee for the Training of Personnel [473] publishes reports of meetings in its periodical *It*.

Collection management

The management of collections is well covered in the literature. Recent concern has focused on standards of collection management (e.g. National Audit Office [246]) and on the cost of managing collections (e.g. Lord, Lord and Nicks [237]). A monograph on the legal aspects (Malaro [238]) has already been referred to. Caring for and documenting collections is becoming increasingly complex. The work of the registrar is described in Case [215]. The documentation of collections is well covered by Dudley, Wilkinson and others [221], and Roberts [264] and Orna and Pettitt [255] provide practical introductions to collection documentation. Roberts [264] and Light, Roberts and Stewart [236] provide introductions to documentation systems with an overview and case studies of practices in different museums and different countries. Sarasan and Neuner [266] look at the use of computers in museum cataloguing. Williams [278] provides a general

guide to the use of computers in museums, and Chenhall and Vance [217] look at recent advances in computer documentation. As far as computer documentation is concerned, it should be pointed out that this is a rapidly developing field, and monographs describing computer software and hardware quickly become out of date. The annual conferences of the Museum Documentation Association focus on different aspects of collection documentation and usually lead to conference reports (e.g. Roberts [263] (1987 conference); Roberts [265] (1988 conference); and separate papers from 1989 conference). A great deal of attention is being devoted to standards (e.g. Museum Documentation Association (1991)). Blackaby and Greeno [208] (a revised and expanded edition of Chenhall's *Nomenclature for museum cataloging*) presents a system for the nomenclature of objects in museum cataloguing. There is one specialized periodical concerned with collection documentation (*Spectra* [121]). A useful periodical concerned with international aspects of documentation is the CIDOC *Newsletter* [456].

On the security of collections, there are monographs by Tillotson [276], Bostick [209] and Burke and Adeloye [211]; on disaster planning and the production of disaster plans, Solley, Williams and Baden [268], Upton and Pearson [277] and Nelson (1991); on the insurance of collections, the Museums Association [245], Nauert and Black [248] and Mitchell [242]; on the storage of collections, Johnson and Horgan [232] and Alsford and Alsford [204]; and for research into collections, Neustupný [249] and ICOM [231].

As has been stated earlier, the conservation of collections is a field of study in its own right. There is a wealth of literature on the subject including a number of general monographs (e.g. Appelbaum [205], Bachmann [207], Kühn (1986) and Plenderleith and Werner [257]); some concerned with the management of conservation (e.g. Keene [233]) and many specialized monographs (e.g. those in the Butterworths' Series in Conservation and Museology) including the museum environment (Thomson [275]); and some on the conservation of particular kinds of object (e.g. Waterer (1973) on leather, Landi [235] on textiles, Howie [229] on geological material, Newton and Davison [250] on glass). Pest control is the subject of a report by the Association of Systematics Collections (Zycherman and Schrock [280]) and a guide by Pinniger [256]. The handling and transportation of collections is the subject of monographs by Stolow [270], [271], Mecklenburg [240], Richard, Mecklenburg and Merrill [261] and Shelley [267]. There are also many specialist organizations which generate their own literature, including the international journal *Studies in Conservation* [122], the Preprints of the triennial meetings of the ICOM International Committee for Conservation [454], *ICCROM Newsletter* [487], the British journal *Conservator* [57], the *Journal of the American Institute for Conservation*, and many others.

Museum management

The management of museums is also an area of growing importance. The subject is covered in part by the various general manuals such as Thompson [137], and

by more specialized monographs (e.g. Ambrose [282], Ambrose and Runyard [283]). It should be remembered, however, that the management of museums has much in common with the management of other institutions and the general literature on management will often be applicable. Some areas such as the design of museum buildings and museum architecture are well covered, with a number of monographs addressing general aspects (Coleman (1950), Bell [286]), new museum building (Brawne [287], Montaner and Oliveras (case studies) [300], Stephens [303], Montaner [299], Lord and Lord [297], and special types of museum buildings – science museums (Anderson and Alexander (1991)) and buildings for the arts (Brown, Fleissig and Morrish (1991)). There are periodical articles in the museum journals and in the large number of journals which are concerned with the many aspects of building design and construction. There are some special issues of such journals (e.g. *Architectural Review*).

The literature on the management of staff is less extensive. In addition to the general manuals referred to above, there is Miller [298], which looks at personnel policies for museums in the USA, Hoachlander [293] (role and functions of the museum registrar), the Canadian Museums Association's *A guide to museum positions . . .* [288], ICOM's *Training of museum personnel* [295], and Teather (1978), which is an analysis of museum jobs and museum studies curricula in Canada. The Office of Arts and Libraries (Great Britain) [319] and Mattingly [335] discuss the role of volunteers in museums, and Ullberg and Ullberg [305] the role and function of trustees. The American Association of Museums issues an extensive list of publications dealing with trustees and governing boards, and with fund-raising, etc. in the American context. Matters of public accountability (for Great Britain) are addressed by the Audit Commission [285] and by the National Audit Office [246]. Basic information about running a new museum is given in Ambrose [282], Paine [301], Greene [292] and (in more detail) George and Sherrell-Leo [290]. Problems of safety in museums and galleries are considered in Howie [294].

Museum services

The services which museums provide for the public include both exhibitions and educational services. There are a number of monographs on the design of exhibits. General monographs concerned with museum exhibition include Brawne [313], Belcher [308], Hall [322] and Velarde [356]. Miles [336] provides a more theoretical approach based mainly on experience at the British Museum (Natural History) (now the Natural History Museum), and the Royal Ontario Museum [346] presents the findings of an extensive literature search on all aspects of communication through exhibits. The use of interactive exhibits is described by Bearman [307], Hoffos [324] and Pring [258]. Bertram [310] addresses the problems of design in small and medium-sized museums, and Witteborg [357] the design of temporary exhibitions. Turner [354] looks at the design of showcases; Rouard-Snowman [345] looks at museum graphics; Kebabian and

Padgett [331] give advice on the production of museum publications; Kentley and Negus [333] deal with the preparation of texts in exhibitions; and Serrell [349] covers the design and production of labels. There is one periodical concerned with museum design (*Museum Design* [88]).

The evaluation of exhibits and educational programmes is another rapidly growing field. Shettel [350] presents the findings of a study to develop research strategies for evaluating the effectiveness of exhibits, Screven [348] describes experimental studies using electronic devices to measure visitor reaction to exhibits, and Loomis [180] and Korn and Sowd (1990) concentrate more on visitor surveys than exhibit evaluation. Miles [336] also includes useful chapters on aspects of exhibition evaluation. A number of studies have been published by the Association of Science–Technology Centers [484], reported in the periodicals *ILVS Review* [70] and *Visitor Behavior* [126], and discussed at the annual conferences of the Visitor Studies Association [491].

Monographs on educational services include Collins [315] (museums as part of education), Nichols [339] (informal education in museums), Newsom and Silver [338] (visual arts education programmes), Olofsson [341] (children in museums), Pitman-Gelles [342] (youth education in museums), Zetterberg [358] (museums and adult education), and Harvey and Friedberg [323] (museums and ethnic minorities). Journals include ICOM's International Committee for Education and Cultural Action's *ICOM Education* [68], the American Association of Museums' *Roundtable Reports - The Journal of Museum Education* [543], and the British *Journal of Education in Museums* [76].

The organization and management of museum shops is covered by Blume [312], the Museum Store Association (1992), Theobald [353], and the *Newsletter of the Group for Museum Publishing and Shop Management* [64].

The vital matter of public relations is covered by Adams [306], ICOM's *Public view* [327] (series of essays on museum public relations) and, more briefly, Veal [355].

In the wider field of heritage interpretation there are general monographs (Sharpe (1976), a textbook on interpreting the environment; Tilden (1977), a philosophical approach to heritage interpretation; and Uzzell (1989)). Periodicals include *Interpretation Journal* [74].

Natural history and geology

Among the few monographs relating specifically to the philosophy and practice of natural history museums are Cato and Jones [154] and Herholdt [228]. More specialized aspects of natural history collection management include Brunton, Besterman and Cooper [210], Howie [229] and Knell and Taylor [234] (all dealing with geological collections); Franks (1965) and Forman and Bridson [225] (botanical collections); Genoways, Jones and Rossolimo (1987) (mammals); and Walker and Crosby (1988) (insects). There are reports on general issues affecting the management of natural history collections, such as those published by

the Association of Systematics Collections (e.g. Irwin and others (1973)) and the Biology Curators' Group (e.g. Morgan (1986)). There are also more specialized publications originating from conferences, such as the British Columbia Provincial Museum report on natural history collections and research (Miller, 1985) and the Smithsonian publication on museum studies and wildlife management (Banks, 1979). Biological recording by museums is the subject of a report of the ASC (Kim and Knutson, 1986), and the National Federation of Biological Recording (UK) has published a series of reports based on papers presented at annual conferences.

There are a number of monographs on preservation techniques (Wagstaffe and Fidler, 1955, 1968; Hangay and Dingley, 1985). There is also a British Museum (Natural History) series Instructions for Collectors with a number of titles (e.g. Cogan and Smith (1974)), some of which are, however, rather out of date. Periodicals include the *Association of Systematics Collections Newsletter* [48]; ICOM's International Committee for Natural History Museums' *Newsletter* [470]; *Biology Curators' Group Newsletter* [52]; *Journal of Biological Curation* [75]; *Geological Curator* [61]; *Der Präparator* (Bochum: Verband Deutscher Präparatoren); *Collection Forum* [55]; and a number of periodicals dealing with taxidermy (e.g. *Guild of Taxidermists* [65]).

Art

Art galleries are often seen as a specialized kind of museum and for this reason they have generated their own literature, particularly in North America. Monographs include Meyer [184] (a critical assessment of the art museum in the United States); Lee (1975) (a compilation of eight papers examining the aims, tasks, problems and future of art museums); and Hendon (1979) who examines art museums from the point of view of their service to the community with an economic analysis of the costs and benefits. Publications have also been generated by art museum associations (e.g. Nauert and Black [248], North (1984) and Association of Art Museum Directors (1971)).

Applied art museums include museums devoted to ceramics, glass, metalwork, furniture, textiles, clothing and accessories. Monographs include those of Fall [223] and Tarrant (1983) (costume).

History

History museums are often seen in the wider context of the study and presentation of history. In the USA, many history museums and historic houses are administered by historical societies, and many aspects of the management and organization of history museums and the management of collections may be discussed in monographs and periodicals not specifically dedicated to museums. This applies particularly to the publications of the American Association for State and Local History [542], with books such as those of Schlereth (1980, 1982)

(*Artifacts and the American past* and *Material culture studies in America*) and the periodical *History News* [67]. More specific are Guthe (1964), Kavanagh [176], Leon and Rosenzweig (1989), Fleming, Paine and Rhodes (1993), George [159] and Taylor (1987). In Britain, the Social History Curators Group publishes both a news bulletin [119] and a journal [118].

Archaeology and anthropology

Monographs include *The role of anthropological museums in national and international education* (1976); *Anthropology in museums of Canada and the United States* (Osgood, 1979); 'The research potential of anthropological museum collections' (Cantwell, Griffin and Rothschild, 1981); Ames [147]; and Pearce [187].

Science and technology

The term 'science museum' is usually used to embrace traditional science museums, technological museums, science centres, health museums and the various kinds of transport museum. Monographs include *The industrial museum* (Richards, 1925) (examines various museums in a range of countries); *Transport museums* (Simmons, 1970) (discusses thirty-four such museums); and the publications of the Association of Science–Technology Centers [484]. Science centres are also discussed by Danilov (1982 and 1990) and Hein [162]. Periodicals include *ASTC Newsletter* [49], *Science and Industry Curators Group Newsletter* [117], and *Transport Museums* [125].

REFERENCES

After Attenborough: arts and disabled people. 1988. London: Bedford Square Press for Carnegie United Kingdom Trust. 131 pp.

American Association of Museums. 1991. *Code of ethics for museums adopted by the AAM Board of Directors on May 18, 1991*. Washington (DC): American Association of Museums. 16 pp.

Anderson, P. and Alexander, B. 1991. *Before the blueprint: science center buildings*. Washington (DC): Association of Science–Technology Centers. 96 pp.

Association of Art Museum Directors. Professional Practices Committee. 1971. *Professional practices in art museums*. New York: Association of Art Museum Directors. 28 pp.

Attenborough, R. 1985. *Arts and disabled people: report of a committee of inquiry under the chairmanship of Sir Richard Attenborough*. London: Bedford Square Press for the Carnegie United Kingdom Trust. 175 pp.

Australia Council for the Arts. 1991. *Art galleries: who goes? A study of visitors to three Australian art galleries with international comparisons*. Chippendale (Australia): Australia Council for the Arts. 125 pp.

Banks, R. C. (compiler) 1979. *Museum studies and wildlife management: selected papers*. Washington (DC): Smithsonian Institution Press. 297 pp.

Brown, C. R., Fleissig, W. B. and Morrish, W. R. 1991. *Building for the arts: a guidebook for the planning and design of cultural facilities*. Western States Arts Federation. 262 pp.

Cantwell, A. M. E., Griffin, J. B. and Rothschild, N. A. (eds.) 1981. The research potential of anthropological museum collections (papers presented at a conference held 25–27 Feb. 1981, in New York City, sponsored by the New York Academy of Sciences). *Annals of the New York Academy of Sciences*, 376, 1–584.

Cogan, B. H. and Smith, K. G. V. 1974. *Insects*. 5th ed. completely rev. London: British Museum (Natural History). 175 pp. (British Museum (Natural History). Instructions for Collectors, 4a.)

Coleman, L. V. 1950. *Museum buildings*. Washington (DC): American Association of Museums. 298 pp.

Danilov, V. J. 1982. *Science and technology centers*. Cambridge (Massachusetts): MIT Press. 364 pp.

Danilov, V. J. 1990. *America's science museums*. Westport (Connecticut): Greenwood Press. 464 pp.

Fleming, D., Paine, C. and Rhodes, J. G. (eds.) 1993. *Social history in museums: a handbook for professionals*. HMSO.

Franks, J. W. 1965. *A guide to herbarium practice*. London: The Museums Association. 33 pp. (Handbook for museum curators. Part E: natural and applied sciences, section 3.)

Genoways, H. H., Jones, C. and Rossolimo, O. L. (eds.) 1987. *Mammal collection management*. Lubbock (Texas): Texas Tech University Press. 219 pp.

Guthe, C. E. 1964. *The management of small history museums*. 2nd ed. Nashville (Tennessee): American Association for State and Local History. 78 pp.

Hangay, G. and Dingley, M. 1985. *Biological museum methods*. Sydney: Academic Press. Vol. 1: *Vertebrates*. 394 pp. Vol. 2: *Plants, invertebrates and techniques*. 338 pp.

Harvey, B. 1987. *Visiting the National Portrait Gallery: a report of a survey of visitors to the National Portrait Gallery*. London: HMSO. 51 pp. (Office of Population Censuses and Surveys. Social Survey Division. SS 1237.)

Hendon, W.S. 1979. *Analyzing an art museum*. New York: Praeger. 279 pp. (Praeger Special Studies.)

Hewison, R. 1987. *The heritage industry: Britain in a climate of decline*. London: Methuen. 160 pp.

Irwin, H.S. and others (compilers and eds.) 1973. *America's systematics collections: a national plan*. [Lawrence (Kansas)]: Association of Systematics Collections. 76 pp.

Kim, K.C. and Knutson, L. (eds.) 1986. *Foundations for a national biological survey*. Lawrence (Kansas): Association of Systematics Collections. 227 pp.

Korn, R. and Sowd, L. 1990. *Visitor surveys: a user's manual*. Washington (DC): AAM. 171 pp.

Kühn, H. 1986. *Conservation and restoration of works of art and antiquities*. London: Butterworths. 320 pp. (Butterworths' Series in Conservation and Museology.)

Lee, S.E. (ed.) 1975. *On understanding art museums*. Englewood Cliffs (New Jersey): Prentice-Hall. 219 pp.

Leon, W. and Rosenzweig, R. (eds.) 1989. *History museums in the United States: a critical assessment*. Urbana: University of Illinois Press. 359 pp.

Majewski, J. 1987. *Part of your general public is disabled. A handbook for guides in museums, zoos and historic houses*. Washington (DC): Smithsonian Institution for Office of Elementary and Secondary Education. 104 pp. [plus videotape; manual also available in audio cassette and braille format].

Mann, P.H. 1986. *A survey of visitors to the British Museum* (1982–3); ed. by M. Caygill and G. House. London: British Museum. 58 pp. (British Museum Occasional Paper, no. 64.)

Miller, E.H. (ed.) 1985. *Museum collections: their roles and future in biological research*. Victoria (British Columbia): British Columbia Provincial Museum. 231 pp. (Occasional Paper/British Columbia Provincial Museum, no. 25.)

Morgan, P.J. (compiler) 1986. *A national plan for systematic collections? Proceedings of a conference held at the National Museum of Wales, Cardiff, 6–9 July 1982*. Cardiff: National Museum of Wales/Biology Curators' Group. 192 pp.

Museum Documentation Association. 1991. *The MDA data standard*. Rev. ed. Cambridge: MDA. Looseleaf.

Museum Store Association. 1992. *The manager's guide: basic guidelines for the new manager*. Denver (Colorado): The Museum Store Association. 147 pp.

Museums and Galleries Commission. 1987. *Museum professional training and career structure: report by a Working Party*. London: HMSO. 157 pp.

Neickel, C.F. 1727. *Museographia oder Anleitung zum rechten begriff und nützlicher anlegung der museorum, oder raritäten - kammern* . . . Leipzig: Hubert. 464 pp.

Nelson, C.L. 1991. *Protecting the past from natural disasters.* Washington (DC): National Trust for Historic Preservation. 192 pp

Nichols, S.K. 1992. *Patterns in practice: selections from the Journal of Museum Education.* Washington (DC): American Association of Museums, Museum Education Roundtable. 403 pp.

North, I. (ed.) 1984. *Art museums and big business.* Kingston (Australia): Art Museums Association of Australia. 48 pp.

Osgood, C. 1979. *Anthropology in museums of Canada and the United States.* Milwaukee: Milwaukee Public Museum. 109 pp. (Milwaukee Public Museum. Publications in Museology, 7.)

Prince, D.R. and Higgins, B.A. 1992. *Leicestershire's museums: the public view.* Leicester: Leicestershire Museums, Art Galleries and Records Service. 166 pp. (Leicestershire Museums publication, no. 123.)

Richards, C.R. 1925. *The industrial museum.* New York: Macmillan. 127 pp.

The role of anthropological museums in national and international education: multinational seminar held at Moesgaard Museum, Denmark. 1976. Moesgaard (Denmark): Moesgaard Museum, Department of Ethnography. 152 pp.

Schlereth, T.J. 1980. *Artifacts and the American past.* Nashville (Tennessee): American Association for State and Local History. 301 pp.

Schlereth, T.J. (ed.) 1982. *Material culture studies in America.* Nashville (Tennessee): American Association for State and Local History. 435 pp.

Sharpe, G.W. 1976. *Interpreting the environment.* New York: Wiley. 582 pp.

Simmons, J. 1970. *Transport museums in Britain and Western Europe.* London: Allen and Unwin. 300 pp.

Snider, H.W. (project director) 1977. *Museums and handicapped students: guidelines for educators.* Washington (DC): Smithsonian Institution. 175 pp.

Spreading the word: national museum periodicals at work. Special issue of *Museum* 168, XLII: 4, 1990, 224-5.

Tarrant, N. 1983. *Collecting costume: the care and display of clothes and accessories.* London: Allen and Unwin. 158 pp.

Taylor, L.W. (ed.) 1987. *A common agenda for history museums - conference proceedings 19-20 Feb. 1987.* Nashville (Tennessee): American Association for State and Local History; Washington: Smithsonian Institution. 62 pp.

Teather, J. L. 1978. *Professional directions for museum work in Canada: an analysis of museum jobs and museum studies training curricula – a report to the Training Committee of the Canadian Museums Association*. Ottawa: Canadian Museums Association. 412 pp.

Tilden, F. 1977. *Interpreting our heritage*. 3rd ed. Chapel Hill (North Carolina): University of North Carolina Press. 138 pp.

Uzzell, D. L. (ed.) 1989. *Heritage interpretation*. London: Belhaven Press. Vol. 1: *The natural and built environment*. 252 pp. Vol. 2: *The visitor experience*. 234 pp.

Wagstaffe, R. and Fidler, J. H. *The preservation of natural history specimens*. London: Witherby. Vol. 1: *Invertebrates*. 1955. 218 pp. Vol. 2: part 2, *Zoology – vertebrates*; part 3, *Botany*; part 4, *Geology*. 1968. 419 pp.

Walker, A. K. and Crosby, T. K. 1988. *The preparation and curation of insects*. New rev. ed. Wellington (New Zealand): DSIR Science Information Publishing Centre. 91 pp. (DSIR Information Series, 163.)

Waterer, J. W. 1973. *A guide to the conservation and restoration of objects made wholly or in part of leather*. 2nd ed. London: Bell. 70 pp.

7 Audio-visual Materials

Audio-visual materials may take the form of photographs, photographic transparencies (slides), holograms, audiotapes, audio records, microform (fiche and film), slide–tape programmes, films, videodiscs and videotapes. Audio-visual material relating to museums and museum studies may be considered in a number of ways.

First, material relating to the collections may include photographic transparencies of objects, audio recordings (e.g. music played on instruments in the collection, recordings of bird song or animal calls, oral history recordings), microform copies of photographs of the collection, and copies of historic film (e.g. historic forms of transport in motion). Secondly, slide–tape programmes, film and video may be used to promote the museum or in educational programmes. Thirdly, slide–tape, film and video may be used in the training of museum personnel.

Most museums sell copies of slides, photographs, etc. of objects in the collection, and details are given (for Great Britain and Ireland) in Roulstone [30] and (worldwide) in *World museum publications 1982* [31], both now somewhat out of date. A growing number of the larger museums sell audiotapes, records and videos. Increasing use is also being made of microform, particularly to provide illustrations of paintings and other objects in catalogues published by art museums. As mentioned in Chapter 3, the National Air and Space Museum of the Smithsonian Institution in Washington makes available for purchase five archival videodiscs, each containing up to 100,000 colour and black and white photographs from the museum's collection. Illustrations of all kinds available from a selection of museums worldwide (as well as from many other sources) are listed in Evans and Evans' *Picture researcher's handbook* (1992). Binder (1992)

includes a directory of videodisc projects in museums (mainly US), and a list of resources available (mainly US), for example vendors, publications, organizations and conferences.

Organizations such as national museums associations and large museums which have well-developed training functions – like the Office of Museum Programs of the Smithsonian Institution [544] and the American Association for State and Local History [542] – often produce and market audio-visual teaching materials. Other useful 'one-off' tapes include *Keeping house: a practical guide to the conservation of old houses and their contents* (UK National Trust); *Marketing the arts* (UK Office of Arts and Libraries); *Conservation of natural history specimens* (Manchester University); and *Collection management at the National Museum of Denmark* (National Museum of Denmark).

Some films and videos containing material of museological interest are available from commercial sources. Films about the wide range of activities in museums can be both educationally successful and entertaining, as Bowman (1980) showed. The British Broadcasting Corporation has a marketing division which sells and hires films used in its broadcasts. The British Universities Film and Video Council also has a comprehensive catalogue with a section on museums. Some commercial films (international oil companies, pest control firms) have produced films which may be of interest.

Publications on the conservation of audio-visual material can be traced through *Art and Archaeology Technical Abstracts* [33] in a section entitled 'Audiovisual source materials'.

REFERENCES

Binder, R. H. 1992. *Videodiscs in museums: a project and resource directory*. Rev. ed. Falls Church (Virginia): Future Systems Inc. 185 pp.

Bowman, R. 1980. Museum, museum, museum: three new films. *Museum News* [95], 58: 6, 17–19.

Evans, H. and Evans, M. 1992. *Picture researcher's handbook: an international guide to picture sources – and how to use them*. 5th ed. London: Blueprint. 516 pp.

8 Trade Suppliers

As museums have become more complex and techniques of collection management (particularly the documentation, preservation and conservation of collections) and the exhibition of collections have become more sophisticated, specialist materials, equipment and services have developed to meet these needs. It has become increasingly difficult to put the suppliers in touch with the museums, but attempts are being made in various ways.

Some initiatives have been taken by museum organizations themselves. In the USA, *The official museum directory* [443] of the American Association of Museums [543] is in two parts, with Part 2 a directory of products and services. For Britain, there is an extensive section 'Suppliers and services' in the *Museums yearbook* [399], and some of the Area Museum Councils also produce lists of suppliers. There is also a commercially produced directory (Heath [374]). In Canada, the Ontario Museums Association produces a directory *Historic Sites Supplies Handbook* in printed form and on computer disk. More specialized organizations producing similar lists include the Group of Designers/Interpreters in Museums (1987), the Society for the Interpretation of Britain's Heritage (1987), and the Geological Curators' Group (see Brunton, Besterman and Cooper [210]).

The larger museum organizations often arrange trade and commercial exhibitions at major conferences and meetings which enable suppliers to exhibit and demonstrate their products. The International Council of Museums [447] and the American Association of Museums [543] are two such organizations which have produced directories of exhibitors. Trade exhibitions have become an important source of income to conference organizers as suppliers are prepared to pay for exhibition space.

Lists of suppliers of specialized equipment and materials are usually specific to individual countries. There is, however, an *Annuaire des fournisseurs des musées* [512] (an international exhibition of suppliers held in France), and the Salon International des Musées et des Expositions (SIME) held its first exhibition in 1988 and thereafter on a biennial basis. In 1990 exhibitors included the Federal Republic of Germany, Spain, Italy, Holland, Switzerland and Austria as well as France. The two directories *Guide–annuaire muséographique* (de Bary [373]) and *Annuaire des fournisseurs des musées* [512] are useful sources.

Some commercial organizations have also set themselves up to provide specialist materials and equipment for museums, and produce their own catalogues (e.g. University Products Inc., Light Impressions). They can be traced through the advertisements which appear in museum periodicals, particularly *Museums Journal* [99], *Museum News* [95] and *Muse* [82], as also can the names and addresses of individual suppliers. Each issue of these periodicals includes an Index of Advertisers, conveniently bringing together in a single list all firms advertising in that issue.

REFERENCES

Group of Designers/Interpreters in Museums. 1987. *Museum designers A to Z*. London: Group of Designers/Interpreters in Museums. 21 pp.

Society for the Interpretation of Britain's Heritage. 1987. *Consultants register*. Manchester: Society for the Interpretation of Britain's Heritage. 12 pp.

PART II

Bibliographical Listing of Sources of Information

Bibliographical Listing of Sources of Information

GENERAL BIBLIOGRAPHICAL GUIDES

1 **Beaudiquez, M.** *Bibliographical services throughout the world 1975–1979*. Paris: UNESCO, 1984. 462 pp. (Documentation, Libraries and Archives: Bibliographies and Reference Works, 7.)
Gives details of the bibliographical services of 121 countries worldwide. A 1980 supplement (114 pp.; 1982) was published as a supplement to the UNESCO publication *UNISIST Newsletter*, 10: 1 (1982).

2 **Sheehy, E. P.** *Guide to reference books*. 10th ed. Chicago and London: American Library Association, 1986. 1,574 pp. 1992 Supplement.
Covers all types of reference work in all subjects, with annotations. International in scope, with emphasis on works published in North America. Classified arrangement; museological material is scattered throughout and is best traced through the index. Particularly useful for tracing reference works in subjects related to museology. Index (authors, editors, compilers, sponsoring bodies, titles, subjects). The North American equivalent of Walford [3].

3 **Walford, A.J.** (ed.) *Walford's guide to reference material*. London: Library Association.
Vol. 1: *Science and technology*. 5th ed. 1989. 801 pp. Author/title index; subject index.
Vol. 2: *Social and historical sciences, philosophy and religion*. 5th ed. 1990. 953 pp. Author/title index; subject index.

Vol. 3: *Generalia, language and literature, the arts.* 5th ed. 1991. 1,046 pp.
Author/title index; subject index.
Covers all types of reference works in all subjects, with annotations. International
in scope, with emphasis on English-language publications. Classified arrange-
ment; museological material is scattered throughout, and is best traced through
the subject index to each vol. Particularly useful for tracing reference works in
subjects related to museology. The British equivalent to Sheehy [2].

BIBLIOGRAPHIES OF MUSEUM STUDIES LITERATURE

4 *Bibliography: theses, dissertations, research reports in conservation; a preliminary report.*
Budapest: ICOM Committee for Conservation Working Group, Training in
Restoration and Conservation, 1987. 188 pp.
First attempt to collect, on a worldwide basis, the results of research carried out
by students of major conservation training institutes. No indexes.

5 **Borhegyi, S. F. de** and **Dodson, E. A.** *A bibliography of museums and museum
work 1900–1960.* Milwaukee: Milwaukee Public Museum, 1960. 72 pp.
(Milwaukee Public Museum. Publications in Museology, 1.)
Unannotated listing of *c.* 1,000 publications of all kinds, worldwide (with US
bias). Arranged in sixteen divisions: museums – general; buildings; organization
and administration; personnel and salaries; training for museum work; educa-
tional work of museums; radio, television, etc.; public relations; exhibits –
general; cataloguing, loans, storage, etc.; packing and shipping; importing
and exporting; museum categories; techniques; foreign museums; dealers.
Author index.
Continued by Borhegyi, S. F. de, Dodson, E. A. and Hanson, I. A. *Bibliography
of museums and museum work 1900–1961: supplementary volume.* Milwaukee:
Milwaukee Public Museum, 1961. 102 pp. (Milwaukee Public Museum. Publi-
cations in Museology, 2.) Arranged on similar lines with similar coverage
(*c.* 1,200 items). Two appendices comprise bibliographies of primitive art and
public relations. Author index serves for both volumes.

6 **Bosdêt, M.** and **Durbin, G.** *GEM museum education bibliography 1978–1988.*
Aberdeen: Group for Education in Museums, 1989. 20 pp.
Unannotated list of over 1,000 items of all kinds on museum education published
between 1978 and 1988. Arranged in 8 sections, most subdivided: history;
principles and developments; serving the community; working in specific subject
areas; using and developing museum resources; outreach; professional develop-
ment; evaluation. No index.
Continued by Supplements in the *Journal of Education in Museums* [76].

7 **Canadian Museums Association.** *Bibliography: an extensive listing of published
material on the subjects of museology, museography and museum and art gallery*

administration. [Ottawa]: Canadian Museums Association, 1976–85. Looseleaf insertions.
Attempts to list major source materials. Emphasis is on North American publications. Includes a wide range of subjects and disciplines of interest to the museum community. Arranged in 28 subject categories, with further sub-categories where necessary. Entries listed alphabetically by author or title within each category. No subject approach apart from that provided by the contents list.

8 Clifford, W. *Bibliography of museums and museology.* New York: Metropolitan Museum of Art, 1923. 106 pp.
Unannotated listing of *c.* 1,500 publications of all kinds, worldwide. Arranged in six divisions: general works; organization, administration and arrangement; scope and functions of museums; museum construction; special museums; periodicals. Index (authors and subjects).

9 de Torres, A. R. (ed.) *Collections care: a selected bibliography.* Washington (DC): National Institute for the Conservation of Cultural Property, 1990. 143 pp.
Annotated bibliography organized under 13 main headings, each with an introduction. Includes list of participants, list of annotators and organizational resource list.

10 Elliott, P. and **Loomis, R. J.** *Studies of visitor behavior in museums and exhibitions: an annotated bibliography of sources primarily in the English language*; ed. by A. Berman. Washington (DC): Office of Museum Programs, Smithsonian Institution, 1975. 36 pp.
Annotated listing of 204 publications of all kinds, worldwide, on the measurement of visitor reactions to museum exhibits, arranged alphabetically by author. No subject approach.

11 Galin, G. A. Bibliografiya po muzeyevedeniv 1945–1977 gg. (Bibliography on museum practice for the years 1945–1977). In: *Voprosy sovershenstvovaniya muzeynykh ekspozitsii. Trudy 103*, pp. 157–63. Moscow: Nauchno-issledovatelskiy Institut Kultury, 1981.
Bibliographic review of Soviet museological literature, arranged in sections: manuals on method; meetings and conferences; archaeological, ethnographic and historical exhibitions; historic and historical – revolutionary museums; material culture; architectonic – creative designs of exhibitions.

12 Mclean, K. (ed.) 1991. *Recent and recommended: a museum exhibition bibliography with notes from the field.* Washington (DC): National Association for Museum Exhibition.

13 *Museum Abstracts International.* Edinburgh: Scottish Museums Council and Routledge, 1990–3. Quarterly.

An information bulletin designed for all those with an interest in the cultural heritage and leisure industries. Abstracts of material received by the Scottish Museums Council's Information Centre in Edinburgh; all abstracts are held on a database which can be searched if required. Includes articles, press cuttings and information sheets from over 200 museological publications on a worldwide scale. Classified arrangement. Index.

14 *Museum studies library shelf list*; project director: D. Kirshman; compilers: B. Thompson and J. Feeley. 2nd ed. San Francisco (California): Center for Museum Studies, John F. Kennedy University, 1986. 48 pp.
Unannotated list of *c.* 800 basic books on the history, philosophy and function of museums, published between 1918 and 1985 mainly in the United States. Generally excludes books on individual museum histories and their collections, and periodical articles. Aims to provide a central corps of books necessary for the study and appreciation of museums. Arranged in three sections: general resources; history and philosophy of museums; museum functions. Based on a list originally published in *Museum Studies Journal*.

15 Noschka, A. (ed.) *Bibliographie – Report 1987 zu den Gebieten Museologie, Museumspädagogik und Museumsdidaktik*. Berlin: Staatliche Museen Preussischer Kulturbesitz, 1987. 203 pp. (Materialen aus dem Institut für Museumskunde, Heft 19.) Includes a summary in En.
Unannotated list of 1,175 national and international publications in museology, museum education and didactics in museums. Arranged alphabetically by author/editor. Indexes of authors/editors arranged under subject categories.

16 Pawłowska-Wilde, B. Bibliografia muzealnictwa polskiego za lata 1972–1982 (wybór) (Bibliography of Polish museology for the years 1972–1982 (selection)). *Muzealnictwo* [105], 26–7 (1983), 164–6.

17 Rath, F. L. and **O'Connell, M. R.** (eds.) *A bibliography on historical organization practices*. Nashville (Tennessee): American Association for State and Local History. 6 vols.
Selective bibliography, with some annotation, of books, pamphlets and periodical articles, most published since 1945, with emphasis on the USA. Attempts to include all significant references. Each vol. includes 'Basic reference shelf', a list of essential publications in the field.
 Vol. 1: *Historic preservation*. 1975. 150 pp. Areas covered are historic preservation in perspective; preservation law; urban development and redevelopment; preservation research and planning; preservation action.
 Vol. 2: *Care and conservation of collections*; compiled by R. S. Reese. 1977. 115 pp. Areas covered are general reference and conservation organizations; philosophy, history, and principles of conservation; conservation laboratories and instrumentation; training of conservators; environmental factors in conservation;

conservation of library materials; conservation of paintings; conservation of works of art on paper; conservation of objects.

Vol. 3: *Interpretation*; compiled by R. S. Reese. 1978. 99 pp.

Areas covered are historical organizations; role of interpretation; visitor surveys; museum programmes; museums and schools; museum exhibits; museums in the media age.

Vol. 4: *Documentation of collections*; compiled by R. S. Reese. 1979. 229 pp.

Areas covered are historical organizations; collections documentation; artefact collections; decorative arts collections; fine arts collections; folk arts and crafts collections.

Vol. 5: *Administration*. 1980. 236 pp.

Areas covered are historical organizations; history and contemporary issues; governing boards; resources for administration; personnel training and management; financial management; fund raising; tax, law and insurance; buildings; printing and publishing; public relations; management of collections; library and archive administration.

Vol. 6: *Research*. 1984. 222 pp.

Areas covered are history; archaeology; architecture; technology and crafts.

18 Rodà, C. (compiler) *Estudis i recerques: bibliografia museològico–museogràfica a Barcelona*. Barcelona: Ajuntament de Barcelona, 1986. 70 pp. (Investigació Museística, 1.)

Unannotated list of museological publications, mainly monographs, worldwide, with an emphasis on literature in Spanish. Classified arrangement. The 1986 vol. included *c*. 800 references. No indexes.

19 Rogers, S. P., Schmidt, M. A. and **Gütebier, T.** *An annotated bibliography on preparation, taxidermy, and collection management of vertebrates with emphasis on birds.* Pittsburgh: Carnegie Museum of Natural History, 1989. 189 pp. (Special Publication, no. 15.)

Annotated bibliography of more than 1,200 references relating to vertebrate preparation with emphasis on birds. Organized in 37 divisions, including a section on literature in languages other than English (Danish, Dutch, French, German, Hungarian, Italian, Latin, Norwegian, Portuguese, Russian, Spanish, Swedish). Author index.

20 *Selected Bibliography of Museological Literature* (formerly: *Bibliographical Selection of Museological Literature*). Bratislava: Institute of Museology of the Slovak National Museum, 1968–90.

Selective listing, with abstracts (in En.) of museological publications of all kinds worldwide, with emphasis on Eastern Europe. *c*. 130 periodicals are scanned, with *c*. 500–600 references in each volume. Classified arrangement, which includes a section 'Museological literature and bibliography'. Foreign titles are translated into En. Classified index.

Also published in S1. as *Výberová Bibliografia Muzeologickej Literatúry* (1962–. Annual).

21 Shapiro, M. S. (ed.) *The museum: a reference guide.* New York: Greenwood Press, 1990. 399 pp. Bibliographic checklist at end of each chapter.

A critical examination of the literature with emphasis on the USA. A collection of 11 essays by invited authors: 'The natural history museum'; 'The art museum'; 'The museum of science and technology'; 'The history museum'; 'The folk museum'; 'Museum collections'; 'Museum education'; 'Museum exhibition'; 'The public and the museum'; 'Biography and the museum'; 'Professionalism and the museum'. Each chapter consists of an introductory historical narrative, a survey of sources, and a bibliographic checklist containing cited and additional sources. Appendices: an annotated list of *c.* 200 museum directories (world directories; national and multinational directories; regional, state and local directories), with an index by location and subject matter; a list of some prominent museum archives and special collections, with a bibliographic checklist; and a very selective list of museum-related periodicals.

22 Sharpe, T. (compiler) *Geology in museums: a bibliography and index.* Cardiff: National Museum of Wales, 1983. 128 pp. (Geological Series, no. 6.)

Contains over 1,000 references to publications of all kinds relating to geological curation. Intended for museum geologists and other staff who may have responsibility for geological collections. In two parts: an unannotated list arranged alphabetically by author with bibliographical details and keywords; a keyword index arranged alphabetically.

23 Smith, R. C. *A bibliography of museums and museum work.* Washington (DC): American Association of Museums, 1928. 308 pp.

Unannotated listing of publications of all kinds on museum work, arranged in a single alphabetical sequence of authors, titles and subjects. Includes a list of subject headings used. Scope is worldwide, but with emphasis on the USA.

24 Stansfield, G. A guide to the literature relating to natural history museums. *Curator* [58], 28: 3 (1985), 221–6. References: p. 226.

Brief guide to relevant literature (mainly English language) relating to natural history museums. Discusses periodicals and their indexes, bibliographies, proceedings of seminars and conferences, irregular publications, theses and monographs. List of addresses.

25 UNESCO–ICOM Museum Information Centre. *Basic museum bibliography/ Bibliographie muséologique de base.* [Paris]: UNESCO, 1986, 42 pp. (Studies and Documents on the Cultural Heritage, 14.)

Latest edition of a selection of essential museological literature of all kinds, unannotated, based on the holdings at the UNESCO–ICOM Documentation

Centre [447]. Arranged in seven sections: general resources; protection of the cultural and natural heritage; philosophy and history of museums; the museum institution; collections; communication and interpretation; museum categories. No index.

BIBLIOGRAPHIES OF PUBLICATIONS BY MUSEUMS

26 Bassett, D.A. Museum publications: a descriptive and bibliographic guide. In: J.M.A. Thompson and others (eds.) *Manual of curatorship* [137], pp. 590-622. London: Butterworth-Heinemann, 1992.
Examines in detail the most important types of museum publications and provides a bibliographic guide to the literature on them. Discusses the role of publication; publications policy; the different kinds of museum publications – primary publications (catalogues and handbooks to permanent collections; exhibition catalogues, handbooks and handlists; periodicals; books and specialist monographs; monographs; theses and dissertations; conference proceedings); secondary publications (directories; bibliographies, abstracts and indexes; computerized information services; manuals or handbooks; 'annual' reports and reviews; museum guides); tertiary publications; a commercial perspective; preparation and publication; design of publications.

27 Clapp, J. *Museum publications*. New York: Scarecrow Press, 1962. 2 vols.
A classified listing of the publications available from 276 museums in the United States and Canada. Publications listed are books, pamphlets, other monographs and serial reprints. Index (authors and subjects) to each vol.
Part I: *Anthropology, archaeology and art*. 4,416 publications.
Part II: *Publications in biological and earth sciences*. 9,231 publications.

28 Laskowska, M. and **Pawłowska-Wilde, B.** *Bibliografia zawartości wydawnictw muzeów w Polsce za lata 1945-1972: druki zwarte i ciągłe* (Bibliography of the contents of museum publications in Poland for the years 1945-1972: monographs and series). Warsaw: Zarząd Muzeów i Ochrony Zabytków, 1974. 2 vols. (Biblioteka Muzealnictwa i Ochrony Zabytków, ser. B, vol. 38.) Contents table and prefatory material also in En.

29 *A magyar múzeumok kiadványainak bibliográfiája* (Bibliography of Hungarian museums' publications). Budapest: Központi Muzeumi Igazgatóság.
Vol. I: *Évkönyvek és folyóiratok repertóriuma 1945-1974* (Repertory of yearbooks and periodicals 1945-1974).
Vol. I/a: *Muzeológia és restaurálás* (Museology and restoration). 1975. 291 pp.
Vol. I/b: *Természettudományok* (Natural sciences). 1976. 248 pp.
Vol. I/c: *Régészet és történelem* (Archaeology and history). 1976. 235 pp.
Vol. I/d: *Néprajz* (Ethnography). 1976. 135 pp.

Vol. I/e: *Müvészetck, irodalom és müvelödésthörténet* (Arts, history of literature and culture). 1977. 166 pp.
Vol. II: *Sorozatok és önálló kiadványok repertóriuma 1945–1974* (Repertory of series and monographs 1945–1974). 1978. 259 pp.
Vol. III: *Kiállitásvezetök és katalógusok repertóriuma 1945–1974* (Exhibition guides, catalogues). To be published.
Vol. IV: *Évkönyvek, folyóiratok, sorozatok, önállö kiadványok, kiállitási vezetök, katalógusok* (Yearbooks, periodicals, series, monographs, exhibition guides, catalogues). 1975–.

30 Roulstone, M. (ed.) *The bibliography of museum and art gallery publications and audio-visual aids in Great Britain and Ireland 1979/80.* Cambridge (England): Chadwyck-Healey, 1980. [560 pp.]
Lists the publications and audio-visual aids (i.e. books, guides, catalogues, bulletins, reports, slides, postcards, photographs, films, records, microform, tapes, etc.) produced by 955 British and Irish museums and art galleries. Arranged alphabetically by institution. Geographical index; author index; subject index.

31 *World museum publications 1982: a directory of art and cultural museums, their publications and audio-visual materials.* New York and London: Bowker, 1982. 731 pp.
Lists the permanent collections of over 10,000 art museums and major art galleries worldwide and the publications and audio-visual materials available from them. The 'Geographic guide to museums' lists the institutions by country. The 'Museum publications and audio-visual materials index' lists over 30,000 publications and audio-visual items by museum and gallery name. Author index – publications; title index – publications; title index – audio-visual materials; key to publishers' and distributors' abbreviations.

ANNUAL BIBLIOGRAPHIES, ABSTRACTS AND INDEXES

32 *Architectural Periodicals Index.* London: RIBA Publications Limited (for the British Architectural Library), 1972/3– (publ. 1974–). Quarterly.
Worldwide coverage of articles on all aspects of architecture, design and planning with emphasis on the UK, from over 300 periodicals. Brief summaries in some cases. Alphabetical arrangement by subject headings, with many articles under 'museums' (1984 vol. included 292 entries under 'museums'). Names index (i.e. architects, planners, authors, etc.); list of subject headings used in each issue; topographical and building names index in the cumulative (i.e. 4th) issue each year. Delay: generally only a few weeks. Available online through DIALOG as ARCHITECTURE DATABASE (1978–. Updated monthly.)
 Continues *RIBA Annual Review of Periodical Articles* (1965–72) and the periodicals index section of the *RIBA Library Bulletin* (1946–72).

33 *Art and Archaeology Technical Abstracts*. London: Getty Conservation Institute/
International Institute for Conservation of Historic and Artistic Works, 1966–.
Twice a year.
Worldwide listing, with abstracts, of publications of all kinds dealing with
the technical examination, investigation, analysis, restoration, preservation and
technical documentation of works of art and monuments having historic or
artistic significance. The main arrangement (revised version introduced in vol. 22
(1985)) is by the material comprising the objects under study or treatment,
e.g. wood, ceramics. Abstracts which do not deal with a class of material as
such are placed in one of the following sections: methods of examination and
documentation; conservation practice; archaeology; architectural conservation;
conservation education and training; history of technology; audio-visual source
materials. Approximately 400 periodicals are abstracted. Some numbers include
as supplements annotated bibliographies on specific topics, e.g. the preservation
of natural stone. Author index for each number; source directory and index for
each number; subject index for each vol. Delay: usually *c.* 6–12 months.

Preceded by *IIC abstracts: abstracts of the technical literature on archaeology and the
fine arts* (London: International Institute for Conservation of Historic and Artistic
Works, vols. 1–5, 1955–65). Publications (similar to those in *AATA*) listed under
various headings. Author index; subject index; cumulative subject index to
vols. 1–10 (1955–73) of *IIC abstracts* and *AATA* forms a supplement to *AATA* 11: 1
(1974). Cumulative author and abbreviated title index to vols. 1–10 (1955–73)
of *IIC abstracts* and *AATA* forms a supplement to *AATA* 12: 2 (1975). Available
online through the Conservation Information Network.

Technical literature on art and archaeology before 1955 is covered back to 1932
by the following two publications:

Gettens, R.J. and Usilton, B.M. *Abstracts of technical studies in art and archaeology,
1943–1952*. Washington: Smithsonian Institution, 1955. 416 pp. (Smithsonian
Institution Publications, 4176; Freer Gallery of Art Occasional Papers, 2(2).)
Lists, with abstracts, 1,399 papers that appeared in approximately the ten-year
period prior to *IIC abstracts*. Arranged under headings: museology; materials,
construction and conservation of objects; technological examination of objects
and analysis of materials; each with subdivisions. Index.

Usilton, B.M. *Subject index to 'Technical Studies in the field of the fine arts' vols. 1–10,
1932–42*. Pittsburgh (Pennsylvania): Tamworth, 1964. 44 pp.
The key to the more than 160 articles and 450 abstracts that appeared in the
above periodical.

34 *Art Index*. New York: H.W. Wilson, 1929– (publ. 1930–). Quarterly with
annual cumulations.
Unannotated list of articles on all aspects of art, including museology, worldwide.
About 200 periodicals are indexed, including several leading museological ones.

Arranged in a single alphabetical author/subject sequence, with full biblio-
graphical details. Includes book reviews, listed separately. Delay: usually 6–12
months. Also available on CD-ROM.

35 *ARTbibliographies Modern: Abstracts of the Current Literature of Modern Art,*
 Photography and Design. Oxford: Clio Press, 1969–. Twice a year.
Abstracts of publications of all kinds, including exhibition catalogues and articles
from *c.* 2,000 periodicals, worldwide, on all aspects of art and design in the 20th
century. Arranged in a single alphabetical sequence containing subjects, names
of artists, artists' groups, collectors and critics. Numerous entries under
'Museums and galleries'. Author index; museum and gallery index (lists by town
or city and gallery the venues of the exhibitions whose catalogues are documented
in the abstracts). Delay: *c.* 1–2 years. Available online through DIALOG as
ARTBIBLIOGRAPHIES MODERN (1974–. Updated twice a year.)
 Superseded *LOMA: literature on modern art* (1969–71).

36 *BHA: Bibliography of the History of Art/Bibliographie d'Histoire de l'Art.*
 Vandoeuvre-lès-Nancy: INIST; Santa Monica: Art History Information
 Program of the J. Paul Getty Trust, 1991–. Quarterly.
Abstracts (in En. or Fr.) of publications of all kinds (including exhibition and
museum catalogues and articles from *c.* 3,000 periodicals) worldwide, on
European art from late Antiquity to the present and American art from the
European discoveries to the present. General sections, including 'Museums and
museology', 'Private collections' and 'Exhibitions', are followed by a chrono-
logical division. Author index; journal index; subject index (in En. and Fr.);
abbreviation list. Available online through DIALOG as ART LITERATURE
INTERNATIONAL (1973–. Updated twice a year) and through QUESTEL.
 The successor to *RILA: International Repertory of the Literature of Art/Répertoire
International de la Littérature de l'Art* ((1975–89); cumulative indexes: vols. 1–5
(1975–9); vols. 6–10 (1980–4); vols. 11–15 (1985–9), and *Répertoire d'Art et
d'Archéologie* (1910–89)).

37 *Bibliografie Muzeologické Literatury.* Prague: Národní Muzeum – Ústřední
 Muzeologický Kabinet, 1967–. Biennial.
Unannotated listing of Czech and Slovak museological literature. Classification
scheme also in Ru. and En. Author index.

38 *International Museological Bibliography/Bibliographie Muséologique Internationale.*
 Paris: UNESCO–ICOM Documentation Centre, 1967–85. Annual.
Aims to provide a comprehensive unannotated bibliography of all literature on
museology and museum practice published during the year. Intended for the
museum professional, museum institutions, universities and research institu-
tions. All types of museological publication worldwide, including articles from
nearly 200 periodicals and series. Vols. 1–14 included bibliographical references

from other museum documentation centres as well as the UNESCO–ICOM Centre, but later vols. listed only documents received by the Centre.

In two parts – part I: a listing in Masterfile number order, with full bibliographical description; part II: subject index; corporate subject index; personal author index; corporate author index; museum index; periodicals and series index.

Continued by a listing on CD-ROM.

39 *Museum Abstracts.* Edinburgh: Scottish Museums Council, 1985–. Monthly. An information bulletin designed for all those with an interest in museums, tourism, the heritage and leisure. Abstracts of material received by the Scottish Museums Council's Information Centre in Edinburgh; all abstracts are held on a database, which can be searched if required. Includes articles, press cuttings and information sheets from a wide range of periodicals and newspapers, but not monographs or details of exhibition openings. Material is mainly British and North American. Classified arrangement. Of the periodicals covered, some are museological, others are of a general nature. Delay: virtually none.

40 *Museum studies bibliography* (formerly: *Bibliography for museum studies training*); ed. by S. Pearce, 10th ed. Leicester: University of Leicester, Department of Museum Studies, 1991. 239 pp. Looseleaf format.
Unannotated major listing of publications of all kinds on museum studies, compiled by staff past and present of the Department of Museum Studies, University of Leicester. Intended as a general work of reference aimed at all those engaged, or soon to be engaged, in museum work. Arranged alphabetically by sections, each with sub-sections, reflecting broad areas of museum activity.

41 *UNESCO List of Documents and Publications.* Paris: UNESCO, 1972–. Quarterly with annual cumulations. Five-year cumulation (1972–6) publ. 1979; four-year cumulation (1977–80) publ. 1984; three-year cumulations (1981–3) publ. 1985; and (1984–6) publ. 1989.
Comprehensive bibliography of everything published recently by UNESCO. Each issue consists of two parts – part I: a listing in number order, giving a full bibliographic description for each item; part II: subject index; personal name index; meeting and corporate body index; title and series index. Delay: only a few months. Includes a great deal of museological material.

Continues *Bibliography of publications issued by UNESCO or under its auspices; the first twenty-five years: 1946 71* (Paris: UNESCO, 1973. 403 pp.) which has a classified arrangement with 'Museums' at 069, and title and author indexes.

42 *Visitor Studies Bibliography and Abstracts.* Shorewood (Wisconsin): Exhibit Communications Research, Inc. for the International Laboratory for Visitor Studies, 1987–. Annual.
Lists publications of all kinds on behavioural, educational and communication aspects of museum and exhibition planning. Includes many publications from

outside the museum field. Arranged in two sections: part I comprises a list of all entries, arranged alphabetically by author, some with abstracts; part II has the entries organized according to popular topic categories (e.g. 'Theory/ Methods', 'Survey').

GUIDES TO PERIODICALS

43 *Historical periodicals directory*; ed. by E. H. Boehm and others. Santa Barbara (California); Oxford (England): ABC-Clio, 1981–6. (Clio Periodicals Directories.) 5 vols. – vol. 1: *USA and Canada*; vol. 2: *Europe: West, North, Central and South*; vol. 3: *Europe: East and Southeast; USSR*; vol. 4: *Latin America and the West Indies*; vol. 5: *Australia and New Zealand*.
International guide to periodicals in history interpreted in its broadest sense (including some museological titles with a historical bias). Includes all titles current at the time and those that have ceased publication since 1960. Arranged alphabetically by title within country of publication. Details include a brief summary of the subject scope. Title index to each vol. Vol. 5 includes a cumulative subject–geographic index and title index.

44 *Serials directory: an international reference book.* Birmingham (Alabama): Ebsco Publishing, 1986–. Annual. 3 vols. + updates.
Gives details of over 113,000 serial titles published worldwide under 147 major subject headings. Comprises 4 major sections: serials listing; alphabetical title index; ceased-title index; ISSN index. Includes details such as year of origin, frequency, publisher's name and address, where abstracted or indexed, and sometimes a brief description of coverage. The 'Museums' section lists over 400 titles. Also available on CD-ROM.

45 *Ulrich's international periodicals directory, now including irregular serials and annuals.* New York: Bowker, 1932–. Annual. 3 vols. + updates.
Gives details of over 116,000 serials currently published worldwide under 668 subject headings. The 'Museums and art galleries' section lists about 500 titles. Includes details such as year of origin, frequency, publisher's name and address, corporate author, where abstracted or indexed. Major sections are: classified list of serials; refereed serials; serials available on CD-ROM; serials available online; cessations; ISSN index; title index. Available online through BRS (File ULRI), DIALOG (File 480) and ESA-IRS (File 103).

PERIODICALS

46 *AIM: Bi-monthly Bulletin of the Association of Independent Museums.* Chichester: Association of Independent Museums, 1978–. Every two months. En.
News about independent museums, and recent meetings held. Forthcoming meetings, events, etc. Details of AIM publications.

47 *Archives and Museum Informatics* (formerly: *Archival Informatics Newsletter* (1987–91)). Pittsburgh (Pennsylvania): Archives and Museum Informatics, 1991–. Quarterly. En.
Newsletter reporting on developments in information technologies, techniques and theories relevant to archives and museums. Regular features include: articles; conference reports; calendar notes; news; software reviews and news; standards. Publication reviews.

48 *ASC Newsletter*. Washington (DC): Association of Systematics Collections, 1973–. Every two months. En.
Covers needs of biological collections including grants, computerization, awards, positions available, curatorial methods, pest control, collection research and management. Individual institutions are featured. Book reviews.

49 *ASTC Newsletter*. Washington (DC): Association of Science–Technology Centers, 1974–. Bi-monthly. En.
News items, reports of surveys, meetings, grants, research and evaluation, personnel, positions available and calendar.

50 *Aviso*. Washington: American Association of Museums, 1968–. Monthly. En.
Newsletter, including news of US government policies affecting museums, meetings, people, a calendar of conferences and workshops, and details of posts available.

51 *Bibliothèques et Musées*. Neuchâtel: Affaires culturelles, 1948–. Annual. Fr.
History of Swiss museums and libraries-holdings, exhibits and acquisitions.

52 *Biology Curators' Group – Newsletter*. Biology Curators' Group, 1975/8–. Three times a year. En.
Aims to facilitate the exchange of information between individuals concerned with the management of biological collections and records, their research, conservation and interpretation, and to present the views of curators of biological collections. Book reviews.

53 *Boletín del Museo del Prado*. Madrid: Museo del Prado, 1980–. Three times a year. Es.
Articles on Spanish works of art.

54 *Chinese Museum* (Zhongguo Bowuguan). Beijing: Chinese Society of Museums (Zhongguo Bowuguan Xuehui), 1983–. Quarterly. Ch. (contents in En.)
Articles relating to Chinese museums. Book reviews.

55 *Collection Forum*. Pittsburgh (Pennsylvania): Society for the Preservation of Natural History Collections, 1985–. Twice a year. En.

Disseminates substantive information concerning the development and preservation of natural history collections. Book reviews.

56 *Conservation News*. London: United Kingdom Institute for Conservation, 1976–. Three times a year. En.
Newsletter discussing new methods and techniques and acting as a forum on conservation issues. 'News and information'. New publications, including book reviews. 'Conference reviews'.

57 *Conservator*. London: United Kingdom Institute for Conservation, 1977–. Annual. En. Cumulative index: nos. 1–9 (1977–85) in no. 10 (1986).
Authoritative papers on conservation topics, including detailed case histories and research.

58 *Curator*. New York: American Museum of Natural History, 1958–. Quarterly. En. Cumulative indexes (author; title; subject): vols. 1–30 (1958–87) in vol. 30 (1987).
A museum studies journal of international status covering all aspects of museum theory and practice with emphasis on natural history and anthropological museums and on exhibition philosophy, design practice and evaluation. Predominantly North American in scope. Book reviews.

59 *Danske Museer* (formerly: *Museumsmagasinet: Meddeleser fra Danmarks Museer/ Museumstjenesten for Statens Museumsnaevn* (1977–88)). Copenhagen: Statens Museumsnaevn, 1977–. Quarterly. Da.
Museological articles and information about Danish museums, exhibitions, etc. List of new books and list of indexed articles published quarterly. Book reviews.

60 *Gendai No Me* (Today's Focus). Tokyo: National Museum of Modern Art, 1959–. Monthly. Ja.
Official newsletter of the Museum. Essays on current exhibitions and screenings of the Museum, the Crafts Gallery and the Film Centre. Articles on modern and contemporary art and artists.

61 *Geological Curator* (formerly: *Newsletter of the Geological Curators' Group* (1974–9)). Geological Curators' Group, 1980–. Three times a year. En.
Techniques of curation and conservation of geological specimens. Geological collections and collectors. Forthcoming meetings. Notes and news. Book reviews.

62 *Group for Costume and Textile Staff in Museums – Newsletter*. Group for Costume and Textile Staff in Museums, 1979–. Twice a year. En.
Summaries of recent meetings held. Forthcoming meetings, exhibitions, events, and news on costume and textile matters. New books.

63 *Group for Education in Museums – Newsletter* (formerly: *Group for Educational Services in Museums – Newsletter* (1972-9)). Group for Education in Museums, 1980–. Quarterly. En.
Notes and news. Book reviews.

64 *Group for Museum Publishing and Shop Management – Newsletter*. Group for Museum Publishing and Shop Management, 1978–. Once or twice a year. En.
Articles on publishing and bookselling. Developments in museum shops in the UK and overseas. Museum news and appointments. List of trade suppliers. New publications. Book reviews.

65 *Guild of Taxidermists*. Guild of Taxidermists, 1978–. Annual. En.
Articles on techniques, historical taxidermy, implications of wildlife laws. Conference proceedings. Book reviews.

66 *Hakubutsukan Kenkyu/Museum Studies*. Tokyo: Nihon Hakubutsukan Kyokai, 1928–. Monthly. Ja. (contents page in En.)
Japanese museums, notes on exhibitions, etc. Lists of books received.

67 *History News*. Nashville (Tennessee): American Association for State and Local History, 1949–. Every two months. En.
Articles relating to history museum practice in the USA and Canada. Current news of grant projects, conferences, educational opportunities, exhibits, appointments, etc. AASLH news. Positions available. 'The bookshelf' (book reviews).

68 *ICOM Education* (formerly: *Museums' Annual: Education, Cultural Action/Annales des Musées: Education, Action Culturelle* (1971-4) and *The Annual: Museums, Education, Cultural Action/Annales: Musées, Education, Action Culturelle* (1969-70)). Paris: International Council of Museums and International Committee for Education and Cultural Action, 1975/6–. Annual. En. Fr.
Articles on museum education. Individual issues devoted to themes (e.g. 'The museum and the world of work', 'Community and museum'). News about CECA [457]. Vol. 7 included a selective bibliography of monographs and articles on museum education and cultural action published 1970-6; vol. 8 included a similar bibliography of works on the same subject published 1976-8.

69 *ICOM News: Bulletin of the International Council of Museums* Paris: International Council of Museums, 1948–. Quarterly. En. Fr. Es.
Short articles on recent events in the museum profession worldwide, culled from ICOM's [447] national and international committees, the world of museums, members, publications and letters sent in. Calendar of forthcoming meetings. Lists of individual members in the ICOM Secretariat, UNESCO–ICOM Museum Information Centre, and ICOM Executive Council; list of chairpersons and secretaries of ICOM international committees; list of chairpersons and

secretaries of affiliated international organizations; list of chairpersons of ICOM national committees; list of chairpersons of ICOM regional organizations; the President of the ICOM Foundation. Brief book reviews.

70 *ILVS Review: A Journal of Visitor Behavior.* Shorewood (Wisconsin): Exhibit Communications Research, Inc. for the International Laboratory for Visitor Studies, 1988–. Twice a year. En.
Concerned with issues, developments, ideas and practical information in the field of exhibit communications.

71 *Informatica Museologica.* Zagreb: Muzejski Dokumentacioni Centar, 1970–. Quarterly. Cr. (contents and summaries in En.)
Includes news of collections, ICOM news, and notes and general news about Yugoslavian museums. Book reviews.

72 *International Centre for the Study of the Preservation and the Restoration of Cultural Property (ICCROM) – Newsletter.* Rome: International Centre for the Study of the Preservation and the Restoration of Cultural Property, 1973–. Annual. En. Fr. Es.
Includes details of ICCROM's administration and organization, courses, publications, conference reports, research and development, and technical assistance, and miscellaneous information such as forthcoming conferences and formation of new associations.

73 *International Journal of Cultural Property.* Berlin: Walter De Gruyter for the International Cultural Property Society, 1992–. En.
An organ of communication among people throughout the world who are interested in questions of cultural property policy, ethics, economics and law. In addition to refereed articles, it publishes documents, judicial decisions, correspondence, a bibliography, and information about meetings and events.

74 *Interpretation Journal* (formerly: *Heritage Interpretation* (1983–90) and *Interpretation (Manchester)* (1975–83)). Liverpool: Society for the Interpretation of Britain's Heritage, 1990–. Three times a year. En.
Articles on the theory and practice of heritage interpretation, with descriptions of new interpretive facilities, mainly in UK. Reports of meetings. News. Book reviews.

75 *Journal of Biological Curation.* Leicester: Biology Curators' Group, 1989–. Annual. En.
Concerned with all aspects of the curation of biological collections and with their use in education and exhibition.

76 *Journal of Education in Museums.* Group for Education in Museums, 1980–. Annual. En.

Articles on matters concerning educational activities in museums both in the UK and overseas. Includes 'Museum education bibliography' (supplement to [6]).

77 *Journal of Indian Museums*. New Delhi: Museums Association of India, 1945–. Annual. En. Cumulative index: vols. 1–28 (1945–72).
Indian museums.

78 *Journal of Museum Ethnography* (formerly: *Museum Ethnographers Group – Newsletter* (1976–88)). Hull: Museum Ethnographers' Group, 1989–. Annual. En.
Articles on ethnographic collections in museums, including papers from conferences and MEG meetings. Concerned with management of collections (recording, documentation), exhibitions and role of museums in ethnography. Book reviews.

79 *Journal of the History of Collections*. Oxford: Oxford University Press. 1989–. Twice a year. En.
Dedicated to the study of collections, including the content of collections, the processes which initiated their formation, and the circumstances of the collectors themselves. Book reviews.

80 *MPG News* (formerly: *Museum Assistants' Group News* (1966–79) and *Natural History Newsletter* (1964–5)). Salisbury: Museum Professionals Group, 1980–. Two or three times a year. En.
Discusses professional matters concerning British museums.

81 *MPG Transactions* (formerly: *Museum Assistants' Group – Transactions* (1963–78)). Salisbury: Museum Professionals Group, 1981–. Once or twice a year. En.
Report of papers given at seminars and study weekends.

82 *Muse* (formerly: *Gazette* (1966–82)). Ottawa: Canadian Museums Association, 1983–. Quarterly. En. Fr.
Articles on developments and issues of primary interest to the Canadian museum community but also pertinent to other countries. 'Museum profiles' looks at museums and exhibitions across the country. Reviews of exhibitions, exhibition catalogues and books.

83 *Musées et Collections Publiques de France* (formerly: *Bulletin Trimestriel de l'Association Générale des Conservateurs des Collections Publiques de France* (1948–55)). Paris: Association Générale des Conservateurs Publiques de France, 1955–. Quarterly. Fr.
History of France through museum collections. History of French museums and museology. Notes and news (including news of the Association's activities), news of research, meetings, decrees, statutes, etc. Book reviews.

84 *Musei e Gallerie d'Italia*. Rome: (Associazione Nazionale dei Musei Italiani) De Luca Editora, 1956–. Twice a year. It.
Articles, notes and news about museums and galleries, mainly in Italy. Book reviews.

85 *Museo* (formerly: *Suomen Museoliitto Tiedottaa* (1972–83)). Joensuu (Finland): Suomen Museoliitto, 1983–. Every two months. Fi. Sw.
Museums in Finland and other countries. Each issue specializes in a particular topic.

86 *Il Museo: Revista del Sistema Museale Italiano*. Rome: Libreria dello stato, 1992–. Three times a year. It.
Articles on Italian museums.

87 *Museogramme* (formerly: *AMC Gazette* (1967–72)). Ottawa: Canadian Museums Association, 1973–. Monthly. Fr. En.
Includes advocacy issues, current events, membership activities, details of current training and professional development activities, and a calendar of worldwide conferences on museum activity.

88 *Museum Design* (formerly: *Group of Designers/Interpreters in Museums – News* (1978–84)). Museum Design Group, 1985–. Three times a year. En.
Comments and reviews on current exhibitions and new galleries, mainly in the UK.

89 *Museum Development*. Milton Keynes: Museum Development Company, 1990–. Monthly. En.
An international journal, launched in October 1989. It focuses on how museums and galleries can generate additional income, covering such areas as sources of grants, membership programmes, sponsorship, retailing, catering, publishing, travel programmes, property development, corporate hospitality and licensing programmes.

90 *Museum International* (formerly: *Museum* (1948/9–1992)). Oxford: Blackwell (for UNESCO), 1993–. Quarterly. En. Fr. Es. Ru. Ar. Cumulative indexes (subject; country; category; author): vols. 1–25 (1948–73); vols. 26–35 (1974–83).
The major international journal describing developments and discussing issues of interest to the world museum community. Special issues on museums of individual countries (e.g. Korea (1986), Hungary (1983)), geographical regions (e.g. Latin America and the Caribbean) and specific topics (e.g. museums of science and technology (1986), temporary exhibitions (1986), ecomuseums (1985), showcases (1985), new directions in museum work (1985), museums and agriculture in the 1980s (1984), the museum as educator (1984), issues in modern

museum practice (1984), museums and the underwater heritage (1983), conservation (1982), museums and disabled persons (1981), return and restitution of cultural property (1979), museum architecture (1974), national museum periodicals (1990), sports (1991), women (1991), and museums and the environment (1973)). Colour and black and white illustrations.

Regular feature: 'WFFM chronicle' **[492]**.

Preceded by *Mouseion* (Paris: Office International des Musées, 1927–45).

91 *Museum Ireland: The Journal of the Irish Museums Association.* Belfast: Irish Museums Association, 1991–. Annual. En.

Articles relating to museum issues and practice in Ireland. Papers from seminars. Book reviews.

92 *Museum Management and Curatorship* (formerly: *International Journal of Museum Management and Curatorship* (1982–9)). Guildford: Butterworths, 1990–. Quarterly. En. Cumulative index: vols. 1–4 (1982–5).

An international forum for the exchange of information between museum professionals. Encourages a continuous reassessment of the disciplines governing the establishment, care, presentation and understanding of museum collections. Specially commissioned articles review the whole range of problems confronting curators, administrators, conservators and designers, and assess the solutions available. Topics of particular concern are museum architecture, the effective employment of manpower resources, and the achievement of maximum efficiency and economy. Regular features: 'Publications digest' (book reviews); 'Professional notes'.

93 *Museum National.* Fitzroy (Australia): Council of Australian Museum Associations and affiliated organizations, 1992–. Quarterly. En.

Represents the views and interests of all member affiliates. Acts as an advocate for museums and associated organizations, and reflects the broad range of functions and interests of the spectrum of its constituents. A forum for a high standard of critical analysis.

94 *Museum News* (London). London: National Heritage, 1972–. Three times a year. En.

Articles of general interest on the museum world in Britain. Information about forthcoming exhibitions. Aimed at the layman. Book reviews.

95 *Museum News* (Washington). Washington, DC: American Association of Museums, 1924–. Bi-monthly. En. Cumulative indexes (subjects; authors) (1980–9).

The primary US journal describing developments and discussing issues relevant to the USA but of interest to other countries. Includes information on the law, relations with the government, recent exhibitions and acquisitions, and American

Association of Museums news. Some issues are planned around specific themes. Colour and black and white illustrations. Book reviews.

96 *Museum Quarterly* (formerly: *Ontario Museum Quarterly* (1971–83)). Toronto: Ontario Museum Association, 1983–. Quarterly. En.
Articles, exhibit reviews, conservation and technical columns. Book reviews.

97 *Museumedia*. Milwaukee: Museumedia. Bi-monthly.
Newsletter with information about films, videos, discs and multimedia for use in education programmes, exhibits and information management. Reports on innovative use of media by museums nationally and internationally.

98 *Museumleven: Jaarboek van de Vlaamse Museumvereniging*. Bruges: Vlaamse Museumvereniging, 1974–. Annual. Nd. (some articles have summaries in En.)
Museum activities in Flanders. Book reviews.

99 *Museums Journal*. London: The Museums Association, 1901–. Monthly. En. Technical indexes (titles arranged alphabetically under broad headings such as 'Archaeology', 'Art'): 1930–55; 1956–66.
The primary UK museum journal with papers on all aspects of museum studies. Mainly descriptive, reporting current developments in museum practice. UK orientated but with some material on non-UK museums. Recently it has devoted special issues to particular subjects (e.g. the role of consultancy (1988), lighting (1986)). Book reviews.
From April 1989, incorporates *Museums Bulletin*.

100 *Museumskunde*. Bonn: Deutscher Museumsbund, 1905–22; new series: 1929–39; third series: 1960–. Three times a year. De.
Articles about museums and museum work, including museology and museum education, with emphasis on German museums. 'Nachrichten und Informationen' includes book reviews, news of individuals, obituaries, details of new and reopened establishments, etc.

101 *Museumsmagasinet: Meddeleser fra Danmarks Museer/Museumstjenesten for Statens Museumsnaevn*. Copenhagen: Statens Museumsnaevn, 1977–. Quarterly. Da.
Museological articles and information about Danish museums, exhibitions, etc. List of new books and list of indexed articles published quarterly. Book reviews.

102 *Museumsnytt*. Oslo: Norske Kunst- og Kulturhistoriske Museer, Norske Naturhistoriske Museers Landsforbund, 1951–. Quarterly. No. Cumulative index: 1951–81 (in vol. 31: 4 (1982)).
Norwegian museums. Book reviews. Each issue includes a list of Norwegian organizations concerned with museology.

103 *Museumvisie.* Amsterdam: Nederlandse Museumvereniging, 1976–. Quarterly. Nd.
Articles, news and information on Dutch museums and the affairs of the Association. Book reviews.

104 *De Museus, Quaderns de Museologia i Museografia.* Barcelona: Generalitat de Catalunya, Departament de Cultura, 1988–. Twice a year. Published separately in Ca. and En. (En. edition does not include photographs).
Articles relating to the museums of Catalonia, museum policy, organization and museology. Book reviews.

105 *Muzealnictwo* (Museology). Warsaw: Ośrodek Dokumentacji Zabytków, 1952–. Annual. Pl. (sometimes summaries in Fr.)
Theoretical and methodological problems of museology. History and activities of individual museums. Notes on important museological events in Poland and elsewhere.

106 *Muzei i Pametnitsi na Kulturata* (Museums and Monuments of Culture). Sofia: Komitet po Kulturata i Izkustvoto, 1961–. Quarterly. Bu. (summaries in En. Fr. De.)
Bulgarian cultural history, archaeology and ethnography; museum organization; historical preservation and restoration; news and reports of meetings and conferences. Book reviews.

107 *Muzejní a Vlastivědná Práce* (Museums and Local Studies) (formerly: *Časopis Společnosti Přátel Starožitností* (1893–1962)). Prague: Národní Muzeum – Ústřední Muzeologický Kabinet, 1963–. Quarterly. Cz. (summaries in Ru. De. En.) Cumulative index: vols. 1–70 (1893–1962) in 1971 vol.
History of Europe, with emphasis on Czechoslovakia and its successor states, regional problems and museology. News of meetings and conferences. Reports of museum activities and exhibitions. Book reviews.

108 *Muzejní Práce* (Museum Studies). Prague: Národní Muzeum – Ústřední Muzeologický Kabinet, 1957–. Annual. Cz.
Articles on various museum activities, e.g. conservation, preparation, scientific processes.

109 *Múzeum: Metodický, Študijný a Informačný Materiál pre Pracovníkov Múzeí a Galérií* (Museum: Guidance, Information and Study Bulletin for Museum and Art Gallery Workers). Bratislava: Muzeologické Informačné Centrum, 1953–. Quarterly. Sl. (summaries and contents list in En. Fr. De. Ru.) Cumulative index: 1953–85.
General museums journal with a range of museum topics: history of Czech and Slovak museums, essays on museology, articles on museums abroad, reviews

of recent exhibitions in Czech and Slovak museums, reviews of museological literature, details of Czech and Slovak museum workers.

110 *Ndiwula.* Blantyre (Malawi): Museums of Malawi, 1989–. Annual. En. Articles on developments, research work and museum practice in the museums of Malawi.

111 *Neues Museum: die österreichische Museumszeitschrift* (formerly: *Mitteilungsblatt der Museen Österreichs* (1952–89)). Vienna: Österreichischer Museumsbund, 1989–. Quarterly. De. Cumulative index: vols. 1–20 (1952–71) and supplements 1–8 as supplement 9.
Covers various aspects of museum work (education, conservation, architecture, etc.) and recent developments in the museum field. Reports on important exhibitions, conferences and awards. Book reviews.

112 *New Zealand Museums Journal* (formerly: *AGMANZ Journal* (1984–91), *AGMANZ News* (1969–84) and *AGMANZ Newsletter* (1954–69)). Wellington (New Zealand): Art Galleries and Museums Association of New Zealand, 1991–. Twice a year. En.
Articles on New Zealand museums and museological issues in general. Reviews of exhibitions. Book reviews.

113 *Reinwardt Studies in Museology.* Leiden: Reinwardt Academie, 1983–. Annual. En.
Each vol. covers a particular theme, e.g. exhibition design as an educational tool (1983); policy (1984); the management needs of museum personnel (1985); management and organization (1986); four evaluation studies in Leiden museums (1987).

114 *Revista Muzeelor* (Review of Museums). Bucharest: Ministerul Culturii, 1964–. Ten times a year. Rm. (summaries in En. Fr. Ru.)
Articles on museums and museum education. Book reviews.

115 *Revue du Louvre: La Revue des Musées de France.* Paris: Réunion des Musées Nationaux, 1951–. Every two months. Fr. Summaries in En. and De.
A review of multidisciplinary research and publishing, and work done by archaeologists and art historians on works belonging to French public collections. Also gives information about activities of French museums: acquisitions, exhibitions, creations, new arrangements.

116 *SAMAB (Southern African Museums Association Bulletin).* Port Elizabeth: Southern African Museums Association, 1936–. Quarterly. En. Af.
A forum for the discussion of all aspects of museology, with particular but not exclusive reference to Southern Africa. 'Notes and news'. Book reviews.

117 *Science and Industry Curators Group – Newsletter* (formerly: *Group for Scientific, Technical and Medical Collections – Newsletter* (1983–7)). Science and Industry Curators Group, 1987–. Three times a year. En.
Articles, reports of meetings, exhibition reviews, forthcoming events, etc. Book reviews.

118 *Social History Curators Group Journal* (formerly: *Group for Regional Studies in Museums – Newsletter* (1975–82). Social History Curators Group, 1982–. Annual. En. Cumulative index to *GRSM Newsletter/SHCG Journal* nos. 1–11 (1975–83).
Articles on social history museums. No. 12 (Dec. 1984) reprinted bibliographies and sources (which had previously appeared in earlier issues) for a diverse range of trades and agriculture. Book reviews.

119 *Social History Curators Group News*. Social History Curators Group, 1982–. Three times a year. En.
Notes and news. Forthcoming meetings and other events. List of new publications.

120 *Sovetskii Muzei/Soviet Museum*. Moscow: Ministerstvo Kul'tury SSR i Akademiia Nauk SSR, 1983–. Every two months. Ru. (contents in En. Fr.)
Articles on museums in the Soviet Union and its successor states, museums elsewhere, new exhibitions, etc. News from ICOM; news from abroad.

121 *Spectra*. East Winthrop (Maine): Museum Computer Network, Inc., 1974–. Quarterly. En.
Newsletter concerned specifically with computer applications in museums. News of coming events. 'Publications noted'.

122 *Studies in Conservation: Journal of the International Institute for Conservation of Historic and Artistic Works*. London: International Institute for Conservation of Historic and Artistic Works, 1952–. Quarterly. En. Fr. Cumulative indexes (author; title; classified; book reviews (authors; titles; reviewers)): vols. 1–12 (1952–67); vols. 13–22 (1968–77).
Original work and reviews on advances in conservation and restoration, covering both practical and scientific aspects, together with technical research on materials and methods of fabrication. Includes abstracts of its own papers. Book reviews.

123 *Studies in Museology*. Baroda (India): University of Baroda, Department of Museology, 1965–. annual. En.
Articles on museum philosophy and practice relating to India. Book reviews.

124 *Svenska Museer*. Stockholm: Svenska Museiföreningen, 1932–. Quarterly. Sw. Cumulative indexes: 1932–41; 1942–51; 1952–81.
Articles on Swedish museums.

125 *Transport Museums: Yearbook of the International Association of Transport Museums*.
Wrocław: Ossolineum, Publishing House of the Polish Academy of Sciences,
1974–. Annual. En.
Articles on transport museums. Includes papers and discussions from the annual
meeting of the Association.

126 *Visitor Behavior*. Jacksonville (Alabama): Psychology Institute of Jacksonville
State in co-operation with the Anniston Museum of Natural History and the
International Laboratory for Visitor Studies, 1986–. Quarterly. En.
Articles, bibliographies and notes on visitor behaviour in museums. Abstracts
from annual Visitor Studies Conference. Book reviews.

127 *VMS/AMS: Mitteilungsblatt des Verbandes der Museen der Schweiz/Bulletin d'Infor-
mation de l'Association des Musées Suisses/Bolletino d'Informazione dell'Associazione dei
Musei Svizzeri*. Basel: Verband der Museen der Schweiz, 1967–. Twice a year.
De. Fr. It.
Articles and information on Swiss museums. Calendar of exhibitions.

128 *Výročné Správy o Činnosti Slovenských Múzeí a Galérií* (Annual Reports on
Activities of Slovak Museums and Galleries). Bratislava: Muzeologické
Informačné Centrum. 1966–. Annual. Sl.
Annual reports of Slovak museums and galleries.

GUIDES TO THESES

129 *Comprehensive dissertation index*. Ann Arbor (Michigan): University Micro-
films International, 1973–. Annual.
Definitive unannotated list of North American doctoral theses. The original *CDI
1861–1972* lists over 417,000 dissertations, arranged by subject and author. *The
CDI ten-year cumulation 1973–1982* lists nearly 351,000 dissertations, and *The CDI
five-year cumulation 1983–1987* lists over 162,000 dissertations. Available online
through BRS (File DISS) and DIALOG as DISSERTATION ABSTRACTS
ONLINE. Annual supplements are produced. Dissertations on aspects of
museum studies can be traced through the keyword indexes. Entries include
references to *Dissertation abstracts international* [130] where abstracts of individual
dissertations appear.

130 *Dissertation abstracts international*. Ann Arbor (Michigan): University Micro-
films International, 1938–. Monthly.
Abstracts of doctoral dissertations submitted to University Microfilms by
over 500 institutions in North America and some European ones. Most North
American universities co-operate in the scheme, but the number of European
universities, especially Eastern European, is still relatively small. In three

sections – A: *Humanities and social sciences*; B: *Sciences and engineering*; C: *Worldwide abstracts*. Author index (cumulates annually); keyword index. Available online through BRS (File DISS) and DIALOG as DISSERTATION ABSTRACTS ONLINE.

A retrospective index (9 vols., 1970) covers vols. 1–29 (1938–69). First 8 vols. are arranged by subject; theses on aspects of museum studies can be traced under appropriate keywords. Vol. 9 is a cumulative author index.

131 Dockstader, F.J. Graduate studies relating to museums: a tentative bibliography, 1919–1978. *Museum News* [95], 58 (1979), 77–83, 88.
Unannotated list of 123 theses from 50 United States institutions. Arranged alphabetically by author.

132 *Index to theses with abstracts accepted for higher degrees by the universities of Great Britain and Ireland and the Council for National Academic Awards*. London: Aslib, 1950/1– (publ. 1953–). Twice a year.
Excludes higher degrees awarded solely in respect of published work or dissertations submitted in partial fulfilment of the requirements for a higher degree in conjunction with a written examination. Includes abstracts from vol. 35 (1986) onwards. Arranged under broad subject headings. Subject index; author index.

Preceded by *Retrospective index to theses of Great Britain and Ireland 1716–1950* (Santa Barbara (California): American Bibliographical Center – Clio Press, 1975–7. 5 vols. + an addenda issue), which lists theses under subject headings. Each vol. includes an author index.

133 Museum studies thesis index. *Museum Studies Journal*, 1: 2 (1983), 65–70.
Unannotated list of *c*. 150 theses from eight United States educational institutions, produced by graduate students in museum studies programmes. Arranged alphabetically by institution.

MONOGRAPHS

General manuals

134 Adams, G. *Museums and galleries: a teachers' handbook*. London: Hutchinson Education, 1989. 222 pp. Select booklist: pp. 194–8.
Handbook giving information and advice on making arrangements for school parties visiting museums. Includes a directory, alphabetically arranged, listing all major museums and galleries in the London area along with local history museums and houses. Useful addresses. Index of museums and galleries; index of reference libraries in museums and galleries.

135 Lewis, R. H. *Manual for museums.* Washington (DC): National Park Service, 1976. 425 pp. Bibliography of park and countryside museums: pp. 390–3. Extensive bibliogs. at the end of individual chapters.

Intended primarily as an in-house manual for the museums administered by the United States National Park Service. Has wide application, however, and may be regarded as one of the most comprehensive general museological reference works. The manual is in 4 parts – 'Museum collections', 'Museum records', 'Furnished historic structure museums' and 'Exhibit maintenance and replacement'. The 8 appendices refer specifically to USNPS procedures.

136 *Museumshåndboka* (Museum handbook). Oslo: Norske Kunst- og Kulturhistoriske Museer, Norske Naturhistoriske Museers Landsforbund, 1980. Updated by supplements.

A handbook in 10 chapters covering all aspects of museum work; for use in museums of social history, art and natural history.

137 Thompson, J. M. A. and others (eds). *Manual of curatorship: a guide to museum practice.* 2nd ed. London: Butterworth-Heinemann, 1992. 772 pp. References and/or bibliographies to each chapter.

Comprehensive reference work on the management and administration of museums, founded on museum practice in the UK but of relevance to museums worldwide. Contributions from 70 museum professionals and professionals providing services to museums. Of relevance to museum staff, governing bodies and supporting organizations.

Arranged in 5 sections: the museum context; management and administration; conservation; collections research; user services. Appendix: Code of conduct for museum professionals.

138 United States Department of the Interior National Park Service. *NPS Museum Handbook, Part 1 – Museum collections.* 1990. Looseleaf. Selected bibliography for each chapter.

A looseleaf manual intended for use within the United States National Park Service with chapters on 'NPS museums and collections'; 'Scope of museum collections'; 'Preservation – getting started'; 'Museum collections environment'; 'Biological infestations'; 'Handling, packing and shipping'; 'Museum collections storage'; 'Conservation treatment'; 'Security and fire protection'; 'Emergency planning'; 'Curatorial health and safety'; 'Programming funding, and staffing'. Sixteen appendices dealing with internal administrative procedures, codes of ethics, and curatorial care of different categories of object. Appendix.

Museum context

139 Abbey, D. S. and **Cameron, D. F.** *The museum visitor: 1 – survey design; 2 – survey results; 3 – supplementary studies.* Toronto: Royal Ontario Museum,

1959–61. 3 vols (12 pp., 38 pp. and 16 pp.) (Reports from Information Services, 1, 2, 3.)
Reports the results of a survey of visitors at the Royal Ontario Museum, Toronto, Canada, during 1958–9. Provides an analysis of the visitors' age, sex, domicile, occupation, education, interests and pattern of visitation.

140 Adam, T. R. *The museum and popular culture.* New York: American Association for Adult Education, 1939. 186 pp. (Studies in the Social Significance of Adult Education in the United States, 14.)
Historically important as an early attempt to evaluate the role of specific types of American museum activity in the diffusion of learning among the adult population.

141 Alexander, E. P. *Museum masters: their museums and their influence.* Nashville (Tennessee): American Association for State and Local History, 1983. 438 pp. Notes and select bibliography at the end of each chapter.
Provides a study of 12 eminent museum 'masters' who have been most influential in establishing the present-day pattern of museums. The 12 masters are Sir Hans Sloane (British Museum), Charles Willson Peale (Philadelphia Museum), Dominique Vivant Denon (Louvre), William Jackson Hooker (Royal Botanic Gardens, Kew), Henry Cole (Victoria and Albert Museum), Ann Pamela Cunningham (Mount Vernon), Wilhelm Bode (Berlin Museums), Artur Hazelius (Skansen, Sweden), George Brown Goode (Smithsonian Museums), Carl Hagenbeck (Stellingen Zoo, Hamburg), Oskar von Miller (Deutsches Museum) and John Cotton Dana (Newark Museum).

142 Alexander, E. P. *Museums in motion: an introduction to the history and functions of museums.* Nashville (Tennessee): American Association for State and Local History, 1979. 320 pp. Some basic museum books: pp. 284–92.
Examines the rise of museums since the 18th century in the fields of art, natural history, science and technology, history, botanic gardens and zoos, with emphasis on US museums. Defines the chief functions of museums from the traditional collection, conservation and research to exhibition, interpretation and services to the community. A final chapter surveys the museum profession today.

143 Ambrose, T. (ed.) *Working with museums.* Edinburgh: HMSO, 1988. 96 pp.
A collection of 5 papers presented at a Scottish Museums Council conference in Edinburgh in 1987. The focus is on museums working with other institutions and organizations, including tourism, industry, contemporary arts, universities and education.

144 American Association of Museums. *America's museums: the Belmont report: a report to the Federal Council on the Arts and the Humanities*, by a special committee of the American Association of Museums: [editor M. W. Robbins]. [Washington (DC)]: American Association of Museums, 1969. 99 pp.

A report prepared by the American Association of Museums and commissioned by the Federal Council on the Arts and the Humanities to respond to the questions: What is the present condition of America's museums? What are their unmet needs? What is the relationship between American museums and other educational and cultural institutions? The report recommended that the National Museum Act be funded with an appropriation of at least $1 million for the first year, that grants to museums from federal departments and agencies already concerned with museums be sharply increased, that the federal government recognize museums as educational institutions, and that the Federal Council on the Arts and the Humanities be asked to study the problems of museums further and make recommendations with reference to existing legislation. Appendices.

145 American Association of Museums. *Data report from the 1989 National Museum Survey*. Washington (DC): American Association of Museums, 1992. 255 pp. + appendices.

The report states that the Data Report of the 1989 National Museum Survey is the beginning of a commitment by the American Association of Museums to a long-term programme of gathering information about US museums. Funds for the survey were provided by the Institute of Museum Services, the National Endowment for the Arts, the National Endowment for the Humanities, and the National Science Foundation together with grants from private foundations and corporations. The aim of the survey was to produce an accurate, reliable survey; to provide useful data to the museum community; to develop common vocabulary and working definitions; to increase an individual museum's sophistication in describing itself and comparing itself to similar institutions; to increase AAM's sophistication in collecting, organizing and disseminating this type of information; to respond to a broader museum community agenda. The survey looked at 5 general areas of museum operations: organizational structure and legal information; administration (facilities, security, physical access, personnel); collections and research (collections, care and maintenance, conservation, research); public activities and audience (attendance and admissions, exhibitions, public programmes, publications and products); and finances, development and membership.

Section 1 describes the background to the survey and the methodology. Section 2 provides an analysis of those museums which were not considered eligible. Section 3 is made up of data tables and figures. Appendices include a copy of the survey document and letter, a list of museums completing the questionnaire, and copies of follow-up letters and phone materials.

146 American Association of Museums. Commission on Museums for a New Century. *Museums for a new century*. Washington: American Association of Museums, 1984. 143 pp.

Report of a commission set up to explore the current social, economic, political and science trends that will affect the future of US museums; to identify trends

in the operations and needs of museums; and to describe the resulting oppor-
tunities and responsibilities facing the museum community.

147 Ames, M. M. *Cannibal tours and glass boxes: the anthropology of museums.*
2nd ed. Vancouver: UBC Press, 1992. 229 pp. Bibliography: pp. 175–201.
Originally published as *Museums, the public and anthropology.*
A collection of essays examining the role of anthropology museums, and in
particular the relationship between museums, the public and anthropology.

148 Auer, H. (ed.) *Museologie: neue Wege – neue Ziele: Bericht über ein internationales
Symposium, veranstaltet von den ICOM-Nationalkomitees der Bundesrepublik Deutsch-
land, Österreichs und der Schweiz vom 11. bis 14. Mai 1988 am Bodensee.* Munich:
Saur, 1989. 289 pp.
Proceedings of a conference of a joint meeting of the ICOM National Committees
of the Federal Republic of Germany, Austria and Switzerland. Explores the
nature of museology; the origins of museology, its principles and theory; current
research methods; and available training and research facilities.

149 Bazin, G. *The museum age* (transl. from the Fr. by J. van Nuis Cahill).
Brussels: Desoer, [1967]. 302 pp. (L'art témoin.)
The first work devoted to the study of museums in civilizations throughout the
world from Antiquity to the present day.

150 Bourdieu, P., Darbel, A. and **Schnapper, D.** *The love of art: European art
museums and their public.* (transl. from the Fr. by C. Beattie and N. Merriman).
Cambridge: Polity Press, 1991. 190 pp. Select bibliography: pp. 174–5.
(Originally published as *L'amour de l'art: les musées d'art européens et leur public*
(France, 1969).)
A classic study, first published in French in 1969. Reports a wide-ranging survey
of museum visitors throughout Europe which attempts to find out who goes to
museums and why, and what distinguishes them from the majority of people
who do not visit. Chapter headings: 'Signs of the times'; 'The research process';
'The social conditions of cultural practice'; 'Cultural works and cultivated
disposition'; 'The rules of cultural diffusion'; and 'Conclusion'. Appendices
include: timetable of research; the questionnaires and the sampling method; the
public of French museums; verificatory surveys; analysis of 250 semi-directed
interviews; and the public of European museums.

151 Boylan, P. J. (ed.) *Museums 2000: politics, people, professionals and profit.*
London: Museums Association in conjunction with Routledge, 1992. 211 pp.
(The Heritage. Care – Preservation – Management.)
Report of a Museums Association conference in May 1989. Includes an intro-
duction by Patrick J. Boylan on 'Museums 2000 and the future of museums',
the opening address by HRH the Duke of Gloucester, and 8 papers under

the headings 'Politics and museums'; 'People and museums'; 'Professionals and museums'; and 'Profit and museums'.

152 Burcaw, G. E. *Introduction to museum work.* 2nd ed. rev. and exp. Nashville (Tennessee): American Association for State and Local History, 1983. 216 pp. Recommended resources: pp. 201–6.

Designed as an introductory text for students embarking on a career in museums and for the museum worker with no prior training, and as a general introduction to the museum profession. Emphasis on the USA. Intended to supplement available publications which deal with museums, museum work and museum theory.

153 Butler, S. V. F. *Science and technology museums.* Leicester: Leicester University Press, 1992. 162 pp. (Leicester Museum Studies Series.) Bibliography: pp. 137–46.

Looks at science and technology museums throughout the world, exploring some of the issues which confront museum professionals in such museums. Contents: 'Science and technology on display'; 'Monuments to manufacture'; 'Museums around the world'; 'The heritage phenomenon'; 'Uncommon classrooms'; 'Frameworks of knowledge'; 'The challenge of the new century'. Appendix of useful addresses (a brief catalogue of most of the major types of institutions presenting exhibitions relating to science, technology and industry).

154 Cato, P. S. and **Jones, C.** (eds.) *Natural history museums: directions for growth.* Lubbock (Texas): Texas Tech University Press, 1991. 256 pp. Literature cited at the end of chapters.

Papers presented at a symposium 'New directions and professional standards for natural history museums' organized by Mountain–Plains Museums Association and the Midwest Museums Conference in Kansas City in 1988.

155 Committee of Inquiry on Museums and National Collections. *Museums in Australia, 1975: report of the Committee of Inquiry on Museums and National Collections* [chairman: P. H. Pigott]; *including the report of the Planning Committee on the Gallery of Aboriginal Australia.* Canberra: Australia Government Publishing Service, 1975. 154 pp.

Report of a committee of inquiry on museums and national collections in Australia together with a report of the Planning Committee on the Gallery of Aboriginal Australia. Makes recommendations for a national policy and organization at national level.

156 Dixon, B., Courtney, A. E. and **Bailey, R. H.** *The museum and the Canadian public/Le musée et le public canadien*; ed. by J. Kettle; transl. by R. Desmeules. Toronto: Culturcan Publications for Arts and Culture Branch, Dept. of the Secretary of State, Government of Canada, 1974. 381 pp. En. Fr.

A classic study on the museum visitor in Canada which places museum visiting in the context of other cultural and leisure activities, including cinema, concerts, theatre, reading, sport and hobbies, and visits to zoos, historic sites and conservation areas. Investigates attitudes to leisure activities, patterns of museum visiting and the image of museums, and includes suggestions for improvements to museums.

157 Durant, J. (ed.) *Museums and the public understanding of science.* London: Science Museum in association with the Committee on the Public Understanding of Science, 1992. 109 pp. Notes and references at the end of some chapters.
Nineteen short papers, published in preparation for an international conference held at the Science Museum, London, in April 1992. Arranged in sections – Introduction; Looking forward; The role of the museum; Educational and other programmes; Current practice; Visitor centres. Contributors drawn from Britain, the USA and France.

158 Edwards, R. and **Stewart, J.** (eds.) *Preserving indigenous cultures: a new role for museums.* Papers from a regional seminar, Adelaide Festival Centre, Sept. 1978. Canberra: Australian Government Publishing Service, 1980. 237 pp.
Papers presented at a regional seminar at the Adelaide Festival Centre in September 1978. Focuses mainly on aboriginal and Pacific cultures.

159 George, G. *Visiting history: arguments over museums and historic sites.* Washington (DC): American Association of Museums, 1990. 118 pp.
Essays exploring the purpose and significance of history museums and historic sites and the experiences they provide.

160 Gluziński, W. *U podstaw muzeologii* (At the bases of museology). Warsaw: Państwowe Wydawnictwo Naukowe, 1980. 451 pp. Bibliography: pp. 399–407.
Discusses the methodological basis of museology.

161 Greenwood, T. *Museums and art galleries.* London: Simpkin, Marshall and Co., 1888. 447 pp.
An early treatise on museums focusing on the role of museums in society. Covers many diverse topics, including Sunday opening, the classification and arrangement of objects, commercial museums, museums in America and museums in Germany, France and other European countries. Appendices include the British Acts of Parliament relevant to museums and libraries. Black and white illustrations.

162 Hein, H. *The Exploratorium: the museum as laboratory.* Washington (DC): Smithsonian Institution Press, 1990. 278 pp.
Tells the story of the Exploratorium, founded in San Francisco in 1969 by Frank

Oppenheimer, which has become a model for museums and science centres throughout the world.

163 Heinonen, J. and **Lahti, M.** *Museologian perusteet* (Basic museology). Helsinki: Suomen museoliito, 1988. 340 pp. Fi. (Suomen museoliiton julkaisuja.)
Basic book on museology. Theoretical study on the museum's role and objectives. A commentary on the museological debate in recent years is followed by an evaluation of today's museology and museography, especially in Finland. Emphasis on acquisition documentation, conservation and exhibition.

164 Hooper-Greenhill, E. *Museums and the shaping of knowledge*. London: Routledge, 1992. 241 pp. (The Heritage. Care – Preservation – Management.)
A critical survey of the changes in assumptions about the nature of museums over 6 centuries. Reveals a variety of different roles for museums in the production and shaping of knowledge.

165 Hudson, K. *Museums for the 1980s: a survey of world trends*. London: UNESCO and Macmillan, 1977. 208 pp. List of publications likely to be helpful: pp. 180–4.
Describes and evaluates the changes in theory and practice which might characterize the museum world in the 1980s. Illustrated by a series of examples of the most original, most forward-looking and most constructive views and their applications on a worldwide basis. Chapters on the museum's resources, conservation, museum buildings, the museum and its visitors, selection and training of personnel, and museum management. Glossary.

166 Hudson, K. *Museums of influence*. Cambridge: Cambridge University Press, 1987. 228 pp. Works consulted: pp. 201–5.
Reviews the development of museums worldwide by identifying 37 pioneer museums in 13 countries – museums which have broken new ground in such an original or striking way that other museums have followed their example.

167 Hudson, K. *1992 Prayer or promise?: the opportunities for Britain's museums and the people who work in them*. London: HMSO for Museums and Galleries Commission, 1990. 79 pp.
Examines the legal, commercial and professional implications of the Single European Act which came into operation on 31 December 1992. Brief details are given of the organization and financing of museums in the European Community's member states (Belgium, Denmark, France, Germany, Greece, Ireland, Italy, Luxembourg, Netherlands, Portugal, Spain, United Kingdom).

168 Hudson, K. *A social history of museums – what the visitors thought*. London and Basingstoke: Macmillan, 1975. 210 pp. List of books and articles consulted: pp. 197–204.

Discusses the social history of museums with an introduction 'The changing idea of a museum' and 5 chapters on entry as a privilege, entry as a right, museums as educational instruments, arrangement and communication, and museums in the market research age. Appendices include published reports of surveys of museum visitors; Milwaukee Public Museum questionnaire 1964; Museum of Non-Objective Painting, New York, public comments; German Federal Republic museum questionnaire 1971.

169 Impey, O. and **MacGregor, A.** (eds.) *The origins of museums: the cabinet of curiosities in sixteenth and seventeenth century Europe.* Oxford: Clarendon Press, 1985. 348 pp. Bibliography: pp. 281–312.
Thirty-three papers from an international symposium held at the Ashmolean Museum, Oxford, in 1983. Papers 1–20 deal with individual collections or with series of collections demonstrating various forms of cabinets of curiosities; 21–26 examine various categories of material which were common to the majority of curiosity collections; 27–33 are concerned with the sources of exotic material which are analysed according to their geographical derivation.

170 International Council of Museums. *The museum and the modern world/Le musée et le monde moderne.* Papers from the Tenth General Conference of ICOM, Copenhagen, 1974. Paris: ICOM, 1975. 123 pp. Some papers in Fr.
Papers discuss the integration of the museum into contemporary society and the various roles it could play in the future.

171 International Council of Museums. *Museums and cultural exchange/Musées et échanges culturels.* Papers from the Eleventh General Conference of ICOM, Moscow, 1977. Paris: ICOM, 1979. 156 pp. Some papers in Fr.
Papers on ICOM'S role in developing international contacts between museums; international museum exchanges as an instrument of mutual enrichment between cultures; and the protection of cultural and natural heritage at the international level.

172 International Council of Museums. *The world's heritage – the museum's responsibilities.* Proceedings of the Twelfth General Conference and Thirteenth General Assembly of ICOM, Mexico City, 1980; [eds: A. Bochi and S. de Valence]. Paris: ICOM, 1981. 188 pp.
Papers consider the role of museums in relation to the documentation and presentation of the world's cultural heritage.

173 International Council of Museums. *Museums for a developing world.* Proceedings of the Thirteenth General Conference and Fourteenth General Assembly of ICOM, London, 1983. Paris: ICOM, 1984. 160 pp.
Includes papers relating to the role of museums in a developing world, including inequality of museum provision, the demands placed upon museums by their

users, museums and cultural identity, contemporary collecting, public access, museum management and the financing of museums.

174 International Council of Museums. *Museums and the future of our heritage: emergency call.* Proceedings of the Fourteenth General Conference and Fifteenth General Assembly of ICOM, Buenos Aires, 1986. Paris: ICOM, 1989. 113 pp.

175 International Council of Museums. *ICOM '89 Museums: generators of culture: reports and comments.* Proceedings of the Fifteenth General Conference of ICOM, The Hague, Netherlands, 1989. The Hague (Netherlands): The ICOM Foundation, 1991. 75 pp.

176 Kavanagh, G. *History curatorship.* Leicester: Leicester University Press, 1990. 201 pp. (Leicester Museum Studies Series.) Bibliography: pp. 174–81. Aimed at graduates training for the museums profession but also of interest to history curators and people with an interest in museums. Presents theoretical and methodological frameworks for professional history curatorship. Explores the background to curatorship and ideas which inform museum work. In 3 parts: 'History museums: past and present'; 'History curation; theories and methods'; 'History in the museum: exhibitions and the public'.

177 Kavanagh, G. (ed). *The museums profession: internal and external relations.* Leicester: Leicester University Press, 1991. 184 pp. Bibliographies at the end of each chapter.
Arises from a conference held at the Department of Museum Studies, University of Leicester, in April 1990, entitled 'Breaking new ground'. Discusses the profession, museum tradition and culture, marketing, performance standards, museums and the economy, and the place of theory in museum activities. A companion volume to [330].

178 Key, A. F. *Beyond four walls: the origins and development of Canadian museums.* Toronto: McClelland and Stewart, 1973. 384 pp. Bibliography: pp. 366–73. Chapters on the origins of museums are followed by a definitive history of Canadian museums from early colonial times. Traces the way in which Canadian museums have been influenced by social, religious and political events, including Canada's Centennial. Attempts a complete list of Canadian museums, historic sites, archives, art galleries and related institutions.

179 Lewis, G. D. Museums. In: P. W. Goetz (ed.-in-chief), *The New Encyclopaedia Britannica*, 15th ed., vol. 24, pp. 478–90. Chicago: Encyclopaedia Britannica Inc., 1987. Bibliography: p. 490.
Article summarizing various aspects of museums. Discusses the precursors of museums, and the establishing of museums; the types of museum (i.e. general, art, etc.); and the museum operation (i.e. the organization of museums, legal arrangements, conservation, etc.).

180 Loomis, R.J. *Museum visitor evaluation: new tool for management.* Nashville (Tennessee): American Association for State and Local History, 1987. 320 pp. Bibliography: pp. 285–300.
A general text and reference book on museum visitor evaluation. Discusses the nature of visitor evaluation and its relationship to management. Chapters on evaluating attendance; surveys; evaluation, marketing and audience development; visitor orientation; exhibit evaluation; and using evaluation to improve programmes.

181 Lumley, R. (ed.) *The museum time machine: putting cultures on display.* London and New York: Routledge, 1988. (A Comedia Book.) 250 pp. Notes and references at the end of each chapter.
A collection of 10 essays on the role of museums in present-day society. Arranged in three sections: 'The landscape of nostalgia', 'Museums in a changing world', and 'Sociology of the museum public'.
Includes contributions from France and Australia and comparisons with the USA and Canada. Contributors include museum professionals and academics.

182 MacDonald, G.F. and **Alsford, S.** *A museum for a global village: the Canadian Museum of Civilization*: ed. by R.A.J. Philips. Hull (Ontario): Canadian Museum of Civilization, 1989. 241 pp.
Provides a comprehensive and generously illustrated account of the Canadian Museum of Civilization which opened in Ottawa in 1989. The book describes and discusses the underlying philosophy and the process by which the museum was designed, including the dramatic architecture, the new exhibitions, behind-the-scene activities, public services, recreational and educational programmes, plans for national outreach, and the ways in which the museum is marketed. The early chapters represent a valuable overview and digest of museum philosophy and practice on a worldwide scale.

183 Merriman, N. *Beyond the glass case: the past, the heritage and the public in Britain.* Leicester: Leicester University Press, 1991. 200 pp. (Leicester Museum Studies Series.) Bibliography: pp. 177–85.
Revised version of a doctoral dissertation presented to the Department of Archaeology, University of Cambridge. Museums and similar institutions are viewed as one of the principal means by which people can gain access to their past. It is argued that museums should be actively involved in their communities. The book focuses on opening up access to museums. Based on a postal survey of 1,500 adults throughout Britain on the patterns of people's heritage visiting; their attitudes to museums; their image of the past; and on other, non-museum ways in which they experience the past. Chapters 4 and 5 present control data on museums and heritage visiting on a national scale; chapter 6 reviews explanations for museum visiting; chapter 7 is a case study; and chapter 8 discusses non-museum activities. Two appendices give details of the survey.

184 Meyer, K. E. *The art museum: power, money, ethics.* New York: Morrow, 1979.
(A Twentieth Century Fund Report.) 352 pp. Bibliography: pp. 334–44.
A critical assessment of the art museum in America. Examines the origins
of American museums; politics; patronage; architecture; trustees; ethics and
professionalism. Appendices give details of new art museum and visual arts
centre construction from 1950 onwards and a transcript of the report to the
American Association of Museums by its Committee on Ethics (1978).

185 Murray, D. *Museums: their history and their use, with a bibliography and list of
museums in the United Kingdom.* Glasgow: MacLehose, 1904. 3 vols. Vol. I: 353
pp.; vol. II: 363 pp.; vol. III: 341 pp.
An important early account of the history and purpose of museums with valuable
footnotes. Vol. I includes a list of UK museums; vols. II and III comprise a
bibliography of museums – I: literature of museums: bibliography of biblio-
graphies; II: museography; III: the collection, preparation and preservation;
the registration and exhibition of specimens; IV: catalogues and other works
relating to particular museums; V: travels and general literature.

186 *La muséologie selon Georges Henri Rivière: cours de muséologie/textes et témoignages.*
Paris: Dunod, 1989. 402 pp. Bibliography: pp. 371–91.
A commemorative volume which pays tribute to Georges Henri Rivière's
contribution to museology, particularly through his teaching at the University
of Paris between 1970 and 1982. Organized in 4 main sections: 'Musée et
société'; 'Musée et patrimoine'; 'Musée, instrument d'éducation et de culture';
and 'L'institution muséale'. Bibliography includes a chronological list of publi-
cations by Rivière.

187 Pearce, S. M. *Archaeological curatorship.* Leicester: Leicester University Press,
1990. 239 pp. (Leicester Museum Studies Series.) Bibliography: pp. 208–19.
Aimed at practising and prospective archaeologists and curators, and to those
with an involvement in the ways in which museums operate. In 3 parts: contem-
porary context (origins: museums and collections to 1960; development 1960–90;
archaeology, museums and the law; ethics and politics); curating the archive (the
formation of the museum archive; approaches to storage; issues in conservation;
documentation and research); museums, the public and the past (our public;
exhibiting archaeology; open-air sites; reaching out into the community; futures:
AD 2000 and beyond). An appendix lists sources.

188 Pearce, S. M. (ed.) *Museum economics and the community.* London: Athlone
Press, 1991. 225 pp. (New Research in Museum Studies, 2.) Bibliography at
the end of each chapter.
Range of papers focusing on ways in which museums function as economic and
social institutions within their communities. Review section covers recent books,
exhibitions and conferences.

189 Pearce, S.M. (ed.) *Museum studies in material culture.* Leicester: Leicester University Press, 1989. 180 pp. Bibliography at the end of each chapter.

Series of papers on a number of different issues of critical concern to museology, given at a conference marking the 21st anniversary of the Department of Museum Studies at the University of Leicester.

190 Pearce, S.M. *Museums, objects and collections: a cultural study.* Leicester: Leicester University Press, 1992. 307 pp. Bibliography: pp. 274–87.

Explores the nature of museums, their collections and the objects which form these collections, and looks at the psychological and social reasons why people collect and the nature of relics, fetishes and systematic assemblages. Considers the nature of the curatorial process and the narratives it produces – collections in store, acquisition and disposal, documentary description and exhibition. Discusses how museum objects operate as signs and symbols, as mediators of a functionalist perspective in a world of goods, and as actors in the process of change. Examines the relationship between museums, museum objects and ideology, and concludes with an attempt to define the curatorial project.

191 Pearce, S.M. (ed.) *Objects of knowledge.* London: Athlone Press, 1990. 245 pp. (New Research in Museum Studies, 1.) Bibliography at the end of each chapter.

Range of papers discussing the ways in which meaning is created through museum objects, and the processes which this involves. Some papers take a broadly theoretical line; others examine specific areas such as museum education and the relationship of museums to native peoples. Review section covers recent books, exhibitions and conferences.

192 Phelan, M. *Museums and the law.* Nashville (Tennessee): American Association for State and Local History, 1982. 298 pp. (AASLH Management Series, vol. 1.) Selected bibliography: pp. 280–1.

A simple and concise guide to the law relating to museum organization in the USA. Useful introductory chapter on the organizational structure of US museums. Covers the law relating to tax; legal liability of museums; artists' rights; museum acquisitions; employee relations; and duties of directors and trustees. Eight appendices. Glossary of legal terms; table of selected cases; table of statutes.

193 *Profile of black museums: a survey commissioned by the African American Museums Association.* Washington (DC): African American Museums Association and American Association for State and Local History, 1988. 69 pp.

Reports a survey of 52 black museums in 23 US states and Canada, providing information on type; location; budget; staff; type of administration; physical facilities; collections; visitors; exhibits; AAMA support; accreditation; accessibility; planning and areas of need. Recommendations for future action.

194 Schiele, B. (ed.) *Faire voir, faire savoir: la muséologie scientifique au présent.*
Montreal: Musée de la Civilisation, 1989. 155 pp.
Proceedings of a 1989 symposium held at the University of Quebec, Montreal,
on the evolution of the science museum and the evaluation of scientific exhibi-
tions, more particularly in a social and communication context.

195 Teather, J.L. Museology and its traditions: the British experience,
1845–1945. PhD thesis, University of Leicester, 1983. 447 pp. Selected biblio-
graphy: pp. 403–47.
Examines theoretical concepts in museology, using the historical evidence of
the museum scene in Britain from 1845 to 1945.
 Part I: 'The museological background' sets the theoretical problem, explaining
the current stage of museological thought, and suggests a role for the history of
museums and museology in the epistemological definition of museology.
 Part II: 'The museological tradition in Britain, 1845–1945' considers the
British scene, beginning with evidence of museum and museological prototypes
in Britain and Europe up to 1845, then examining the numbers, types and growth
patterns of museums, legislation and funding levels, from 1845 to 1945. Next,
the museum staff are analysed in terms of museum jobs, training, status, profes-
sionalization and the control of expertise built on a basis of knowledge and skill.
The content and underlying problems in the 'body of knowledge' of museological
thought are identified under three headings: (1) the views of the museum's role;
(2) the experience of the visitor; (3) the experience of the object.
 Part III: 'Museological conclusions' summarizes the findings to formulate
conclusions for museological theory. The thesis attempts to rediscover aspects of
the long tradition of museum work along with characteristic weaknesses. It argues
that the fundamental problem is the conceptual base of thought about museums,
which remains pragmatic and experiential often without factual corroboration.
 Includes a partial list of relevant British graduate theses on museums (appendix
I); a chronological listing of societies and their museums (appendix III); and
building dates of museums in Britain and dates of museums in historic buildings
(appendix IV).

196 van Mensch, P. (ed.) *Professionalising the muses: the museum profession in motion*;
essays by A.G. Ballestrem and others. Amsterdam: AHA Books, 1989. 163
pp. (Discours, 11.) Literature: pp. 159–63.
Eight essays which look at professional aspects of museum work, including the
role of the curator, the educator and the conservator; interdisciplinarity; profes-
sional organizations; museum training; museum ethics; and trends and the
future. Appendices: the ICOM code of professional ethics, and criteria for
examining professional museum studies programmes.

197 van Zoest, R. (ed.) *Generators of culture: the museum as a stage.* Amsterdam:
AHA books – Art History Architecture, 1989. 121 pp. (Discours, 1.)

A collection of essays on various museum issues, such as funding, return and restitution, display, and the museum's public role and research tasks.

198 Vergo, P. (ed.) *The new museology*. London: Reaktion Books, 1989. 238 pp.
A compilation of 9 critical essays on museum history, theory and practice aimed at improving the understanding of the purpose and direction of museums. Select bibliography and index.

199 Weil, S.E. *Beauty and the beasts: on museums, art, the law and the market.* Washington (DC): Smithsonian Institution Press, 1983. 272 pp.
A collection of 19 essays and speeches by the deputy director of the Hirshhorn Museum and Sculpture Garden of the Smithsonian Institution, written since 1971. Essays 1–6 examine the present-day role of museums, the crises they face and how they might be better managed. Essays 7–12 discuss legal aspects of museums, and essays 13–19 the relationship between museums and the art market. Relates mainly to museums in the USA.

200 Weil, S.E. *Rethinking the museum and other meditations*. Washington: Smithsonian Institution Press, 1990. 191 pp.
Nineteen essays examining the purposes and function of museums in the late 20th century, some of which have been published earlier. The essays explore how museums can better function to serve the larger society, and cover a number of management issues, including the refinement and upgrading of collections, how museum workers ought to be trained, how directors should be chosen, and some legal aspects of museum administration. Relates mainly to museums in the USA.

201 *What museums for Africa? Heritage in the future: proceedings of the Encounters*. Paris: ICOM, 1992. 461 pp. Bibliography: pp. 411–41.
Papers given at a series of meetings in Benin, Ghana and Togo, summarized in the final report.

202 Wittlin, A.S. *The museum, its history and its tasks in education*. London: Routledge and Kegan Paul, 1949. 312 pp. (International Library of Sociology and Social Reconstruction.) References and notes at the end of each chapter.
Standard work on the history of museums. Thorough analysis of the background to the establishment of early private museums and an account of the growth of public museums up to the outbreak of the Second World War. Extensive notes.

203 Wittlin, A.S. *Museums: in search of a usable future*. Cambridge (Massachusetts) and London: MIT Press, 1970. 316 pp.
Enlarged, updated and extended version of Wittlin [202], including the period from 1945 to 1970. Includes 12-point plan for museum renewal. Appendix includes facsimiles of early descriptions and accounts of museums. Illustrated.

Collection management

204 Alsford, D. and **Alsford, S.** *Housing the reserve collection of the Canadian Museum of Civilization.* Ottawa: Canadian Museum of Civilization, 1989. 74 pp.
Describes the storage system and related collections management aspects of the new Canadian Museum of Civilization in Ottawa, Canada, and discusses the factors that influenced the design of the new system. Gives details of space, storage furniture, safety and security provisions, environmental conditions, architectural requirements and constraints, and access provisions. Sets new standards for the storage of historical collections.

205 Appelbaum, B. *Guide to environmental protection of collections.* Madison (Connecticut): Sound View Press, 1991. 270 pp.
A reference book intended for individuals without a technical background who care for collections of art, historical artefacts or other kinds of cultural materials, or for natural history collections. Part 1 is concerned with 5 major issues in environmental protection – temperature and relative humidity, light and lighting, air quality, mould and pest control, and preventing physical damage. Part 2 is concerned with assessing the needs of collections, with chapters on inorganic materials, organic materials, objects of mixed materials, and assessing a specific collection. Appendices include postscript – if you want to do more; further reading (USA); sources of supply (USA); sources of information (USA); and a sample record for paintings.

206 *'Appropriate technologies' in the conservation of cultural property.* Paris: UNESCO, 1981. 136 pp. (Protection of the Cultural Heritage. Technical Handbooks for Museums and Monuments, 7.)
Five papers by various authors describing traditional techniques and materials appropriate for the conservation of historic buildings and collections appropriate to countries where high-technology solutions are not available. Includes traditional crafts in Nepal, monuments in Egypt, museum collections in India and mud buildings in Peru. Black and white photographs.

207 Bachmann, K. (ed.) *Conservation concerns: a guide for collectors and curators.* Washington (DC): Smithsonian Institution Press, 1992. 158 pp. Reading list: pp. 141–9.
A collection of 22 essays on aspects of conservation, including principles of storage; emergency planning; control of temperature and humidity in small collections; construction materials for storage and exhibition; storage of works on paper; warning signs: when works on paper require conservation; storage and care of photographs; warning signs: when photographs need conservation; preservation and storage of sound recordings; painting storage: a basic guideline; when is it time to call a paintings conservator?; storage of historic fabrics and costumes; textile conservation; warning signs: when textiles need conservation;

storage containers for textile collections; storage of stone, ceramic, glass and metal; care and conservation of metal artefacts; furniture conservation; upholstery conservation; preserving ethnographic objects; care of folk art: the decorative surface; composite objects: materials and storage conditions. Appendix: conservation suppliers (USA); organizations and agencies; conservation centres; conservation and collections care training (North America).

208 Blackaby, J.R., Greeno, P. and the **Nomenclature Committee.** *The revised nomenclature for museum cataloging: a revised and expanded version of Robert G. Chenhall's system for classifying man-made objects.* Nashville (Tennessee): American Association for State and Local History, 1988. 513 pp. Selected bibliography: chapter 6, pp. 1–9.

Introductory chapters: 'Looking at *nomenclature*', 'Using *nomenclature*' and '*Nomenclature* classifications defined'. The main part of the book is taken up by chapter 4 – 'Hierarchical list of preferred terms' – and chapter 5 – 'Alphabetical list of preferred terms'. This is an updated and expanded version of Chenhall, R. G. *Nomenclature for museum cataloging: a system for classifying man-made objects* (Nashville (Tennessee): American Association for State and Local History, 1978. 520 pp.), a handbook presenting a structured system for the naming of man-made objects – a system which includes a partial lexicon expandable by the user, together with definitions for major artefact categories, reflecting North American names.

209 Bostick, W.A. *The guarding of cultural property.* Paris: UNESCO, 1977. 40 pp. (Protection of the Cultural Heritage. Technical Handbooks for Museums and Monuments, 1.) Bibliography: pp. 32–3.

Very basic practical handbook on security of cultural property with emphasis on museums. Covers security in museums, security outside museums, the human element, mechanical and electronic devices, and enlisting public support. Appendices include security survey, suggested rules and regulations for a museum security force, and a model job description for a Chief Museum Security Officer.

210 Brunton, C.H.C., Besterman, T.P. and **Cooper, J.A.** (eds.) *Guidelines for the curation of geological materials.* London: Geological Society, 1985. 212 pp. (Geological Society of London Miscellaneous Paper, no. 17.)

A looseleaf manual setting out guidelines for the curation of geological materials (collections), described by the authors as a good housekeeping guide. In 5 parts – acquisition, documentation, preservation, occupational hazards, uses – each separately paginated and coded. Appendices on adhesives, products and suppliers, and the geological site documentation scheme.

211 Burke, R.B. and **Adeloye, S.** *A manual of basic museum security.* Paris: International Council of Museums, International Committee for Museum Security in liaison with Leicestershire Museums, 1986. 125 pp.

A very basic practical manual, originally intended for museums in developing countries. Defines security problems faced by museums, covers staff responsibilities, administration of security staff, collections security, perimeter protection, electronic alarms, fire protection, building construction and reconstruction, and staff safety. Appendices include a security questionnaire, training recommendations, security staff duties, risk assessment chart, and security checklists intended for different situations. Well illustrated.

212 Burnham, B. *Art theft: its scope, its impact, and its control.* New York: International Foundation for Art Research, 1978. 205 pp.
Reports the result of a study on the feasibility of a central art theft archive as a means of combating the theft of works of art. Appendices give art theft statistics, a list of important worldwide art thefts, 1975–7, details of a museum survey, and details of an art dealer survey.

213 Burnham, B. *The protection of cultural property: a handbook of national legislations.* Paris: International Council of Museums, 1974. 203 pp. Select bibliography: pp. 201–3.
Summarizes and presents in digestible form the national laws for the protection of cultural property which relate to the problem of illicit destruction of the cultural heritage. Concerned mainly with laws which control the discovery, ownership, circulation and sale of cultural property. Part 2 presents abstracts of national legislation arranged alphabetically by country. Part 3 is made up of appendices and documents, including useful addresses, international resolutions and conventions.

214 Cameron, C. (ed.) *Museums and anthropology: acquisitions, curation, research: a collection of papers presented at the 6th Symposium of Man*; symposium co-ordinator: K. Martin. Fullerton (California): Museum of Anthropology, California State University, Fullerton, 1986. 89 pp. (Occasional Papers of the Archaeological Research Facility, California State University, Fullerton, no. 3.)
Seven papers covering administration of the private museum, collections and the public, maintenance and conservation, children's museums, revitalizing an established institution, international regulations concerning collections in American museums, and museum collections as resources for research.

215 Case, M. (ed.) *Registrars on record: essays on museum collections management.* Washington (DC): American Association of Museums, 1988. 271 pp. Bibliography: pp. 247–53.
Series of essays on collections management commemorating the 10th anniversary of the founding of the Registrars Committee of the AAM. Contributions by registrars aimed at informing a broad public with the fundamentals of collections management, including documentation, insurance, shipping, and risk management. Highlights fundamental changes which have taken place in the roles of

North American museum staff in the past decade because of the rigorous application of law and ethics and the use of new technology to automate information and museum procedures.

216 Chenhall, R. G. *Museum cataloging in the computer age.* Nashville (Tennessee): American Association for State and Local History, 1975. 269 pp.
Describes the 'state of the art' in the cataloguing of collections by computer in the 1970s in the United States. Although the introductory chapters are still relevant, the later descriptive chapters are now of historical interest.

217 Chenhall, R. G. and **Vance, D.** *Museum collections and today's computers.* Westport (Connecticut): Greenwood Press, 1988. 179 pp. Selected bibliography: pp. 155–63.
Describes the use of computers in the documentation of museum collections at the end of the 1980s. The book is intended to provide a better understanding of the computer facilities needed in present-day collection management, and is aimed at executives of major museums, those who manage small museums, and others who may have a peripheral interest in the use of computers in museums. Part 1 focuses on the nature of artefact records; Part 2 on the principles of database management systems; Part 3 on the computer storage of visual images; and Part 4 describes the step-by-step design and implementation of a computerized catalogue file for a small museum. Inevitably some parts of the book are now out of date, but it nevertheless provides a valuable introduction to the subject. Useful glossary.

218 Choudhury, A. R. *Art museum documentation and practical handling.* Hyderabad: Choudhury and Choudhury, 1963. 319 pp. References: p. 286.
Early monograph on documentation and handling procedures for museum collections with emphasis on fine and applied art collections. Based upon a survey of North American and European museum practice. Illustrated with many black and white photographs and reproductions of forms used in documentation.

219 Clapp, A. F. *Curatorial care of works of art on paper: basic procedures for paper preservation.* New York: Nick Lyons Books, 1987. 201 pp. Bibliography: pp. 181–6.
A basic guide to the care of paper objects, aimed at the conservation technician rather than the fully trained conservator. Part 1 provides information about factors that can be injurious to paper together with suggested safeguards. Part 2 outlines procedures for treatment: initial care, matting, framing and storage. Part 3 deals with formulas, materials and equipment. Appendices include a list of suppliers (USA), and a list of materials and equipment for environmental control and for the workshop.

220 *Conservation of cultural property with special reference to tropical conditions.* Paris: UNESCO, 1968. 341 pp. (Museums and Monuments, XI.) Also in Fr. Es. Bibliography at the end of most chapters.

Illustrated handbook by various authors. Chapters relating to collections cover climate and microclimate; combating moulds; insect pests; equipping the laboratory; moulding, casting and electrotyping; pottery and glass; entomological materials in the tropics. Chapters relating to monuments cover conservation problems; preservation of monuments in India; conservation of urban sites; conservation of wall paintings; conservation and restoration of easel paintings; conservation of stone, metals, textiles, leather, wood, bone, ivory and archival materials; environmental control; and synthetic materials used in the conservation of cultural property. Black and white photographs.

221 Dudley, D. H., Wilkinson, I. B. and others. *Museum registration methods*. 3rd rev. ed. Washington (DC): American Association of Museums, 1979. 446 pp. Bibliography: pp. 155–66.

An updated and enlarged edition of the classic book first published in 1958. Describes procedures for registering and cataloguing museum accessions and loans. Includes procedures for measuring and marking objects, storage and care, loans from museum collections, packing and shipping, importing and exporting, and insurance. Part 2 of the book describes 20 specific applications of documentation, with bibliographies at the end of most articles.

222 *L'entretien des objets de musée: manipulation, transport, entreposage*. Basel: ICOM-Suisse, 1988. 55 pp. Fr. De. It.

Concise publication on the care of museum objects. Principally addressed to people working in small museums but also to staff members of large institutions who, without being conservators, are often in direct contact with valuable objects – junior curators, storage assistants, caretakers, guards. Presents the major rules to be observed when handling various types of objects of different materials.

223 Fall, F. K. *Art objects: their care and preservation: a handbook for museums and collectors*. La Jolla (California): McGilvery, 1973. 341 pp. References: pp. 302–7; bibliographies at the end of each chapter.

A comprehensive handbook on the production, care, handling and preservation of art objects arranged according to the nature of the collection.

224 *Field manual for museums*. Paris: UNESCO, 1970. 171 pp. (Museums and Monuments, XII.) Also in Fr. Bibliography at the end of some chapters.

Illustrated handbook on museum fieldwork by various authors with chapters on the organization of research in the field; organization of exhibitions; documentation in the field; techniques of archaeological excavation; prospecting methods in archaeology; treatment of skeletal remains; ethnographical fieldwork; and fieldwork in geology, botany and zoology. Black and white photographs.

225 Forman, L. and **Bridson, D.** (eds.) *The herbarium handbook*. Kew: Royal Botanic Gardens, 1989. 218 pp. References: pp. 205–9.

Deals primarily with the technical aspects of herbarium work: the preparation, housing, preservation and organization of herbarium collections and associated subjects. Organized in 5 sections: The herbarium building, collections and materials; Herbarium techniques and management; Additional techniques; Collecting; and The herbarium in the wider context.

226 Granger, F. and **Alsford, S.** *Canadian Museum of Civilization optical disc project: a report.* Ottawa: Canadian Museum of Civilization, National Museums of Canada, 1988. 62 pp. Select bibliography: pp. 52–3. Also published in Fr.
Reports a pilot study at the Canadian Museum of Civilization begun in 1985 and completed in 1987 to record images of every artefact in its collection on the interactive laser-read optical disc system. The system integrates computer-retrieved textual information on pictorial and artefactual collections, with images of those collections on a second screen. Printers can also be linked to the system, producing either coloured prints of publishable quality or fast and inexpensive black and white prints. The long-term aim is to install interactive systems in the museum galleries.

227 Greenfield, J. *The return of cultural treasures.* Cambridge: Cambridge University Press, 1989. 379 pp. Bibliography: pp. 328–50, arranged in sections – Principal legal cases (Denmark, England, Canada, USA); Other cases cited; Books and articles by author; Books and articles by organization; Other publications; UNESCO Conventions and Recommendations; National legislation; Other documents; Principal press references.
Presents a case on historical and aesthetic grounds for the return of certain kinds of objects. Chapters: 'The Icelandic manuscripts'; 'The Elgin Marbles debate'; 'British and other European approaches'; 'Some British cases'; 'American and Canadian approaches'; 'International and regional regulations'; 'Art theft and the art market'; 'The return of cultural treasures: some conclusions'.
Appendices in microfiche: Denmark; United Kingdom; USA and Latin America; Europe; international recommendations and reports; international conventions.

228 Herholdt, E. M. (ed.) *Natural history collections: their management and value.* Pretoria (South Africa): Transvaal Museum, 1990. (Special Publication, No. 1.) 172 pp. References at the end of each chapter.
Seventeen papers presented at a symposium in South Africa, dealing with management, preparation, storage, documentation and use of natural history collections in South Africa.

229 Howie, F. (ed.) *The care and conservation of geological material: minerals, rocks, meteorites and lunar finds.* Oxford: Butterworth-Heinemann, 1992. 153 pp. (Butterworth-Heinemann Series in Conservation and Museology.) References at the end of each chapter.

Intended primarily for those with responsibilities for the care of institutional geological collections, but the editor suggests that it will be of assistance also to both private collectors and students of museology. Seven contributors drawn from museums and conservation organizations in the UK, USA, Australia and Canada. Nine chapters: 'The stability of minerals'; 'Conserving light-sensitive minerals and gems'; 'Temperature- and humidity-sensitive mineralogical and petrological specimens'; 'Elements, alloys and miscellaneous minerals'; 'Sulphides and allied minerals in collections'; 'Pyrite and marcasite'; 'Meteorites'; 'The lunar sample collection'; 'Hazards for the mineral collector, conservator and curator'. Four appendices: 'Effects of construction materials on rock and mineral collections'; 'Collecting rocks and minerals'; 'Cleaning minerals'; 'Repair and consolidation of minerals and rocks'.

230 International Committee for Museum Security. *Museum security survey*; based on the document by G. H. H. Schröder; ed. by D. Menkes; transl. by M. de Moltke. Paris: International Council of Museums, 1981. 122 pp. En. Fr. Bibliography: p. 116.
A checklist of questions on museum security arranged under 21 headings intended to reveal the risks facing a museum and to evaluate the state of security existing in a museum, with instructions on how to prepare the final report.

231 International Council of Museums. *Museums and research/Musées et recherche.* Papers from the Eighth General Conference of ICOM, Cologne–Munich, 1968. Munich: Deutsches Museum (for ICOM), 1970. 126 pp. Some papers in Fr.
Paper examine various aspects of museums and research.

232 Johnson, E. V. and **Horgan, J. C.** *Museum collection storage.* Paris: UNESCO, 1979. 56 pp. (Protection of the Cultural Heritage. Technical Handbooks for Museums and Monuments, 2.) Select bibliography: pp. 55–6.
A practical guide to museum collection storage based upon the papers presented at an international conference in Washington in 1976. Chapters on planning; records, accessibility and retrieval; security; conservation; and storage systems.

233 Keene, S. (ed.) *Managing conservation.* Papers given at a conference held jointly by the United Kingdom Institute for Conservation and the Museum of London, 1990. London: United Kingdom Institute for Conservation, 1990. 32 pp. References at the end of some papers.
Eight papers consider a number of management issues that are fundamental to conservation.

234 Knell, S.J. and **Taylor, M.A.** *Geology and the local museum: making the most of your geological collection.* London: HMSO, 1989. 162 pp. Bibliography: pp. 105–11.

A guide for the non-specialist on the curation and use of geological collections, including basic documentation, conservation and security, display themes and techniques, and education. There are appendices devoted to 'Geological Locality Record Centres'; 'A simple stratigraphic classification'; 'A simple biological classification'; 'Igneous rocks'; 'Classification of metamorphic rocks'; 'Sedimentary rocks'; 'Minerals'; 'Merchandise'; and 'Useful addresses'.

235 Landi, S. *The textile conservator's manual.* 2nd ed. Oxford: Butterworth-Heinemann, 1992. 357 pp. (Butterworth-Heinemann Series in Conservation and Museology.) References: pp. 330–1; Further reading: pp. 332–3.
A comprehensive manual on the conservation of textiles. Part 1 – 'The manual' – is divided into chapters on 'The profession'; 'Technology'; 'Examination, options and choice'; 'Recording, handling and preparation'; 'Chemicals and their uses'; 'Cleaning'; 'Support and consolidation'; 'Reassembly and finishing'; 'Display, storage and transportation'; 'Equipment and the workroom'; with appendices on 'Materials and equipment'; 'Emergency procedures: fire, flood and infestation'; 'Glossary of weaving terms'; and 'The environment'. Part 2 – 'Ideas and experience' – is divided into chapters on 'Old case histories revisited'; 'Detection and reconstruction'; 'Upholstery'; 'The conservation of large objects'; 'Experience and experiment'; and 'Disasters'.

236 Light, R. B., Roberts, D. A. and **Stewart, J. D.** (eds.) *Museum documentation systems: developments and applications.* London: Butterworths, 1986. 345 pp. Sources and references: pp. 315–26.
An introduction to the documentation systems and procedures used on a national scale and within individual institutions in 11 different countries. Individual chapters were completed during an 18-month period and most refer to developments in late 1982 and early 1983. An authoritative review of the current state of the application of information technology to museum documentation.

237 Lord, B., Lord, G. D. and **Nicks, J.** *The cost of collecting: collection management in UK museums.* A report commissioned by the Office of Arts and Libraries. London: HMSO, 1989. 183 pp.
Reports a study to identify the costs of collecting objects. The study had 4 objectives – to identify the cost categories when considering the cost of managing collections, including new acquisitions, staff, and operating and capital requirements; to explore variations in costs related to the nature of collections and the type of institution; to establish a profile of the costs of collecting in British museums; and to provide information to facilitate good management. The study was carried out by means of a questionnaire distributed to 100 museums followed by case-study visits to 20 museums. Appendices include: research design; survey questionnaire; survey results; list of responding museums and case studies; bibliography and literature review; summary of seminar.

238 Malaro, M. C. *A legal primer on managing museum collections.* Washington
(DC): Smithsonian Institution Press, 1985. 364 pp. Selected bibliography:
pp. 337–40.

A scholarly treatise on the law as it relates to the management of museum collec-
tions in the United States. Covers legal definitions of museums, questions of
accountability, collection management policies, acquisition procedures, the
disposal of objects, loans, tax considerations, appraisals and authentications,
care of collections, insurance, access to collections, and visitor and employee
safety. Appendices include transcripts of the Arts and Artifacts Indemnity Act
(1975); Immunity from Seizure Statute; Convention on Cultural Property
Implementation Act; and Convention on the Means of Prohibiting and
Preventing the Illicit Import, Export and Transfer of Ownership of Cultural
Property adopted by the UNESCO General Conference (1970).

239 Matthai, R. A. (ed.) *Protection of cultural properties during energy emergencies.* 2nd
ed. New York: Arts/Energy Study and American Association of Museums,
1978. 24 pp. Bibliography: p. 24.

A basic guide to the protection of cultural buildings and museum collections from
damage in the event of energy emergencies. Covers preparation for energy
emergencies, protection of cultural buildings, facilities and collections, and
sources of assistance (USA).

240 Mecklenburg, M. F. (ed.) *Art in transit: studies in the transport of paintings.*
Washington (DC): National Gallery of Art, 1991. 372 pp. Selected biblio-
graphy: pp. 359–72.

Twenty-seven papers presented at an International Conference on the Packing
and Transportation of Paintings, London, 1991, organized by the Canadian
Conservation Institute of Communications Canada, the Conservation Analytical
Laboratory of the Smithsonian Institution, the National Gallery of Art, and the
Tate Gallery. Glossary.

A companion volume to [261].

241 Messenger, P. M. (ed.) *The ethics of collecting cultural property: whose culture?*
whose property? Albuquerque: University of New Mexico Press, 1989. 292 pp.
References at the end of most chapters.

A compilation of 22 contributions focusing on the ethical dilemmas that confront
archaeologists and society in general on issues relating to the ownership and
preservation of artefacts of past cultures. Based upon papers presented at a
conference 'The ethics of collecting cultural property: whose culture? whose
property?' in Minnesota, USA, in May 1986. Contributors include archaeo-
logists, dealers, museum staff, customs staff and academics.

242 Mitchell, R. *Insurance for independent museums.* 2nd rev. ed. Ellesmere Port:
Association of Independent Museums, 1988. 32 pp. (AIM Guideline, no. 7).

Comprehensive guide, aimed primarily at UK independent museums, to all aspects of museum insurance, including buildings, contents, liabilities, personal accident and sickness, pensions and life, permanent health and medical, and 'key person' life. Final chapter: 'Insurance on a limited budget'.

243 *Museum collecting policies in modern science and technology: proceedings of a seminar held at the Science Museum, London, 3 November 1988.* London: Science Museum, 1991. 52 pp.
Six papers and ensuing debate, discussing the nature of modern science and technology and problems in collecting representative artefacts for documentation and exhibition.

244 Museum Documentation Association. *Practical museum documentation.* 2nd ed. Duxford: Museum Documentation Association, 1981. 196 pp. References: pp. 169–77.
Forms part of the MDA's Museum Documentation System [538]. Practical introduction to the documentation of museum collections, acting as a guide to techniques for collection documentation, object documentation, locality documentation, bibliographic documentation, biographic documentation and event documentation. Also considers cataloguing and indexing, computerization of documentation, administrative and physical organization. Appendices describe conventions for numbering objects, provide lists of suppliers of equipment and materials (UK), and give the results of a small test computerization project.

245 Museums Association. *An approach to museum insurance.* London: Museums Association, 1978. 7 pp. (Museums Association, Information Sheet, 23.) Bibliography: pp. 4–5.
Brief introduction to museum insurance in the UK with appendices on the covering of risks to objects in the national collections and ICOM guidelines for loans.

246 National Audit Office (Great Britain). *Management of the collections of the English national museums and galleries: a report by the Comptroller and Auditor General.* London: HMSO, 1988. 17 pp. (HCP 394 1987–8.)
Records the results of an examination by the National Audit Office into: whether museums and galleries have sound policies for acquiring and disposing of collection objects; whether display, storage, conservation and security are satisfactory; and whether there are proper arrangements for inventory control and stocktaking. Report concentrates on the collections of the British Museum, the Victoria and Albert Museum, and the Tate Gallery.

247 National Fire Protection Association. Technical Committee on Libraries, Museums and Historic Buildings. *Recommended practice for the*

protection of museums and museum collections. Boston (Massachusetts): National Fire Protection Association, 1985. 27 pp. (NFPA 911.)
Excellent concise publication on recommended practices for the protection of museums and museum collections from fire. Advice on construction, building equipment and materials, fire protection equipment, improving protection in existing buildings, alterations and renovations, special facilities, museum management and operation, organization and supervision. Includes a chapter: 'Museum fire experience' – case histories of how fires started and the results. Appendices on fire detection systems, fire signalling systems and fire extinguishing systems with a sample Firesafety inspection form for museums.

248 Nauert, P. and **Black, C. M.** *Fine arts insurance: a handbook for art museums.* Washington (DC): Association of Art Museum Directors, 1979. 111 pp. Selected bibliography: pp. 100–1.
General introduction to fine arts insurance in the USA, including practical advice on insurance procedures, premiums and claims. Appendices include details of the activities of the Insurance Committee of the Association of Art Museum Directors, 1972–9, details of insurance experience of fine arts museums in the USA, 1970–7, and a list of service organizations. Glossary.

249 Neustupný, J. *Museum and research* [transl. by B. Vančura]. Prague: Národní Muzeum, 1968. 160 pp. (Museum Work series.)
Scholarly analysis of the role of research in museums. Investigates the form and stages of research, types of research; research into museum exhibitions, conservation, museum collections; research workers in museums; scientific organization of museums and museum work; and museums and museology. Detailed notes at end of chapters.

250 Newton, R. and **Davison, S.** *Conservation of glass.* London: Butterworths, 1989. 335 pp. Sources of information: pp. 284–8; Bibliography: pp. 289–309. (Butterworths' Series in Conservation and Museology.)
Provides a theoretical background and describes practical procedures for the conservation of different kinds of glass. Chapters devoted to: defining the nature of glass; history of glass making; raw materials and manufacturing techniques; development of furnaces and melting techniques; deterioration of glass; materials used in conservation; examination; conservation techniques. Glossary.

251 Oddy, A. (ed.) *The art of the conservator.* London: British Museum Press, 1992. 192 pp. Further reading at the end of each chapter.
A collection of contributions by leading conservators describing the conservation of 11 outstanding artefacts of international importance and representing different materials and different examination and conservation techniques. Black and white photographs and colour plates.

252 O'Keefe, P.J. and **Prott, L.V.** *Law and the cultural heritage.* London: Butterworths. [in 5 vols.] Vol. 1: *Discovery and excavation.* 1984. 461 pp. Bibliography: pp. 371–86.

Discusses the need to protect antiquities and the historical development of legislation for that purpose; the need for protection; development of legal controls; jurisdiction; co-ordination of law and administration; context of the archaeological heritage; ownership and control; the archaeological excavation; the law on finds; enforcement. Appendices cover national legislation and international legal instruments.

Vol. 3: *Movement.* 1989. 1,098 pp. Bibliography: pp. 929–77.

Discusses the problems of movement of movable cultural heritage: trade in cultural goods; movement into and out of collections; transfer of ownership; national controls of movement, including recovery of illicitly trafficked goods; regional and international arrangements, including return and restitution. Develops new principles of law relating to the retrieval of expatriated heritage. Appendices cover a list of national legislation, international legal instruments, UNESCO documents, and a list of international conferences.

253 Organ, R.M. *Design for scientific conservation of antiquities.* London: Butterworths for the IIC, 1968. 508 pp. References and bibliography: pp. 465–9.

A comprehensive treatise on the theory and practice of designing conservation workshops, including the design of laboratory furniture; a description of conservation processes; the layout of laboratories and workshops; and notes on equipment. List of some suppliers.

254 Orna, E. *Information policies for museums.* Cambridge: Museum Documentation Association, 1987. 48 pp. (MDA Occasional Paper, 10.)

Aims to help museums to get the best value out of their information resources by developing integrated information policies based on the museum's aims.

255 Orna, E. and **Pettitt, C.** *Information handling in museums.* London: Bingley, 1980. 190 pp. Bibliography: pp. 181–3.

A comprehensive approach to information handling in museums with suggestions on how to define needs, analyse problems, devise solutions and make sound and economic choices. Includes chapters on indexing and the management of museum computer systems. Case studies.

256 Pinniger, D. *Insect pests in museums.* Denbigh (Wales): Archetype Publications, 1990. 47 pp. References: pp. 46–7. (Originally publ. London: Institute of Archaeology Publications, 1989.)

A basic guide to the identification, prevention and control of insect pests in museums, with suggestions for a pest control strategy. Focuses on Britain.

257 Plenderleith, H.J. and **Werner, A.E.A.** *The conservation of antiquities and works of art: treatment, repair and restoration.* 2nd ed. London: Oxford University Press, 1971. 413 pp.

Standard, if somewhat dated, guide to conservation techniques. General treatise on the restoration and preservation of antiquities and works of art. Discusses organic materials, metals, stone, ceramics and glass. Eighteen appendices cover scientific aspects of conservation.

258 Pring, I. (ed.) *Image '89: the international meeting on museums and art galleries image databases.* Proceedings of the IMAGE meeting held at the University of London Audio-Visual Centre, UK, 18–20 May 1989; translation and text editing by J. Davis. London: IMAGE, 1990. 114 pp.

Report of a meeting which brought together individuals from many countries working with image databases and members of the interactive media community, to further the development and use of image databases in the cultural sector. Appendices: delegate directory; exhibition directory.

259 *The protection of movable cultural property: compendium of legislative texts/La protection du patrimoine culturel mobilier: recueil de textes législatifs;* prepared by H. Saba, with the assistance of N.G. Salamé. Paris: UNESCO, 1979–84. 2 vols. in En., 2 in Fr.

Provides information on the legal status of cultural property in 45 countries. Intended for museum curators, art dealers, antique dealers, private collectors, customs and police services, etc. with a view to fostering international co-operation in the prevention and repression of offences concerning movable cultural property. Both vols include texts of the legislative provisions of 45 countries, arranged alphabetically, and the texts of certain international instruments (conventions and recommendations). Vol. I also includes an analysis of legislative provisions concerning the protection of movable cultural property.

260 Reibel, D.B. *Registration methods for the small museum: a guide for historical collections.* Nashville (Tennessee): American Association for State and Local History, 1978. 160 pp. Bibliographical note: pp. 155–8.

A basic approach to museum registration methods at the small historical society museum (particularly in the USA). Appendices include sample registrar's manuals and examples of forms and register entries.

261 Richard, M., Mecklenburg, M.F. and **Merrill, R.M.** (eds.) *Art in transit: handbook for packing and transporting paintings.* Washington (DC): National Gallery of Art, 1991. Looseleaf.

Practical handbook describing procedures that will enable staff involved with packing and transporting paintings to use effectively the results of specialist research. Sections on: assessing risks; transit climate conditions; temperature

protection; relative humidity protection; shock and vibration hazards; shock protection; vibration protection; packing cases; role of the courier. Glossary. A companion volume to [240].

262 Rixon, A. E. *Fossil animal remains: their preparation and conservation.* London: Athlone Press, 1976. 310 pp. References at the end of each chapter.
A practical manual for the preparation and conservation of fossils by a former Senior Experimental Officer in the Palaeontology Laboratory of the British Museum (Natural History). Covers collecting and treatment in the field, mechanical and chemical development, treatment of iron pyrites in fossils, casting, and mounting fossils for exhibition. Appendices give details of special tools and techniques, and list materials, manufacturers and suppliers (UK).

263 Roberts, D. A. (ed.) *Collections management for museums: proceedings of an international conference held in Cambridge, England, 26–29 September 1987.* First Annual Conference of the Museum Documentation Association. Cambridge: Museum Documentation Association, 1988. 257 pp. Bibliography: pp. 231–4.
Thirty-six papers presented at the conference arranged in 7 sections: 'Surveys of collections management systems and practice'; 'System design'; 'Role of professional groups'; 'Procedural and policy developments in individual museums'; 'Training and advisory developments'; 'Consultancy support for museums'; and 'Collections management systems'.

264 Roberts, D. A. *Planning the documentation of museum collections.* Duxford (England): Museum Documentation Association, 1985. 574 pp. Sources of further information: pp. 539–41; references: pp. 542–53.
Describes the result of a project undertaken between 1981 and 1983 to investigate the state and future development of documentation procedures in museums. The most extensive work on the subject. Thorough examination of the status of documentation in museums; the growing pressures of public accountability; current procedures; data and terminology standards; documentation for the management of collections; retrospective documentation; collections audit; planning an automated system; and future developments. Appendices include a glossary of documentation terms; advice on assessing documentation systems; technical aspects of automated systems; and a review of current documentation practice in over 50 museums in the United Kingdom, Canada and the United States.

265 Roberts, D. A. (ed.) *Terminology for museums: proceedings of an international conference held in Cambridge, England, 21–24 September 1988.* Cambridge: Museum Documentation Association, 1990. 637 pp. Primary sources: pp. 574–80; bibliography: pp. 581–99.
Based on the papers of the Second Conference of the Museum Documentation Association held in Cambridge in 1988. Ninety-seven papers divided into 13

sections: 'Terminology in context'; 'International developments'; 'National developments'; 'Institution-wide initiatives'; 'Controlling personal and corporate body names'; 'Controlling geographic descriptions'; 'Discipline developments: archaeology, anthropology and ethnography'; 'Discipline developments: fine art, iconography and visual representation'; 'Discipline developments: social history, decorative art, material culture, science and technology'; 'Discipline developments: natural history and geology'; 'Discipline developments: conservation'; 'Internal and external users: working with museum terminology'; 'Future expectations'.

266 Sarasan, L. and **Neuner, A. M.** (compilers) *Museum collections and computers: report of an ASC survey.* Lawrence (Kansas): Association of Systematics Collections, 1983. 300 pp. Annotated bibliography: pp. 265–73.

Report of a survey carried out in the USA in the 1970s, presented in four sections. Section I (chapters 1–4) is a report on the project with an overview of the situation in the USA and guidelines for those embarking on a computer management project. Section II (chapter 5) (the major part of the book) summarizes in a standard format the projects surveyed, arranged alphabetically by state. Section III is an annotated bibliography of publications pertinent to museum computerized projects. Section IV indexes the projects summarized in section II.

267 Shelley, M. *The care and handling of art objects: practices in the Metropolitan Museum of Art.* New York: Metropolitan Museum of Art, 1987. 112 pp. Suggested reading: pp. 98–100.

The first part provides simple, useful guidelines for dealing with the entire spectrum of works in the Museum: paintings, drawings and prints, textiles, costumes, musical instruments, and three-dimensional pieces, whether monumental sculpture or filigree jewelry. Applicable to all museums with similar collections. The second part addressess the worst of the dangers: excessive illumination, and fluctuations of temperature and humidity. Selected glossary.

268 Solley, T. T., Williams, J. and **Baden, L.** *Planning for emergencies: a guide for museums.* Association of Art Museum Directors, 1987. 72 pp. Bibliography: pp. 61–70.

Designed to offer museums a framework which can be used to construct disaster plans tailored to meet individual needs. Part I describes the steps museums should take to create their own disaster plans. Part II surveys emergency prevention and response in general, and then examines specific types of disaster (e.g. fire, flood) from the point of view of prevention, crisis and aftermath. Appendices comprise emergency supplies and equipment; sample accident report forms; bomb threat report form; and how to handle works of art in emergencies.

269 Stolow, N. *Conservation and exhibitions: packing, transport, storage and environmental considerations.* London: Butterworths, 1987. 266 pp. (Butterworths' Series in Conservation and Museology.) References and notes: pp. 225–40.
Reviews past and current methods and techniques for the handling and conservation of collections during exhibition and transport; also presents new ideas and concepts from recent research and industrial technology. Fourteen chapters provide semi-technical information with fuller, detailed treatment in several appendices. Numerous illustrations, diagrams.

270 Stolow, N. *Conservation standards for works of art in transit and on exhibition.* Paris: UNESCO, 1979. 129 pp. (Museums and Monuments, XVII.) Also in Fr.
Definitive, well-illustrated handbook. Chapters on agents of deterioration; examination and preparation; design of packing cases and packing techniques; procedures during transportation; and guidelines and standards of care. Appendices comprise recommended relative humidity levels for collections, notes on the measurement of relative humidity, and a selected glossary of conservation and technical terms. Black and white photographs.

271 Stolow, N. *Procedures and conservation standards for museum collections in transit and on exhibition.* Paris: UNESCO, 1981. 56 pp. (Protection of the Cultural Heritage. Technical Handbooks for Museums and Monuments, 3.) Select bibliography: pp. 55–6.
Basic guide dealing briefly with deterioration of museum objects; storage of collections; handling and packing techniques; transportation; and standards and guidelines for exhibitions and travel. Appendices comprise sample documents. Condensed version of Stolow [270].

272 Storer, J. D. *The conservation of industrial collections: a survey.* London: Science Museum and the Conservation Unit of the Museums and Galleries Commission, 1989. 67 pp.
Reports a survey to discover the extent of industrial collections; their range and variety; their present condition; the extent and effectiveness of conservation facilities currently available; the appropriateness of storage and display; and to make recommendations.

273 Summerfield, P. M. *Historical collections: classification scheme for small museums.* Perth (Australia): Museums Association of Australia – Western Australian Branch, 1988. Bibliography: pp. 18–22.
Practical thematic classification scheme for historic or folk art collections. Includes a model registration card.

274 Sykes, M. H. *Manual on systems of inventorying immovable cultural property.* Paris: UNESCO, 1984. 180 pp. (Museums and Monuments, XIX.)

A study in 3 parts of methods of inventorying immovable cultural property. Part 1 gives an overview of the methodology, part 2 a description and analysis of 11 systems, each from a different country, and part 3 enables comparisons to be made between the systems.

275 Thomson, G. *The museum environment.* 2nd ed. London: Butterworths (in association with the International Institute for Conservation of Historic and Artistic Works), 1986. 293 pp. (Butterworths' Series in Conservation and Museology.) References: pp. 271–85.

A textbook for conservators and curators dealing with damaging effects of light, humidity and air pollution on museum collections and describing measures to be taken to minimize the damage. Part I is intended for the non-scientist and part II for the conservation research worker, summarizing information which previously had been widely scattered. Well illustrated with colour plates, photographs and diagrams.

276 Tillotson, R.G. *Museum security/La sécurité dans les musées;* ed. by D.D. Menkes; transl. by M. de Moltke. Paris: International Council of Museums, for the International Committee for Museum Security, 1977. 244 pp. En. Fr. Es. Bibliography: pp. 198–230.

A basic, commonsense approach to museum security intended for all working in museums. Chapters on staff responsibilities, inventory control, protection against fire, protection against theft and burglary, internal security, personal security, damage, response to thefts and vandalism, architectural plans, conclusions and recommendations. Appendices include sample emergency plans and bomb threat checklist. Well illustrated with black and white photographs.

277 Upton, M.S. and **Pearson, C.** *Disaster planning and emergency treatments in museums, art galleries, libraries, archives and allied institutions.* Canberra: Institute for the Conservation of Cultural Material Incorporated, 1978. 54 pp. Literature: pp. 52–3.

A practical guide for preparing contingency plans to deal with disasters which might face museums, including civil disturbance, armed conflict, fire, flood, earthquake and hurricane. Describes the nature of the problem, action to be taken and emergency treatment of materials. Appendices include transcripts of the Hague Convention of 1954 and the proposed procedure and format of a disaster plan.

278 Williams, D.W. *A guide to museum computing.* Nashville (Tennessee): American Association for State and Local History, 1987. 190 pp. Bibliography: pp. 125–6.

Aimed at the first-time computer user. Gives basic information about applying small computers to registration and collection management, including their use in accounting, publishing and word processing. Glossary. Appendices describe specific applications in certain US institutions.

279 Williams, S.A. *The international and national protection of movable cultural property: a comparative study.* Dobbs Ferry (NY): Oceana, 1978. 319 pp.
The definitive book on the law relating to the national and international protection of movable cultural property. Begins with an analysis of the historical background of the international protection of cultural property and goes on to consider the protection of property in the event of armed conflict and in times of peace. Chapter 4 examines domestic protection of cultural property in times of peace, including export controls in selected countries comprising France, Italy, Mexico, the UK and Canada, and import controls in the USA. Section IV of chapter 4 looks at the role of museums in ensuring ethical acquisition policies and the role of the International Council of Museums. Chapter 5 discusses the protection of cultural property rendered by international agreements and recommendations including the 1970 UNESCO Convention on the Means of Prohibiting and Preventing the Illicit Import, Export and Transfer of Ownership of Cultural Property. Proposals for reform are followed by appendices giving the texts of various Conventions, Acts, Regulations, etc.

280 Zycherman, L.A. and **Schrock, J.R.** (eds.) *A guide to museum pest control.* Washington (DC): Foundation of the American Institute for Conservation of Historic and Artistic Works and the Association of Systematics Collections, 1988. 216 pp. References at the end of each chapter; partially annotated bibliography: pp. 177–98.
An updated version of Edwards, S.R., Bell, B.M. and King, M.E. (eds.) *Pest control in museums: a status report* (1980). Presented in 4 sections: 'Policy, law and liability'; 'Pests and pest identification'; 'Treatment'; 'References'. Focuses mainly on insect pests in North America and practice in the United States. Valuable chapter entitled 'Effects of insecticides on museum artefacts and materials'.

Museum management

281 Ambrose, T. (ed.) *Money, money, money and museums.* Edinburgh: HMSO for the Scottish Museums Council, 1991. 86 pp.
Eight papers, presented at a conference in Edinburgh in 1989, which explore ways in which museums can earn money through retailing and trading, merchandising, facilities use, fees and subscriptions.

282 Ambrose, T. *New museums: a start-up guide.* Edinburgh: HMSO, 1987. 63 pp. Further information: pp. 62–3.
Arranged in 4 sections: 'First steps' poses general questions about running museums; 'Managing the museum' describes the various management responsibilities which go with new museum ventures; 'Managing the collections' looks at the ways in which museums form and care for their collections; 'The museum

and its users' examines the range of services provided for users and how these form part of the museum's marketing operation.

283 Ambrose, T. and **Runyard, S.** (eds.) *Forward planning: a handbook of business, corporate and development planning for museums and galleries.* London: Museums and Galleries Commission in conjunction with Routledge, 1991. 183 pp. (The Heritage. Care – Preservation – Management.) Further reading at the end of some sections. Equal opportunities: select bibliography.
A collection of 25 papers presented under 4 headings: 'Assessing your position'; 'Writing your plan'; 'Forward planning in specialist areas'; and 'Using your plan', with samples and extracts from two forward plans and a checklist of tasks.

284 Association of Independent Museums. *Charitable status for museums.* Beaulieu (England): Association of Independent Museums, 1981. 43 pp. (AIM Guideline, no. 3.)
A guide for independent museums in England and Wales on the procedure for registration as a charity under the Charities Act 1960.

285 The Audit Commission for Local Authorities and the **National Health Service in England and Wales.** *The road to Wigan Pier? Managing local authority museums and art galleries.* London: HMSO, 1991. 48 pp.
Presents the results of a study to undertake a value-for-money review of local authority support for museums in England and Wales. Looks at the immediate challenges facing local authority museums and the more long-standing challenges which need to be addressed if value for money is to be improved.

286 Bell, J. A. M. *Museum and gallery building: a guide to briefing and design procedure.* London: Museums Association, 1972. 7 pp. (Museums Association Information Sheet, no. 14.) References: p. 7.
Analyses the roles of the architect and the curator in designing new museum buildings.

287 Brawne, M. *The new museum: architecture and display.* New York: Praeger, 1965. 208 pp. Text in En. De. References: p. 206; index of architects: p. 207.
Case studies of new museum buildings and exhibitions. Arranged by countries and regions with chapters on lighting; climate control; security; walls, panels, cases and supports; storage and workshops; objects in the open air; labels; furniture; and entrance halls. Generously illustrated with black and white photographs and plates.

288 Canadian Museums Association. *A guide to museum positions, including a statement on the ethical behaviour of museum professionals* [a study by the Canadian Museums Association]. Ottawa: Canadian Museums Association, 1979. 28 pp. En. Fr. Bibliography: pp. 26–8.

Sets out duties, responsibilities and suggested qualifications for 14 job titles with a brief statement on the ethical behaviour of museum professionals.

289 French, Y. *The handbook of public relations for museums, galleries, historic houses, the visual arts and heritage attractions*. Milton Keynes: Museum Development Company, 1991. 192 pp. Information sources: pp. 177–85. Useful publications: p. 186.
Aimed at all individuals who have responsibility for public relations within their organization such as chairmen, directors, curators, marketing executives and public relations officers. Appendices include 'Thirty-three do's and don'ts' and various case histories (the Tate Gallery and Winsor and Newton; Dulwich Picture Gallery; Horniman Museum and Gardens; the Gold of the Pharaohs).

290 George, G. and **Sherrell-Leo, C.** *Starting right: a basic guide to museum planning*. Nashville (Tennessee): American Association for State and Local History, 1986. 151 pp. Further information at the end of each chapter.
Intended for members of community organizations and individuals considering setting up a museum. Discusses issues to be faced and offers advice on all aspects of museums from the choice of a building, through collections, care, registration, conservation and exhibits, to staffing, financial management and fund raising. Part III gives examples of basic documents such as sample bylaws, a standard accession record, a typical budget list, a recommended certificate of gift, a sample job description and basic organization chart.

291 Government of Canada. National Museums Task Force. *Muse = musée = museum: report and recommendations of the Task Force charged with examining federal policy concerning museums*. Ottawa: Minister of Supply and Services, Canada, 1986. 83 pp. En. Fr.
The report of a task force set up to study the mandate and operations of the National Museums of Canada Corporation, including both its services to the Canadian museum community and its responsibility for the four major federal museums (the Canadian Museum of Civilization (formerly: National Museum of Man), the National Museum of Natural Sciences, the National Museum of Science and Technology, and the National Gallery of Canada) together with the other museums associated with them.

292 Greene, J.P. (compiler) *Setting up and running a new museum*. Beaulieu (England): Association of Independent Museums, 1980. 35 pp. (AIM Guideline, no. 2.)
A brief guide for independent museums to the setting up and running of a new museum. Covers practical details of administration and organization.

293 Hoachlander, M. *Profile of a museum registrar*. Washington (DC): Academy for Educational Development, 1979. 126 pp. Bibliography: pp. 55–68.

Research study delineating the role and functions of the museum registrar, establishing guidelines for training materials and methods, and determining from the directors of museums and from registrars how this position is perceived within the organizational structure of the museum. Appendices include the survey questionnaire, analytical tables and videotape script.

294 Howie, F. (ed.) *Safety in museums and galleries.* London: Butterworths, in association with the *International Journal of Museum Management and Curatorship*, 1987. 196 pp. Further reading: pp. 169–71; bibliography/further reading at the end of most sections.

A special supplement to the *International Journal of Museum Management and Curatorship* [92]. Based on a series of papers presented at the 1985 Conference on Safety in Museums and Galleries, organized by the Museums Association, the United Kingdom Institute for Conservation, and the British Museum (Natural History). Examines the current state of health and safety legislation, policy and practice, mainly in the UK. Arranged in 4 sections: 'Legal and administrative framework'; 'Aspects of museum safety'; 'Hazards and their control'; and 'Information sources and training in safety'. Appendices comprise safety checklists for use in museums and galleries; bibliography, including references to law relating to safety and health in museums and galleries in the UK and USA, regulations applicable to working in museums, and Health and Safety Executive Guidance Notes published by HMSO; and sources of information, training and legal advice (UK and USA).

295 International Council of Museums. *Training of museum personnel/La formation du personnel des musées.* London: Hugh Evelyn for ICOM, 1970. 242 pp. Some papers in Fr.

Ten papers on aspects of training of museum personnel in different countries and different types of museum, together with a directory of training courses throughout the world and details of the courses offered.

296 Larsen, J. (ed.) *Museum librarianship.* Hamden (Connecticut): Library Professional Publications, 1985. 149 pp. Notes and/or bibliography at the end of each chapter.

A manual for the museum librarian. Nine chapters, each written by a museum librarian with expertise in the area discussed. Topics covered are staffing; building, organizing and maintaining the collections; services; the museum library's role in support of educational and outreach programmes; basic reference tools and professional resources (from a US viewpoint); and facilities.

297 Lord, B. and **Lord, G. D.** (eds.) *Planning our museums.* Ottawa: National Museums of Canada, Museums Assistance Programme, 1983. 309 pp. Bibliography: pp. 293–304.

Collection of writings by different individuals on museum planning, with

emphasis on the proposed construction, renovation or upgrading project. Arranged in 3 sections: planning for people; planning for collections; and planning for construction, rehabilitation and renovation. In looseleaf binder form. Glossary.

298 Miller, R. L. *Personnel policies for museums: a handbook for management.* Washington (DC): American Association of Museums, 1980. 175 pp. Selected references; pp. 163–4.

A guide for museum directors, administrators and trustees to the preparation of policy statements for the management of museum personnel in the USA. Thirty-four sections relating to job descriptions and specifications, recruitment, selection, promotion and transfer, performance appraisal, termination of employment, vacation, discipline and appeal procedures, and other conditions of service.

299 Montaner, J. *New museums.* London: Architecture Design and Technology Press, 1990. 192 pp. Bibliography: pp. 188–91.

An international and wide-ranging survey of museums designed and built during the 1980s. It documents and analyses developments in museum design over a period which has seen a growing number of great cultural complexes and national museums, and specialized, single-theme museums. Following the introductory chapter, there are 26 case studies with descriptions, floor plans, and colour and black and white photographs.

300 Montaner, J. and **Oliveras, J.** *The museums of the last generation.* London: Academy Editions; New York: St Martin's Press, 1986. 144 pp. En. Es. Bibliography: p. 142.

Discussion on trends in museum architecture followed by 31 examples of recent museum buildings, generously illustrated by black and white and colour photographs and plans.

301 Paine, C. *The local museum: notes for amateur curators.* 2nd ed. Milton Keynes: Area Museums Service for South Eastern England, 1986. 60 pp. Further reading included throughout.

Practical guide to the setting up of a new museum covering planning, museum management (including sources of funds), collecting and documenting, how to defeat enemies such as fire, rot, pests, etc., basic conservation, displays, exhibitions and the visitor. Aimed at the amateur but useful to the professional also. Relates specifically to Britain but relevant worldwide. Appendices include Code of Practice for Museum Authorities, and Code of Conduct for Museum Curators.

302 *The role of the library in a museum.* Session proceedings of the joint annual meeting of the American Association of Museums/Canadian Museums Association, Boston (Massachusetts), June 1980; chaired by R. S. Ratner and

V. Monkhouse. Smithsonian Institution; National Museums of Canada, [1981?]. 18 pp.
Four papers on aspects of museum libraries, discussing museum library services and the role of the museum librarian.

303 Stephens, S. (ed.) *Building the new museums*. The annotated proceedings of 'Art against the wall', a three-part symposium on the architecture of art museums, sponsored by the Architectural League of New York, Dec. 1985. Princeton: Princeton Architectural Press and the Architectural League of New York, 1986. 96 pp.
Series of papers looking at recent developments in the planning and design of art museums, primarily in the USA. In 3 sections: 'Art and architecture'; 'Art and the walls within'; and 'Art and the walls without'.

304 Tobelem, J.-M. *Musées et culture: le financement à l'américaine*. Mâcon: Editions W, 1990. (Collection museologia.)
Reports a one-year enquiry into the funding of United States museums with an assessment of their strengths and weaknesses. Part 1 looks at support provided by individuals, foundations, commercial companies, federal agencies, and individual states and cities. Part 2 reviews financial resources generated by the museums themselves, including endowments, entry charges and subscriptions, and contains a discussion on the ever-increasing commercial activities of American museums and the impact which these have on the primary functions of museums.

305 Ullberg, A. D. and **Ullberg, P.** *Museum trusteeship*. Washington (DC): American Association of Museums, 1981. 135 pp. Further reading: pp. 93–117.
A handbook for museum trustees based on US experience. Covers the responsibilities of trustees, the structure and operation of trustee boards, accountability and liability.

Museum services

306 Adams, G. D. *Museum public relations*. Nashville (Tennessee): American Association for State and Local History, 1983. 247 pp. (AASLH Management Series, vol. 2.) Sources of further information: pp. 221–30.
A basic reference work to museum public relations activities. Covers the roles of staff and committees, research and planning, the museum public, fund-raising, publications, media reports and relations with the media, promotional campaigns and daily operations. Appendices give examples of fact sheets, letters and questionnaires. Sources of further information are predominantly American.

307 Bearman, D. (ed.) *Hypermedia and interactivity in museums: proceedings of an international conference*. Pittsburgh (Pennsylvania): Archives and Museum

Informatics, 1991. 334 pp. (Archives and Museum Informatics Technical
Report, no. 14.) References at the end of some chapters.
Forty-three papers presented at a conference in Pittsburgh in 1991 covering the
theory and practice of the use of hypermedia in interactive exhibits in museums
and cultural institutions. Presented in 6 sections: 'The changing museum';
'Museum issues'; 'Museum projects'; 'Broader cultural issues'; 'Technological
issues'; and 'Abstracts and brief communications'. Contributors drawn mostly
from the USA but also from the UK, Denmark and Japan.

308 Belcher, M. *Exhibitions in museums.* Leicester: Leicester University Press,
 1991. 224 pp. (Leicester Museum Studies Series.) Bibliography: pp. 215–24.
Aimed at all individuals concerned with the preparation of exhibitions in
museums. Arranged in 5 sections: the interface between museum and the public;
museum exhibitions: communication function, modes and types; exhibition
policy, planning and brief; the exhibition environment; and the museum visitor
and exhibition effectiveness.

309 Berry, N. and **Mayer, S.** (eds.) *Museum education history, theory and practice.*
 Reston (Virginia): The National Art Education Association, 1989. 257 pp.
 Bibliography.
A collection of essays dealing with the history, educational models, strategic
planning and education in relation to art museum education.

310 Bertram, B. *Display technology for small museums.* [Sydney]: Museums
 Association of Australia, New South Wales Branch, with the Division of
 Cultural Activities, Premier's Dept., New South Wales, 1982. 89 pp.
A practical handbook dealing with the technology of developing and installing
displays. Aimed at the small to medium-sized museum; more expensive and
sophisticated techniques are not covered.

311 Bickerton, J. *The handbook of retailing: a guide to retailing for museums, galleries,
 heritage and visual arts organizations.* Milton Keynes: The Museum Development
 Company, 1990. Looseleaf. 2 vols.
Vol. 1: Contents: 'Why open a shop?'; 'Where are the customers and what do
they want?'; 'Creating a retail rationale'; 'Choosing a product range'; 'A suitable
site'; 'Using designers and how to brief them'; 'The business plan'; 'Product
development'; 'Broader training opportunities'; 'Communicating with your
customer'; 'Running the shop'; 'Other opportunities'. Appendix: Trading
Standards. Vol. 2: Retail Directory.

312 Blume, H. *The museum trading handbook.* London: Charities Advisory Trust,
 1987. 175 pp.
Comprehensive guide to all aspects of museum trading in the UK. The result
of a 2-year study. Discusses why trade?; the educational role of trading; what

to sell and where to get it; commercial companies; shop design and layout; financial and information control; stock control and security; staff management; how to reach a market beyond the museum; and museum shops abroad. Includes statistical information on museum trading and chapter on resources (for further information).

313 Brawne, M. *The museum interior: temporary and permanent display techniques.* London: Thames and Hudson, 1982. 160 pp. References: p. 160.
Records some of the innovations in the presentation of collections in museums over the last 20 years. Provides guidelines on the installation of displays and the need to consider such details as wall and floor coverings, types of display case, supports and pedestals, lighting, temperature, humidity, air pollution, security control, verbal communication and audio-visual media. Some examples are given. Numerous illustrations, drawings, plans, etc.

314 Chadwick, A. F. *The role of the museum and art gallery in community education.* Nottingham: University of Nottingham, Department of Adult Education, in association with the National Institute of Adult Education, 1980. 166 pp. (Nottingham Studies in the Theory and Practice of the Education of Adults.) Bibliography: pp. 143–52.
Based upon the author's PhD thesis, this study aims to elucidate the present function of the UK museum and art gallery in terms of community education, and considers changes which might take place in the future, including changes in organization and in staff qualifications and training.

315 Collins, Z. W. (ed.) *Museums, adults and the humanities: a guide for educational programming.* Washington (DC): American Association of Museums, 1981. 423 pp.
Papers presented at 4 seminars organized by the American Association of Museums Standing Committee on Education in 1979–80 on the subject of 'Lifelong learning in the humanities', together with case studies and notes on funding. Papers organized under the headings 'Relating the humanities to the museum', 'Adults as learners', 'Lifelong learning and the museum' and 'Developing humanities programs for adults'.

316 *Excellence and equity: education and the public dimension of museums.* Washington (DC): American Association of Museums, 1992. 27 pp.
A report from the American Association of Museums which points the way for museums to expand their role as educational institutions, especially with regard to culturally diverse audiences.

317 Falk, J. H. and **Dierking, L. D.** *The museum experience.* Washington (DC): Whalesback Books, 1992. 222 pp. References: pp. 171–96; annotated bibliography: pp. 197–205.

Investigates the museum experience from the point of view of the visitor. Draws upon the authors' original research and research in a wide variety of disciplines as well as museum and visitor studies ranging from science centres and zoos to art and natural history museums in the UK, India and the USA. Provides a valuable overview of why people go to museums, what they do there and what they learn. Arranged in 4 parts: before the visit; during the visit; the museum visit remembered; and a professional's guide to the museum experience. Appendix: transcript of interviews.

318 Fondation de France and **ICOM.** *Museums without barriers: a new deal for disabled people.* London: ICOM in conjunction with Routledge, 1991. 227 pp. (The Heritage: Care – Preservation – Management.) Select bibliography: pp. 191–203.

Presents some of the best museum practice in respect of disability, and sets out an agenda for future action in museums worldwide. The book has its origins in a conference organized by the Fondation de France in 1988 in which European museum experts shared their experience of providing for disabled people with professionals from other disciplines and other countries. There are 41 contributions organized in 6 sections: 'Cultural policies concerning disabled people, in France and abroad'; 'Funding possibilities'; 'Museums and physical disabilities'; 'Museums and people with impaired vision'; 'Museums and people with impaired hearing'; and 'Museums and mentally disabled people'.

319 Great Britain. Office of Arts and Libraries. *Volunteers in museums and heritage organisations: policy, planning and management.* London: HMSO, 1991. 117 pp. Select bibliography: p. 102.

Examines the involvement of volunteers in British museums and heritage organizations, providing practical advice on policy planning, recruitment, induction and training, and addressing such issues as employment law and liability and relations between paid and volunteer staff. Appendix 1 gives a sample of national, local authority and independent museums to compare management practices and the involvement of volunteers in different museum functions; appendix 2 gives 9 case studies taken from Britain and the USA; appendix 3 gives details of volunteer organizations and support services; and appendix 4 gives suggested guidelines for the new volunteer.

320 Grinder, A. L. and **McCoy, E. S.** *The good guide: a sourcebook for interpreters, docents and tour guides.* Scottsdale (Arizona): Ironwood Press, 1985. 161 pp. References at the end of each chapter.

A source book for guides and instructors in history, art, science and natural history museums, historical organizations, and state and national parks. Part 1 reviews the historical background to museum guided tours and the nature of the learning process. Part 2 deals with specific techniques, visitor characteristics and the development of communication skills.

321 Groff, G. and **Gardner, L.** *What museum guides need to know: access for blind and visually impaired visitors.* New York: American Foundation for the Blind, 1989. 62 pp. Bibliography.

Provides basic information on blindness and visual impairment, and on the ways in which blind and visually impaired people experience and appreciate art. Offers advice on how their museum visits can be optimized.

322 Hall, M. *On display: a design grammar for museum exhibitions.* London: Lund Humphries, 1987. 256 pp. Bibliography: pp. 247–51.

Begins with brief introduction to the history, philosophy and strategy of exhibition design. The main body of the text is made up of short chapters devoted to aspects of museum design (design brief, security, heating and ventilation, showcases, etc.) and 'a designer's notebook' looking at the display of different kinds of museum object and different kinds of subject matter. Appendices on designing exhibitions for the disabled, exhibition budget checklist, checklist of site details and checklist of security/fire/safety precautions.

323 Harvey, E. D. and **Friedberg, B.** (eds.) *A museum for the people.* A report of proceedings at the Seminar on Neighborhood Museums, Brooklyn, 1969. New York: Arno Press, 1971. 102 pp.

Historically important as the report of the first seminar on neighbourhood museums. In particular, looks at museum provision in the inner cities for disadvantaged and ethnic minorities.

324 Hoffos, S. *Multimedia and the interactive display in museums, exhibitions and libraries.* Boston Spa (England): British Library, 1992. 96 pp. (Library and Information Research Report, 87.) Publications and events: pp. 80–1.

A 2-part report. Part 1 addresses fundamental concepts and technical issues to explain how interactive multimedia systems work, and introduces platforms, including LaserDisc and interactive video (IV), compact disc (CD-DA, CD-ROM/XA, CD-I, CDTV, Photo CD), Digital Video Interactive (DVI), holograms and high-definition television (HDTV). Part 2 describes over 30 projects at 26 sites, with first-hand observation, comments and advice. The report includes brief descriptions of many more applications and listings of sites worldwide, plus sources of further information.

325 Hooper-Greenhill, E. *Museum and gallery education.* Leicester: Leicester University Press, 1991. 222 pp. (Leicester Museum Studies Series.) Bibliography: pp. 195–211.

Traces the development of the educational role of museums from the beginning of the 19th century up to the present and into the future. Offers strategies for managing museum education, outlines appropriate methods for working, and describes examples of good practice. Arranged in 3 parts: historical perspectives; management and methodologies; and audiences and approaches. Appendix lists UNESCO survey articles.

326 International Council of Museums. *The museum in the service of man: today and tomorrow: the museum's educational and cultural role* . . . Papers from the Ninth General Conference of ICOM, Grenoble, 1971. Paris: ICOM, 1972. 199 pp. Some papers in Fr.
Papers on the museum's educational and cultural role.

327 International Council of Museums. *Public view: the ICOM handbook of museum public relations* [ed. by C. Bellow and the ICOM Museum Public Relations Committee]. Paris: International Council of Museums, 1986. 189 pp. Selective bibliography: pp. 185–9.
Revised and enlarged version of essays on museum public relations originally issued on the occasion of the ICOM General Conference in Mexico (1980). Has 29 chapters by different authors arranged in 4 sections (a warm welcome; museum patronage; communications management; special exhibitions). Represents the first serious attempt to provide guidance for museum staff about their relations with the public.

328 Karp, I., Kreamer, C.M. and **Lavine, S.D.** (eds.) *Museums and communities: the politics of public culture.* Washington (DC): Smithsonian Institution Press, 1992. 624 pp.
A stimulating collection of 17 essays emanating from a conference entitled 'Museums and communities', held at the Smithsonian Institution in March 1990. Essays 'examine the often controversial interactions between museums, festivals, tourism, and historic preservation projects and the communities they profess to represent and serve, demonstrating how the contested terrain of cultural representation both brings together and separates museums and communities'.

329 Karp, I. and **Lavine, S.D.** (eds.) *Exhibiting cultures: the poetics and politics of museum display.* Washington (DC): Smithsonian Institution Press, 1991. 478 pp.
Papers emanating from a conference at the International Center of the Smithsonian Institution in September 1988. The book comprises 27 essays by eminent scholars and museum professionals which examine the 'politically charged relationships among aesthetics, contexts, and implicit assumptions that govern how cultural differences and art objects are displayed'.

330 Kavanagh, G. (ed.) *Museum languages: objects and texts.* Leicester: Leicester University Press, 1991. 186 pp. Bibliographies at the end of each chapter.
Arises from a conference held at the Department of Museum Studies, University of Leicester, in April 1990, entitled 'Breaking new ground'. Discusses museum communication in its many forms, museum visiting, and collecting. A companion volume to [177].

331 Kebabian, H. and **Padgett, W.** *Production of museum publications: a step by step guide.* Hamilton (New York): Gallery Association of New York State, 1990. 11 pp. Suggested references: p. 10.

A technical guide giving information on planning, aids to organizing the job, steps to save money and improve quality, and a glossary of useful terms.

332 Kenney, A.P. *Access to the past: museum programs and handicapped visitors.* Nashville (Tennessee): American Association for State and Local History, 1980. 141 pp. Further reading: pp. 122–5.

Intended as a guide to the implementation of Section 504 of the United States Rehabilitation Act of 1973. Provides an excellent practical approach to making museums and museum collections more accessible to various categories of disabled person, including those with limited mobility, vision, hearing and mental capacity.

333 Kentley, E. and **Negus, D.** *Writing on the wall: a guide for presenting exhibition text.* Greenwich: National Maritime Museum, 1989. 27 pp.

Presents suggestions and guidelines for the preparation of text in exhibitions. In 2 parts: writing readable copy; and making the copy legible. Numerous illustrations.

334 Matthews, G. *Museums and art galleries: a design and development guide.* Oxford: Butterworth Architecture, 1991. 115 pp. (Butterworth Architecture Design and Development Guides.) References and sources of information: pp. 84–8.

Aim: 'to provide all those involved in the initial stages of the building process – clients, users and members of the design team – with a set of tools'. Contents: 'Introduction'; 'Types of museum and art gallery'; 'The building process'; 'Inception'; 'Preliminary programme'; 'Feasibility'; 'Detailed programme'; 'Outline proposals'; 'Scheme design'. Appendices: site survey/analysis; the main consultants; programming and design methods. Well illustrated with black and white photographs and figures.

335 Mattingly, J. *Volunteers in museums and galleries: the report of a survey into the work of volunteers in museums and galleries in the United Kingdom.* Berkhamsted: Volunteer Centre, 1984. 111 pp. Bibliography: pp. 96–8.

Analyses the extent and nature of volunteer involvement in museums and galleries in the UK; the characteristics of museum volunteers; motivation; recruitment, selection and training; organization and management; and attitudes to volunteers. Conclusions and recommendations.

336 Miles, R.S. and others (compilers) *The design of educational exhibits.* 2nd ed. London: Unwin Hyman, 1988. 210 pp. Bibliography: pp. 189–93.

A handbook on the design of educational exhibits giving practical guidance on planning, designing, producing, evaluating and updating exhibitions. Based

largely on experience at the British Museum (Natural History). Revised, updated and extended version of first edition (1982) and includes developments in computer and videodisc exhibits, and new thinking on the relationship between media and modes. Glossary.

337 *Museums, imagination and education.* Paris: UNESCO, 1973. 148 pp. (Museums and Monuments, XV.) Also in Fr. Annotated bibliography on the museum as educator: pp. 145-8.
Chapters by various authors on aspects of museum exhibition and education including changing museums in a changing world; museums – teachers, students and children; museums in developing countries; science, museums and planetaria; children and art; television and the museum; temporary and travelling exhibitions; reaching a distant public; exhibitions needed by a developing country; use of mass media by museums; and collaboration between museum and school. Black and white photographs.

338 Newsom, B. Y. and **Silver, A. Z.** (eds.) *The art museum as educator: a collection of studies as guides to practice and policy*; [prepared by the] Council on Museums and Education in the Visual Arts. Berkeley (California); London: University of California Press, 1978. 830 pp.
Reports a study into visual arts education programmes in museums, schools, universities and community centres in the United States. Analyses more than 100 educational programmes in terms of purpose, philosophy, method, funding and effect on participants.

339 Nichols, S. K. (ed.) *Museum education anthology 1973-1983: perspectives on informal learning, a decade of Roundtable Reports.* Washington (DC): Museum Education Roundtable, 1984. 258 pp.
A selection of short papers from the periodical *Roundtable Reports* on the subject of informal education in museums. Index, 1973-83 (volume index; topic index; author index; institution index).

340 Oliver, R. N. (ed.) *Museums and the environment: a handbook for education.* New York: Arkville Press for American Association of Museums, 1971. 276 pp. List of publications: pp. 220-6.
A reference work for those wishing to mount exhibits or initiate educational projects on topics relating to the environment. Chapters on man and the environment, population, environmental pollution, creating and building environmental exhibits, added dimensions through the use of films, the emerging role of museums in environmental education, and programmes of action. Appendices include a list of organizations conducting environmental programmes.

341 Olofsson, U. K. (ed.) *Museums and children.* Paris: UNESCO, 1979. 195 pp. (Monographs on Education.) Select bibliography: pp. 183-95.

Compilation of papers on museum practice relating to children in 14 countries, worldwide.

342 Pitman-Gelles, B. *Museums, magic and children: youth education in museums*; ed. by C. Bannerman and A. Kendall. Washington (DC): Association of Science–Technology Centers, 1981. 262 pp. Bibliography: pp. 240–59.
Describes and discusses children's museums and science–technology centres in the USA. Eight chapters deal with aspects of youth education in museums, and a further 8 chapters describe particular programmes. Chapters on reference materials (mainly US) include 'Resources from museums'; 'Resource organizations'; 'Film producers and distributors'; and 'Selected periodicals'.

343 Pizzey, S. *Interactive science and technology centres*. London: Science Projects Publishing, 1987. 233 pp.
Part I describes 12 innovative projects in Europe, North America and Australia as described by their originators. Part II comprises chapters on designing and making exhibits, interacting with design students, setting up a workshop, market research, charitable trusts, formative evaluation and using volunteers.

344 Pöhlmann, W. *Ausstellungen von A–Z: Gestaltung, Technik, Organisation*. 2nd rev. ed. Berlin: Gebr. Mann Verlag, 1990. 338 pp. Bibliography: pp. 273–81. (Berliner Schriften zur Museumskunde, 5.)
Practical guide for professional or would-be designers to all aspects of the subject. Contains many helpful illustrations and examples.

345 Rouard-Snowman, M. *Museum graphics*. London: Thames and Hudson, 1992. 192 pp. Bibliography: p. 188.
A collection of high-quality graphics (330 illustrations – 179 in colour) commissioned by 59 art institutions in 10 countries. The introduction examines, among other topics, the use of graphics in art institutions, the growth of the museum movement, a brief history of graphics, graphics and national identity, the profession of the graphic artist, and the language of graphic design (glossary). For each museum there is a brief historical introduction and description of its graphic programme. Designers' biographies. Useful addresses.

346 Royal Ontario Museum. Communications Design Team. *Communicating with the museum visitor: guidelines for planning*. Toronto: Royal Ontario Museum, 1976. 518 pp. Selected bibliography: pp. 477–91.
Report prepared by the Communications Design team at the Royal Ontario Museum in Toronto in preparation for the complete redisplay of the museum galleries. Presents the findings from an extensive literature search, visits to museums, and consultations into all aspects of communication through exhibition. Includes discussions on learning and communications theory, design considerations, media selection and human responses.

347 Royal Ontario Museum. Discovery Room Working Group. *Hands on: setting up a discovery room in your museum or school.* Toronto: Royal Ontario Museum, 1979. 183 pp.
Reports a study investigating the feasibility of establishing a Discovery Room at the Royal Ontario Museum. Discusses the creation, launching and operating of a Discovery Room with evaluation and conclusions. Appendices give details of the components and their evaluation.

348 Screven, C.G. *The measurement and facilitation of learning in the museum environment: an experimental analysis.* Washington (DC): Smithsonian Institution Press, 1974. 91 pp. (Office of Museum Programs, Smithsonian Institution. Publications in Museum Behavior, 1; Smithsonian Institution Press publication, 5230.) References: pp. 88–91.
Describes experimental studies carried out at the Milwaukee Public Museum using audio-visual devices, portable response devices, public access teaching machines and programmed interactive exhibits to measure visitor reaction to exhibits and information retention. Appendices give audio-visual scripts and details of pre- and post-tests and self-testing machine questions.

349 Serrell, B. *Making exhibit labels: a step-by-step guide.* Nashville (Tennessee): American Association for State and Local History, 1983. 125 pp. Bibliography: pp. 115–16.
Manual of the theory and practice of producing exhibit labels. Covers planning labels for an exhibit; writing copy; composition and printing; readability, legibility and effectiveness; production, placement and mounting; and case histories. Address list of suppliers (USA).

350 Shettel, H.H. and others. *Strategies for determining exhibit effectiveness.* Washington (DC): US Dept. of Health, Education and Welfare, 1968. 2 vols. 243 pp. (ERIC Reports.) References: pp. 160–1.
An extensive study designed to develop research strategies and hypotheses for evaluating the effectiveness of exhibits. Based on an exhibit on the role of the federal government in science and technology.

351 Spencer, H. and **Reynolds, L.** *Directional signing and labelling in libraries and museums: a review of current theory and practice.* [London]: Royal College of Art, Readability of Print Research Unit, 1977. 117 pp. References pp. 109–11.
Reports a study which examines current practice in the provision of graphic information in libraries, museums and other information centres; reviews relevant research findings; and determines priorities for further research. Embraces directional signing and object labelling. Appendices list organizations consulted (international), and manufacturers of signing and labelling materials (UK).

352 Stansfield, G. *Effective interpretive exhibition.* Cheltenham: Countryside
 Commission, 1981. 68 pp. (CCP 145.) Bibliography: pp. 54–63.
A study which reviews research into the effectiveness of communication achieved
through exhibitions. Reviews the literature and collates the findings. Covers the
formulation of objectives, characteristics of exhibitions, the written word, media
selection, and evaluation.

353 Theobald, M.M. *Museum store management.* Nashville (Tennessee):
 American Association for State and Local History, 1991. 229 pp.
Expressly written for museum store managers. Includes store definition;
merchandising; educational role of related merchandise; product development;
retail pricing; ratios and inventory; and security. Provides examples of contracts,
licenses, shop designs, job descriptions, product labelling, etc.

354 Turner, I.K. *Museum showcases: a design brief.* London: British Museum,
 1980. 104 pp. (British Museum Occasional Paper, no. 29.) Bibliography:
 pp. 90–4.
The report of a study undertaken under a British Museum Design award,
sponsored jointly by the British Museum and the Royal Society of Arts. Intended
for designers and summarizing available information on the design of showcases.
Chapters on temperature and relative humidity, pollutants, lighting, types of
showcase, showcase security, lighting design and the visitor. Illustrations.

355 Veal, F.R. *Museum public relations*; cartoons by D. Downe. Manchester:
 Association of Independent Museums, 1983. 39 pp. (AIM Guideline, no. 5.)
A basic guide to museum public relations, aimed primarily at the indepen-
dent museum. Covers contacts with the media, writing press notices and
providing photographs. Useful appendices with sample press releases and
comments.

356 Velarde, G. *Designing exhibitions.* London: Design Council, 1988. 188 pp.
 Bibliography: p. 177.
A comprehensive monograph on the design of exhibitions with chapters devoted
to the exhibition; the designer; the brief; words; design; management; produc-
tion; completion; maintenance; and results. Glossary.

357 Witteborg, L.P. *Good show! A practical guide for temporary exhibitions.*
 Washington (DC): Smithsonian Institution Traveling Exhibition Service,
 1981. 172 pp. Bibliography: pp. 163–8.
Practical and descriptive guide to the production of temporary exhibitions, with
chapters on advance planning; preparation; fabrication; illumination; titles and
labels; installation; security; evaluation; the handicapped; tools; raw materials;
and sources. Well illustrated with drawings and diagrams.

358 Zetterberg, H. L. *Museums and adult education*. London: Evelyn, Adams and Mackay for ICOM, 1968. 100 pp. Bibliography: pp. 76–89.

A report prepared under a UNESCO/ICOM contract. Sets out to identify problems and potentialities of adult education in museums. Adopts a sociological and psychological approach. Analyses services provided to different sections of the community. Appendices include conclusions from ICOM Symposium on the Educational and Cultural Role of Museums (1964) and case studies from Russia and Mexico.

GENERAL DIRECTORIES (CONFERENCES, CURRENT RESEARCH, GRANTS, INDIVIDUALS, ORGANIZATIONS, TRAINING OPPORTUNITIES)

359 British Library Document Supply Centre. *Index of conference proceedings received*. Boston Spa (England): British Library Document Supply Centre, 1964–. Monthly, with annual, five- and ten-year cumulations.

A worldwide list of conference proceedings received by the BLDSC covering all subjects. Up to 1992, *c*. 280,000 conference titles had been listed, with *c*. 18,000 added annually. Arranged alphabetically by subject keywords taken from the title of the conference proceedings. Information given includes the date of the meeting, its title and where it was held. Delay: most meetings listed were held within the last 2 or 3 years, but publication delays can be considerable. A microfiche cumulation is available covering 25 years (1964–88); includes over 130 conferences under 'Museum' and related headings. Available online through BLAISE as CONFERENCE PROCEEDINGS INDEX. Also available on CD-ROM.

360 *Commonwealth universities yearbook: a directory to the universities of the Commonwealth and the handbook of their Association*. London: Association of Commonwealth Universities, 1914–. Annual. 4 vols.

Gives detailed information about universities in Commonwealth countries, which are listed alphabetically. Details include address, names of all officers, teaching staff (arranged by department), administrative and other staff, and general information including details of courses available. Appendices include details of university admission requirements and a select bibliography. Abbreviations for universities, degrees, etc. General index (institutions and topics, subjects of study); names index.

361 *Current research in Britain* (formerly: *Research in British universities, polytechnics and colleges*). Boston Spa (England): British Library Document Supply Centre, 1985–. Annual. 6 vols.

The national register of current research being carried out in universities, colleges and other institutions including museums, within the United Kingdom. The 1991

volume gave details of some 58,000 projects at over 400 institutions covering more than 4,000 individual departments. Divided into four main areas of study: physical sciences; biological sciences; social sciences; and humanities. Each area of study is arranged by institution and has its own series of indexes (name index; study area index; keyword index). 'Museum(s)' appears in the keyword index of all the volumes, with most entries in the *Humanities* volume, which has a separate section for research at museums and other institutions. Available online through PERGAMON INFOLINE.

362 *Encyclopedia of associations*. Detroit (Michigan): Gale Research, 1956–. Annual.
Vol. 1: *National organizations of the United States* lists (in the 27th ed.) over 23,000 national organizations of the USA arranged in broad subject sections, with details of membership, activities and publications. Name and keyword index; over 100 organizations are listed under 'museum' or 'museums'. Vol. 2 comprises geographic and executive indexes covering the material in vol. 1. Vol. 3 is a supplement listing newly formed associations. Further volumes cover international organizations and regional, state and local organizations. Available online through DIALOG (File 114). Also available on CD-ROM.

363 Farnell, G. *The handbook of grants: a guide to sources of public funding for museums, galleries, heritage and visual arts organisations*. Milton Keynes: Museum Development Company, 1990. 222 pp.
Gives information about the financial support from public sources available to museums and similar organizations in the UK. Lists over 140 different grant programmes in 2 sequences: 'UK grants' and 'National and regional grants'. Each entry includes a summary of the scheme, special conditions, details of grants, and a contact point. Index lists the names of the grant programmes and the areas of work which the various schemes support. Looseleaf format.

364 *The grants register*. London: Macmillan, 1969–. Every two years.
International directory of scholarships, fellowships, grants and similar financial aids, from government agencies and international, national or private organizations, available to students at or above graduate level and those who require further professional or advanced vocational training. Arranged alphabetically by grant-giving body with information on the type of assistance offered. Subject index; index of awards and awarding bodies.

365 Hyamson, A. M. *A dictionary of universal biography of all ages and of all peoples*. 2nd rev. ed. London: Routledge and Kegan Paul, 1951. 691 pp.
International index to the biographies of over 100,000 individuals worldwide (pre-*c*. 1950) prominent in all fields including museums.

366 International Council of Museums. *Directory*. Paris: ICOM, 1992. 560 pp.
The first part covers the structures of ICOM: ICOM presidents; general
conferences; Executive Council; international committees; regional organi-
zations; international affiliated organizations; honorary members; ICOM
Foundation; countries with ICOM members. The second part, arranged
alphabetically by country, lists for each country institutional members, institu-
tions with ICOM members, and individual members. Index of individual
members; country codes.

367 International directory of arts. Munich: Saur, 1952/3–. Annual. 2 vols.
Detailed lists of addresses and other information worldwide on all aspects of art,
the fine art trade and museum organizations. Arranged in subject groups:
museums and public galleries; associations; antique dealers and numismatics;
galleries; auctioneers; restorers; art publishers; art periodicals; and antiquarian
and art booksellers. Within these groups arranged by countries. No indexes.

368 International index of conservation research/Répertoire international de la recherche en
 conservation/ICCROM. Washington (DC): Smithsonian Institution, Conserva-
 tion Analytical Laboratory, 1988. 158 pp. Introductory material also in Fr.
Lists abstracts of conservation research being done in 1988 worldwide and not
yet published. Arranged by categories and sub-categories according to the type
of material or object under study.

369 Museum studies international (formerly: *Museum studies programs in the United*
 States). ICOM International Committee for the Training of Personnel, 1976–.
 Last published 1988.
Compilation, without comment, of museum training opportunities in the USA
and elsewhere known to the Office of Museum Programs. The 1988 edition
contained 460 entries. Arrangement: for the USA, by state and city; for
other countries, mostly by city. Information given includes name of institution,
type of programme offered, brief description of programme, eligibility require-
ments and contact person. Index by category; index by discipline; index by
institution.

370 Museums and Galleries Commission, Conservation Unit. *Conservation*
 sourcebook. London: HMSO, 1991. 122 pp.
Gives information on British organizations of relevance to the conservation of
artefacts and buildings. Organizations are arranged alphabetically. Information
given includes name, address and telephone number, and summary of activities.
Appendix of international conservation organizations; appendix of full-time
training courses in conservation in Britain. Subject index.

371 National faculty directory: an alphabetical list, with addresses, of approximately
 600,000 members of teaching faculties at junior colleges, colleges, and universities in the

United States and at selected Canadian institutions. Detroit (Michigan): Gale
Research, 1970–. Irreg. 4 vols.
A single alphabetical list of names and addresses.

372 *The world of learning.* London: Europa Publications, 1947–. Annual.
A world directory of academies, learned societies, research institutes, libraries
and archives, museums and art galleries, universities and colleges, arranged
alphabetically by country. Details include address, names of principal officials
(staff below Reader level are not included), a list of publications, descriptions
of activities and (where available) numbers of teachers, students or members.
Section on international scientific, educational and cultural organizations, and
a list of abbreviations. Index of over 25,000 institutions, but no index of persons.

DIRECTORIES OF MUSEUM PRODUCTS AND SERVICES

373 de Bary, I. (compiler) *Guide–annuaire muséographique.* Paris: Muséodoc,
1989. Binder and looseleaf cards.
Directory of manufacturers and suppliers of exhibition materials, services and
products. Over 2,000 products and services are registered. Index by supplier and
index by subject.

374 Heath, M. *The directory: products and services for museums, galleries, historic houses,
heritage and related arts organisations.* Milton Keynes: Museum Development
Company, 1991. 520 pp.
Lists specialist British products and services available to museums and similar
organizations in the heritage sector. Arranged in two sections: 'Products' and
'Services', each classified according to the type of product or service supplied.
Each entry includes address, contact name, summary of each product or service,
and a list of clients. Index to names of consultants and suppliers.

DIRECTORIES OF MUSEUMS

International directories

375 Hudson, K. and **Nicholls, A.** *The directory of museums and living displays.*
3rd ed. London: Macmillan, 1985. 1,064 pp.
An extensive list of nearly 35,000 museums worldwide, including living displays,
i.e. the world's zoos, aquaria, botanical gardens and living-history farms.
Criterion for selection was that the establishment should be regularly open to the
public, have a permanent collection of some kind or a coherent exhibition policy,
and have made efforts to present and interpret what is on display. Information
given for each museum includes name, address and a brief description of the

collections. Arranged alphabetically by country, and within each country alphabetically by place, preceded by a brief summary of the national situation. Also included: a note on museums in the context of population and national income, and a glossary of terms used.

The 2nd ed. (1981) included a select bibliography of national museum directories and articles, arranged under countries.

376 *Museums of the world.* 4th rev. and enlarged ed. Munich: Saur, 1992. 651 pp. (Handbook of International Documentation and Information, vol. 16.) Lists nearly 24,000 museums worldwide from 182 countries. Information given for each museum includes name, address, museum type, year of founding and a summary of collections and facilities. Arranged alphabetically by country, and within each country alphabetically by place. Alphabetical index of museums; person index; subject index.

The 2nd ed. (1975) included a short bibliography of international and national museum directories.

The 3rd ed. (1981) included a list of national and international museum associations.

Specialized museums

Art

377 Jackson, V. (ed.-in-chief) *Art museums of the world.* New York and London: Greenwood Press, 1987. 2 vols. Selected bibliography; pp. 1517–42.
Scholarly articles on the history and collections of selected major art museums worldwide. Arranged alphabetically by country, place and name of institution. Each entry includes the history of the museum with development of the collections, the administrative structure and funding of the museum, a selective analysis of its collections, and a selected bibliography of museum publications and references from other sources. An introduction gives an outline history of art museums. Glossary of terms.

Children's museums

378 Zucker, B.F. *Children's museums, zoos, and discovery rooms: an international reference guide.* Westport (Connecticut): Greenwood, 1987. 278 pp. Selected bibliography: pp. 241–60.
Profiles of 235 children's museums or museums that have special children's areas, worldwide (a high proportion are in the USA). Arranged alphabetically by country, state or province (USA and Canada), city and institution. Each entry includes a brief history and details on the building, collections, special facilities, staff, hours of opening, publications and/or reference sources, etc. Appendices comprise alphabetical listing of institutions; chronological listing of institutions; and classified listing of institutions. Index.

Herbaria

379 *Index herbariorum: a guide to the location and contents of the world's public herbaria*.
Utrecht: International Bureau for Plant Taxonomy and Nomenclature of the
International Association for Plant Taxonomy, 1952–. (Regnum vegetabile.)
Part 1: *The herbaria of the world*. 7th ed. 1981; ed. by P.K. Holmgren and
W. Keuken. 458 pp.
List of *c*. 1,500 herbaria arranged alphabetically by town and including address,
telephone number, date of foundation, number of specimens, description, details
of staff, specialities in research, loan arrangements, publications, etc. Index to
important collections, herbarium abbreviations and personal names.
Part 2: vol. 1 – *Collectors' index*.
Gives details of individual collectors arranged alphabetically by name, with codes
to indicate where specimens are housed.

Mineral collections

380 International Mineralogical Association. *World directory of mineral collections*. 2nd ed. Copenhagen: Geological Museum, 1977.
Lists mineral collections in 32 countries. Information given includes name
(original and in English); address; name of person in charge; total specimens
(usually divided into minerals, rocks, ores, gems, meteorites/tektites); uses of the
collection; speciality; loan facilities; exchange arrangements; catalogues; and
times of admission.

Motor vehicles

381 Nicholson, T.R. *The world's motor museums*. London: Dent, 1970. 143 pp.
Arranged alphabetically by country. Information given includes name and
address; opening times; and brief description of the collection, with mention of
outstanding vehicles.

Musical instruments

382 Jenkins, J. (ed.) *International directory of musical instrument collections*. Buren
(Netherlands): Knuf, for ICOM, 1977. 175 pp.
Lists *c*. 400 collections in about 100 countries, arranged alphabetically. Includes
instrument collections that are part of a more general museum, and also
private collections. Information given includes name, address and telephone
number; opening times; summary of collection; services available; and any
publications.

Natural sciences

383 *Directory of the natural sciences museums of the world*; compiled by H.G. Rodeck;
ed. by R. Muzeelor. Bucharest: Romanian National Committee of ICOM,
1971. 380 pp.
Lists and briefly describes *c*. 660 natural sciences museums worldwide. Arranged

alphabetically by country. Includes address, details of staff, hours, fees, activities, exhibits and research collections. Countries and localities index.

Palaeontology

384 Cleevely, R.J. *World palaeontological collections*. London: British Museum (Natural History)/Mansell, 1983. 365 pp.
Designed to help locate collections made by named individuals. The main part of the book is an alphabetical index of collectors, with dates and brief biographical notes and museums where collections are housed. Also includes index of institutions and collection holdings, arranged mainly by continent; bibliographies on the history of palaeontology and fossil collecting, and collections and collecting; biographical and other reference sources; bibliography of published catalogues of cited material.

Science and technology

385 *The 1992 ASTC/CIMUSET directory*. 9th ed. Washington (DC): Association of Science–Technology Centers, 1992. 63 pp.
Lists museums of science and technology worldwide. ICOM's International Committee of Museums of Science and Technology (CIMUSET) lists its institutional members as part of the ASTC Directory.

Museums by continent/country

Africa

386 *Directory of African museums/Répertoire des musées d'Afrique*; prepared by the UNESCO–ICOM Documentation Centre (later: Museum Information Centre). Paris: UNESCO, 1981. 223 pp.
Selective listing of major African museums, compiled from information held in the UNESCO–ICOM Documentation Centre [447]. Arranged alphabetically by country, and by town within each country. Information given includes address, name of director or curator, opening hours and admission charges, status, historical background, nature of the collections, publications and services. Where possible, a bibliography is included for each country and for some museums.

387 *Directory of museums in Africa*. London: Kegan Paul International Ltd, 1989. 208 pp. Indexes.
The Directory's aims are twofold. First, recognizing that African museums have a primary role in affirming cultural identity on the continent, it aims to encourage local communities to use museum resources. Secondly, it provides visitors and scholars from other parts of the world with a detailed view of the diversity of African culture and is an invaluable guide to the rich study and research material in African collections.

Organized alphabetically by country, city and institution, the entries (En. and Fr.) consist of address, chief officer, opening hours and admission charges, status,

historical background, type of collection, publications and services. Indexes by city, institution and type of collection.

Argentina

388 *Argentina y sus museos: guía/Argentina and its museums: directory/L'Argentine et ses musées: répertoire*. Buenos Aires: Secretaria de Cultura de la Nación, Dirección Nacional de Museos, 1986. 288 pp.
Directory of over 500 museums in Argentina, providing information in three languages (En. Fr. Es.). Arranged alphabetically by province, location and museum. Maps. Index of museums; index of locations.

Asia

389 *Directory of Asian museums/Répertoire des musées d'Asie*; prepared by the UNESCO–ICOM Documentation Centre (later: Museum Information Centre). 3rd ed. Paris: UNESCO, 1985. 295 pp.
Selective listing of major Asian museums, compiled from the literature held in the UNESCO–ICOM Documentation Centre. Arranged alphabetically by country, and by city within each country. Information given includes address, details of staff, opening hours and admission charges, status, historical background, nature of the collections, publications and services. Where possible, a bibliography is included for each country and for some museums. Index of provinces by country (covers certain countries).

390 *A who's who in Asian and Pacific museums*. Seoul: ICOM Asia Agency, 1984. 264 pp.
A list comprising 517 persons from 25 countries. Arranged alphabetically by country. Based on results of a questionnaire.

Australia

391 *Australian art museums and public galleries: directory*. 2nd ed. Fitzroy (Australia): Art Museums Association of Australia Inc., 1991. 102 pp.
Information relating to collections, staff and full contact details, public programmes, and access.

392 Stanbury, P. *Discover Australia's museums*. Ultimo: Museums Association of Australia, 1983. 71 pp.
Popular, selective guide. Arranged geographically by state. Information given includes address, telephone number, opening hours, brief details of collections and publications. Photographs.

Austria

393 Dawid, M. and **Egg, E.** *Der österreichische Museumsführer in Farbe: Museen und Sammlungen in Österreich*. Innsbruck: Pinguin-Verlag; Frankfurt am Main: Umschau-Verlag. 1985. 452 pp.

Belgium

394 *Guide des musées 1991–1992.* Brussels (Belgium): Ministère de la Communauté française, 1991. 315 pp.

Bolivia

395 Oporto, L. P. *Museos, parques naturales y educación en Bolivia.* La Paz (Bolivia): Centro de Estudios Sociales (CENDES), 1989.

Brazil

396 Santos, F. H. and others. *Catálogo dos museus do Brasil.* Xerox do Brasil SA, for the Associação Brasileira de Museologia, 1984. 50 pp.
Arranged geographically by town.

British Isles

397 Hudson, K. *The good museums guide: the best museums and art galleries in the British Isles.* 2nd ed. London: Macmillan, 1982. 282 pp.
The first consumer guide to museums and art galleries in the British Isles. Lists and assesses the 400 'best' museums and art galleries and provides details of opening hours, car parking, refreshments, shops, seating, facilities for the handicapped, attitudes of staff, suitability for children and whether there is an admission charge or not. List of museums with outstanding special-interest collections. Maps. Indexes of museums, people, places.

398 Hudson, K. and **Nicholls, A.** *The Cambridge guide to the museums of Britain and Ireland.* Cambridge: Cambridge University Press, 1987. 461 pp.
A comprehensive guide to over 2,000 museums of Great Britain and Ireland arranged alphabetically by town. Each museum has a short description and symbols to indicate whether there is an admission charge, car park, refreshment facilities, facilities for the disabled, guided tours, etc. Locations maps. Black and white photographs and colour plates. Index of museum names; index of subjects; index of museums associated with individuals.

399 *Museums yearbook, including a directory of museums and galleries of the British Isles* (formerly (to 1975): *Museums calendar*). London: The Museums Association, 1956–. Annual.
Directory of the museums and art galleries of the British Isles and their staff, alphabetically arranged by place. Includes also a list of related organizations, Area Museum Councils, Regional Federations of British Museums, Regional Arts Boards and Associations, Specialist Groups, other museums associations, Long Courses, and a directory of products and services. A further section is a guide to the activities and membership of the Museums Association, including details of the functions of the organization and its codes of practice and guidelines which it endorses. Index to museums and art galleries of the British Isles and related organizations.

Bulgaria

400 Rajcev, M.G. *Muzei, starini, i pametnici v Balgarija* (Museums, antiquities and monuments in Bulgaria). Sofia: Nauka i Izkustvo, 1981. 344 pp.

Canada

401 Canadian Museums Association. *The official directory of Canadian museums and related institutions/Répertoire officiel des musées canadiens et des institutions connexes*; 1993–4. Ottawa: Canadian Museums Association, 1992. 441 pp.
Details of over 2,000 Canadian museums and related institutions, listed alphabetically by province, within province by location and within each location by institution name. Information given includes name, year of opening, address, telephone and fax numbers, names of staff, brief description of collections and activities, publications, admission information and governing authority. List of institutions by category; alphabetical index of institutions; alphabetical index of personnel. Also includes a list of museums associations, related organizations and government agencies, both national and regional, and a selection of international and foreign organizations.

Chile

402 *Museos de Chile*. Santiago: Museo Viajero Ltda. 1984. 48 pp.
List of museums and national parks in Chile, arranged alphabetically by region. Includes address, telephone number, opening hours and descriptions of collections for the more important museums. Some photographs.

Colombia

403 Dussán de Reichel, A. *Guía de los museos de Colombia*. Bogotá: Instituto Colombiano de Cultura, Ministerio de Educación Nacional, 1973. 141 pp.

404 *Museos de Colombia 1986*. Bogotá: Asociación Colombiana de Museos, Institutos y Casas de Cultura (ACOM), 1986. 71 pp.
Directory of museums in Colombia, arranged by city.

Costa Rica

405 Gutiérrez, C.R. *Museos de Costa Rica*. San José: Dirección General de Museos, 1985. 40 pp.

Czechoslovakia and its successor states

406 Pubal, V. and others. *Múzeá a galérie v ČSR* (Museums and galleries in the Czech Socialist Republic). Prague: Olympia, 1985. 240 pp.
A guide to *c*. 600 museums, galleries, monuments and specialized exhibitions of national, regional, district and local significance, from 445 places. Arranged alphabetically by place. Information given includes address, telephone number, opening hours, history of the building, details of the collections, publications, etc. Subject index; author index (writers, artists, political figures, etc.).

Denmark

407 Birkebaeaek, F. *Museumsguide Danmark*. Viborg: Museumstjenesten, for Danske Museer, 1992. 242 pp. En. Da. De.
Comprehensive guide to all 148 Danish state or state-subsidized museums.

408 Reimert, E. (ed.) *Alle danske museer*. Copenhagen: Svenson, 1976. 266 pp.
List of Danish museums, arranged regionally. Information given includes address, opening hours and details of collections. Combined index and subject overview. Photographs.

Europe

409 *Handbuch der Museen/Handbook of museums*. Bundesrepublik Deutschland, Deutsche Demokratische Republik, Österreich, Schweiz, Liechtenstein [ed. by H. Gläser and others]. 2nd rev. ed. Munich; London: Saur, 1981. 779 pp.
Contains detailed information on over 3,400 museums in German-speaking countries. Arranged by country and by place within each country. Each entry contains the name and address of the museum, telephone number, sponsor or parent organization, name of the director and assistant director, hours of operation, admission price, number of exhibition rooms, year of the latest installation, and information on tours and special offers. Also included are data on the organization, nature, contents and history of the collections; special facilities; and plans for future expansion. Entries for the larger museums also include notes on the organization of the museum departments, research facilities, laboratories, associated foundations, and educational programmes with name of director. Geographical index; index of museum names; subject index.

410 Hudson, K. and **Nicholls, A.** *The Cambridge guide to the museums of Europe*. Cambridge: Cambridge University Press, 1991. 509 pp.
A guide to *c.* 2,000 selected museums of Western Europe. Countries covered are: Austria, Belgium, Britain, Denmark, Finland, France, Germany, Greece, Ireland, Italy, Liechtenstein, Luxembourg, Malta, Monaco, the Netherlands, Norway, Portugal, Spain, Sweden, Switzerland. Each museum has a short description and symbols to indicate whether there is an admission charge, car park, refreshment facilities, facilities for the disabled, guided tours, etc. Location maps. Black and white photographs and colour plates. Index of subjects; index of museum names; index of museums associated with individuals.

Finland

411 *Suomen museot* (Finnish museums). Helsinki: Suomen Museoliitto, 1990. 467 pp.
Guide to 531 Finnish museums, arranged by place. Details include address, opening hours and a brief summary of the collections. Illustrations. List of collective bodies associated with museums; alphabetical index of museums; index of museums by type.

France

412 Cabanne, P. *Guide des musées de France*. 3rd ed. Paris: Bordas, 1984. 567 pp.
Lists 1,700 museums. Arranged by *département* (with an introduction to each
département including colour photos of outstanding objects), then by town. Infor-
mation includes address, telephone number, opening hours, entrance fee and
details of collections. Section on *départements* overseas. Subject index to type of
collection; index of towns.

413 *Musées et services publics: guide des services culturels*. 2nd ed. Paris: Réunion des
musées nationaux, 1992. 431 pp.
Comprehensive guide to museums in France and their public services: lecture
programmes, guided visits, programmes for children, research facilities, con-
certs, films, etc. Also includes details of ancillary activities, such as restaurants,
bookstores and museum shops, on the premises.

Greece

414 Kokkines, S. *Ta mouseia tes Ellados: odegos, istoria, thesauroi, bibliographia* (The
museums of Greece: guide, history, treasures, bibliography). Athens: Estia,
1979. 325 pp.
Arranged geographically. Entries for each museum give address, opening
days, opening hours, a short description of the collections, and a bibliography.
Appendices include laws relating to museums, numbers of visitors and museums
arranged by subject. Index of museums and collections.

Guatemala

415 Luján Muños, L. *Guía de los museos de Guatemala*. Guatemala: Instituto de
Antropología e Historia de Guatemala, Consejo Internacional de Museos,
1971. 35 pp.

India

416 Agrawal, U. *Brief directory of museums in India*. 3rd ed. New Delhi: Museums
Association of India, 1980. 148 pp.
Arranged by city. Information includes name and address of museum, telephone
number, opening hours, name of controlling authority, types of collection and
publications.

Iran

417 *Guide to museums in Iran*. Tehran: Ministry of Islamic Guidance, Department
of Cultural Research and Planning, 1985. 92 pp. En. Ar.
Information given for each museum includes address, opening hours, brief details
of holdings, etc.

Israel

418 Rahmani, L. Y. *The museums of Israel*; photographs by P. Larsen. London: Secker and Warburg, 1976. 236 pp.
Describes 60 museums in Israel, with numerous illustrations. Arranged regionally, with a summary of the contents of each museum.

419 Rosovsky, N. and **Ungerleider-Mayerson, J.** *The museums of Israel.* New York: Abrams, 1989. 256 pp.
Brief descriptions of 120 museums in Israel, arranged in 8 regions. Index of museums by subject; index of museums listed alphabetically; index of museum locations.

Italy

420 Sgarbi, V. *Tutti i musei d'Italia.* Rozzano: Editoriale Domus, 1984. 855 pp.
Regional arrangement. Information given includes address and telephone number, opening hours and types of collection. Regional index of museums; index of places.

Japan

421 Roberts, L. P. *Roberts' guide to Japanese museums.* Tokyo; New York; San Francisco: Kodansha International, 1978. 359 pp.
Selective listing of Japanese museums with 355 entries, arranged alphabetically. Information given includes address, telephone number, opening hours and details of the collections. Glossary. Four indexes of museums: by Japanese names; by branch museums and other collections; by prefectures; by types of collection.

Korea

422 *Museum directory of Korea*; compiled by the National Museum of Korea and the ICOM Agency for Asia and the Pacific. Seoul: Tong-Chun Moonhwa Publishing Co., 1988. 213 pp.
Lists national, public and private museums, including university and college museums, according to province. Botanical gardens, parks, zoos and aquaria are not included. Each notice includes a short description of the museum's history and collections, as well as services available (parking, cafeteria, photography, shop, facilities for the handicapped).

Latin America and the Caribbean

423 *Directorio de museos de América Latina y el Caribe*; prepared by the ICOM Cuban National Committee. Havana: Editorial José Marti for the ICOM Cuban National Committee, 1991. 346 pp. Es.
Lists Latin American and Caribbean museums by country, province and town. Each entry gives the full address, opening times, type of collections and status of the museum.

Malaysia

424 Mohamed Zulkifli bin Haji Abdul Aziz. *Directory of museums in Malaysia.*
Kuala Lumpur: Muzium Negara, 1977. 111 pp.
Covers National Museum and museums of national importance; state museums;
departmental museums; art gallery; zoo and aquarium; parks; and caves.

Mexico

425 Arriaga, A. M. and **Gonzales, M. C.** *Atlas cultural de México: museos.* Mexico,
DF: SEP/INAH/Planeta, 1987. 188 pp.
Guide to museums in Mexico arranged by geographic region, with historical
résumés.

Netherlands

426 *Nederlands Museumland.* The Hague: CIP–Gegevens Koninklijke Bibliotheek,
1988.
Popular guide to 550 Dutch museums. Index of place names; index of themes.

New Zealand

427 Thomson, K. W. *Art galleries and museums of New Zealand.* Wellington: Reed,
1981. 210 pp.
A general introductory chapter on New Zealand's art galleries and museums
and the use made of them is followed by descriptions of the principal galleries
and museums and the work of the New Zealand Historic Places Trust. Index
of art galleries and museums (arranged by region) giving address, brief details
of collections, opening hours, staff, etc. Appendices list and give some details of
less easily accessible special collections, of more important private museums, of
museums under development and of related buildings or displays by organi-
zations such as the Historic Places Trust or the National Parks Authority.
Index.

Norway

428 Espeland, E., Sveen, K. and **Tonseth, B.** (eds.) *Museer i Norge.* Oslo:
Museumsnytt, 1988. 183 pp. (Special issue of *Museumsnytt*, 3 (1988).)
Directory of museums in Norway arranged by region and by type of museum.

Pakistan

429 Dar, S. R. *Repositories of our cultural heritage: a handbook of museums in Pakistan
(1851–1979).* Lahore: Lahore Museum, 1979. 133 pp.

430 *Museums and art galleries in Pakistan.* Pakistan Society of Archaeology,
Archives and Museums, 1988.

Panama

431 Horna, J. E. *Museos de Panamá*. Panama: Instituto Nacional de Cultura de Panamá, Dirección Nacional del Patrimonio Histórico, 1980. 129 pp. Bibliography: p. 125.
Directory of museums in Panama.

Peru

432 Ravines, R. *Los museos del Peru*. Lima (Peru): Dirección General de Museos, Instituto Nacional de Cultura, [1989].

Philippines

433 Tantoco, R. B., Caberoy, F. F. and **Napao, J. M.** *Directory of museums in the Philippines*. Manila: National Museum of the Philippines, 1984. 96 pp.
Arranged alphabetically by name of museum. Information includes address, telephone number, type of museum, details of collections, opening hours and staff members.

Poland

434 Maisner-Nieduszyńska, J. and **Pawłowska-Wilde, B.** *Muzea w Polsce: informator* (Museums in Poland: a guide). Warsaw: Zarząd Muzeów i Ochrony Zabytków, 1986.
Details of 525 Polish museums.

Portugal

435 Santos, V. P. dos. *Roteiro dos museus de Portugal*. 3rd ed. Lisbon: Instituto Português do Património Cultural, 1981. 86 pp.

Romania

436 Mihalache, M. *Guide des musées de Roumanie*. Bucharest: Editions Touristiques, 1972. 218 pp.

Russia

437 Antonova, I. A. (ed.) *Museums in the USSR*. Moscow: Central Museum of the Revolution, 1989.

South-East Asia

438 *The directory of the museums of ASEAN*. Singapore: ASEAN Committee on Culture and Information, 1988. 219 pp.
Covers Brunei, Indonesia, Malaysia, the Philippines, Singapore and Thailand. Each museum entry includes name of museum, telephone number, brief description, objective, history, collections, exhibition galleries, staff, facilities, educational activities, publications, hours of opening and admission charges. Colour illustrations.

Spain

439 Sanz-Pastor Fernández de Piérola, C. *Museos y colecciones de España.*
Madrid: Ministerio de Cultura, 1991. 780 pp.
List of Spanish museums, arranged by province. General bibliography on
museums in Spain. Details of museum legislation. Subject index; title index;
geographic index.

Sweden

440 Nyström, B. (ed.) *Museiguiden: vägledning till svenska museer.* Stockholm: LTs
Förlag/Svenska Museiföreningen, 1984. 135 pp.
Guide to Swedish museums, arranged by province. Information given includes
name, address, opening hours, etc. with brief description of the collections
(summary in En.). List of places; alphabetical list of museums; list of museums
by type.

Syria

441 *Catalogue des musées et sites archéologiques en Syrie.* Damascus: Direction
Générale des Antiquités et des Musées, 1979. 25 pp. Fr. Ar.
Arranged geographically by region. Information given includes date of founding,
brief details of the museum and any publications.

Thailand

442 *Museum directory in Thailand.* Bangkok: National Museum, Department of
Fine Arts, 1974. 290 pp. Th. En.

United States

443 *The official museum directory* (formerly: *Museums directory of the United States and
Canada*). Washington (DC): American Association of Museums/National
Register Publishing Co., 1971-. Annual.
An extensive list of over 7,000 institutions in the USA. Information given for
each museum includes name, address, telephone number, year of founding,
personnel, governing authority, summaries of collections, research fields,
facilities, activities, publications, hours and admission prices, and membership
charges. Arranged by states and territories. Includes also details of the American
Association of Museums, its Council, staff, regional conferences and regional and
state representatives; a list of AAM accredited museums; state/province museum
associations; state museum co-ordinators; regional arts organizations; state arts
agencies; NEA regional representatives; state humanities committees; other
cultural organizations; and international organizations and museum associa-
tions. Index of institutions; index of personnel (directors and department heads);
list of institutions by category.
A separate Product and Service directory lists over 1,600 museum suppliers.

Yugoslavia and its successor states

444 Adresar muzeja i galerija Jugoslavie. *Informatica Museologica*, 3 (1984), 68–80. Cr. (abstracts in En.)
List of addresses of museums and galleries in the then Yugoslavia.

MUSEOLOGICAL DICTIONARY AND GLOSSARY

445 Blanchet, J. and **Bernard, Y.** 1989. *Glossary of museology*. Ottawa: Canadian Government Publishing Centre, Supply and Services Canada, 1989. 263 pp. En. Fr.
Contains 2,900 entries on the most important concepts in the field of museology. Gives explanatory notes for certain general concepts (e.g. cultural property, heritage, preservation) but not, unfortunately, for other, more technical ones (e.g. carbon dating).

446 *Dictionarium museologicum*; compiled by the ICOM International Committee for Documentation Working Group on Terminology and the National Centre of Museums; eds.-in-chief: I. Éri and B. Végh. Budapest: Hungarian Esperanto Association, 1986. 829 pp.
Aims to promote the development of a unified terminology for all branches of museum work. Provides a multilingual vocabulary of the major technical terms used in museums. Arranged in 2 main sections: a listing of terms in 20 languages; and the 20 alphabetical word indexes by language. Also includes an alphabetical listing of international museological organizations (ICOM, its international committees and other international bodies) in the 20 languages.

PART III

List of Selected Organizations

List of Selected Organizations

Part III of this *Keyguide* is a list of selected museological organizations of various kinds. It is arranged in two parts: international organizations; and organizations arranged alphabetically by country. The international section is subdivided into International Council of Museums (ICOM), ICOM regional organizations, ICOM international committees (arranged alphabetically by subject keyword), international organizations affiliated to ICOM (arranged alphabetically by subject keyword), and other international organizations (arranged alphabetically by title).

Information on countries not represented in this list can be obtained through the list of chairmen of ICOM national committees which appears in each issue of *ICOM News* [69].

The organizations are of various kinds; committees and professional associations predominate, but also included are government bodies, councils, congresses, institutions, etc.

The information given for each organization comprises its name, contact point, address, telephone, telex and fax numbers (where known), a note of aims and activities, and details of publications (where appropriate). Names of personnel have deliberately not been given since these change in the course of time. Names of current personnel for ICOM, its international committees and international organizations affiliated to ICOM can be found in the latest issue of *ICOM News* [69]. Names of current personnel at the organizations for many of the countries listed can be found in some of the latest national museum directories such as the *Museums yearbook* [399], *The official museum directory* [443] and *The official directory of Canadian museums and related institutions* [401].

All the organizations listed are willing to supply information.

An asterisk in front of an organization's name indicates that it did not reply to the questionnaire sent for the 2nd edition.

INTERNATIONAL ORGANIZATIONS

447 International Council of Museums (ICOM)

Maison de l'UNESCO, 1 rue Miollis, 75732 Paris Cedex 15, France (Tel: 33 1) 47 34 05 00; Fax: (33 1) 43 06 78 62).

Founded in 1946. An international, non-governmental and professional organization open to all members of the museum profession worldwide. Membership (1992): *c.* 8,000 individual and institutional members from 120 countries. Has consultative status with the UN and UNESCO [490] and co-operates closely with UNESCO [490], ICOMOS [488] and ICCROM [487] and with other national, regional or international, inter-governmental and non-governmental organizations, with authorities responsible for museums and with specialists of other disciplines. ICOM works through: (1) national committees in 87 countries; (2) international committees covering specialist museum disciplines (costume, applied art, etc.; see below [451]–[473]; (3) international organizations affiliated to ICOM (International Congress of Maritime Museums, etc.; see below [474]–[483]). Current information on ICOM, its national and international committees, and international organizations affiliated to ICOM can be found in the latest issue of *ICOM News* [69]. This includes lists of staff in the ICOM Secretariat and the UNESCO–ICOM Museum Information Centre (see below) and members of the ICOM Executive Council, a list of chairpersons and secretaries of ICOM international committees [451]–[473], a list of chairpersons and secretaries of affiliated international organizations [474]–[483], and a list of chairpersons of ICOM national committees.

ICOM administers the UNESCO–ICOM Museum Information Centre, a specialized library for museology and museum operations (open 1400 to 1730 Monday to Friday for ICOM members; visitors should contact the staff). Holdings are unique, covering publications and documents on museology worldwide in almost every language. Most of the collection dates from the 1950s although a few early publications go back to 1927. The indexing of periodicals, documents and monographs is done by the staff of the Centre and information entered into the computerized database (ICOMMOS) which is shared with the ICOMOS Documentation Centre [488]. Information is gathered from monographs (works on museology, conference proceedings, research reports, catalogues of permanent collections and temporary exhibitions, ICOM publications, directories); periodicals (museological periodicals, annual reports, periodicals issued by museums, museum associations and cultural institutions); and documents (brochures and pamphlets, unpublished working documents, legislation, files compiled from press clippings and ephemera). The Centre's roles

include supporting ICOM staff and providing service to ICOM members. Its priorities are bibliographic control of museum literature, development of directories to museums, and the provision of access to its own collections (approx. 3,500 monographs, 12,000 guides, catalogues, etc. and 600 periodical titles). It has an automated catalogue of about 35,000 references to published literature. The Centre can provide bibliographies on selected subjects; literature searching; orientation for further research and contacts; and short lists of museums by specialization.

Publications: *International Museological Bibliography/Bibliographie Muséologique Internationale* [38]; *Basic museum bibliography/Bibliographie muséologique de base* [25]; *Dictionarium museologicum* [446]; *Directory of Asian museums/Répertoire des musées d'Asie* [389]; *Directory of African museums/Répertoire des musées d'Afrique* [386]; *ICOM News* [69]; *Directory* [366]; various monographs, including conference proceedings.

448 ICOM Foundation

c/o International Council of Museums, Maison de l'UNESCO, 1 rue Miollis, 75732 Paris Cedex 15, France (Tel: 33 1) 47 34 05 00; Fax: (33 1) 43 06 78 62). Established in 1965 to promote co-operation between museums and members of the museums profession, and the part played by museums in communities at the local level. Raises funds for ICOM's activities and to sponsor specific projects. Particularly active in providing ICOM members from less favoured countries with assistance to participate in museum conferences and workshops.

ICOM regional organizations

449 ICOM Asia–Pacific Organization

450 ICOM Latin America and the Caribbean Regional Organization

Co-ordinates and motivates activities (meetings, seminars, courses, etc.) between ICOM national committees of the region.

Publications: *Chasqui/Messenger* (annual; information about regional committees and short articles about museum topics); *Cuenca* (every three years; contains reports of meetings, seminars, courses, etc. in the region and details of events organized by national committees of the region).

ICOM international committees

451 *International Committee for Museums of Applied Art (ICAA)

Encourages studies and visits for members of ICOM interested in applied art.

Publications: *Lettre d'Information* (includes reports of meetings, notes of exhibitions, lists of members).

452 *International Committee of Museums of Archaeology and History (ICMAH)

453 International Committee on Architecture and Museum Techniques (ICAMT)
Interested in exchange of information and expertise in all subjects related to museum building, including exhibition design.
Publications: *Brief* (newsletter).

454 *International Committee for Conservation
Founded in 1967. Aims: to attain a high level of competence in conservation and the study of works of art by establishing contact between those responsible for cultural treasures: conservators, researchers, physicists, chemists and restorers; to develop means of preventive conservation within museums; to accumulate information on materials and workshop methods; to promote study and scientific or technological laboratory research; to distribute the results of such investigations through publications or specialized working meetings; and to inform the general public and those responsible at a national or regional level, either directly or through the media, of the action needed to preserve our cultural heritage. Membership (1986): over 700.

Working Groups operate in the following areas: ethnographic materials; natural history collections; control of bio-deterioration; lighting and climate control; care of works of art in transit; theory and history of restoration; training in conservation and restoration; documentation; scientific examination of works of art; wet organic archaeological materials; textiles; stone; metals; graphic and photographic documents; resins; leather and similar objects; mural paintings and mosaics; easel paintings on rigid support; icons; polychromic sculpture; structural restoration of paintings on canvas; glass ceramics and related materials; rock art; furniture; and reference materials. The Committee meets for a week every 3 years in order to report on developments in research in the specific areas of the Working Groups and to establish a programme of activities for the next 3-year period.

Publications: *Newsletter* (1983–); some Working Groups produce their own newsletters. Before the triennial meeting mentioned above, Working Groups submit a report to their co-ordinator; once accepted, these reports are published in the Pre-prints of the meeting, distributed, and put on sale at ICOM [447] and ICCROM [487]. They constitute a detailed account, every 3 years, of the state of research and practical applications in the field of conservation. Pre-prints published so far: Venice (1975, 2 vols.); Zagreb (1978, 2 vols.); Ottawa (1981, 4 vols.); Copenhagen (1984, 2 vols.); Australia (1987); Dresden (1990, 2 vols.).

455 International Committee for Museums and Collections of Costume
Established as a forum for museum professionals committed to the study, interpretation and preservation of all aspects of apparel. Dissemination of information is done through specialized sub-committee projects, bibliographies, newsletters, publication of selected research projects, and an annual meeting at which papers are given and discussion takes place around an established theme.

456 International Committee for Documentation (CIDOC)
The international focus for the documentation interests of museums and similar organizations. Has over 500 members in 50 countries. Members include documentation specialists, registrars, computer managers, system designers, advisers and trainers. Benefits of CIDOC membership include receiving a regular Newsletter with reports on meetings, projects and initiatives; taking part in research organized in Working Groups; and attending and contributing to annual conferences.

Each annual conference includes plenary sessions with invited keynote papers and reports on documentation initiatives; Working Group sessions during which members of the Groups pursue their projects; concurrent topical sessions on specific issues; and visits to museums to review their documentation practices. When possible a Study Tour and Seminar are scheduled around the conference itself.

The Working Groups are the active arm of CIDOC:

The Archaeological Sites Working Group works with national sites and monuments organizations and the Council of Europe in the development of standards for site documentation.

The Data Model Working Group (formerly: the Reconciliation of Standards Working Group) is developing a theoretical data standard as a model, prepares publications and training workshops concerning the model, and advises other projects about the application of the model.

The Data and Terminology Working Group (formerly: the Documentation and Terminology Working Groups) concentrates on the development of practical data standards and reviews of terminology resources. Its draft standards for art and archaeology have been used for the NARCISSE project.

The Iconography Working Group is examining the available data standards and classification schemes for iconography, and evaluating the need for new resources.

The Interactive Multimedia Working Group examines standards and applications concerned with multimedia technology.

The CIDOC Services Working Group is developing publications (including a Handbook about documentation practice) and other services for members.

The Database Survey Working Group is surveying computer use in museums and producing a database about this information. This currently includes files from a number of countries.

The Museum Information Centres Working Group represents the interests of museum information centres, including arranging seminars about museum libraries and bibliographic collections.

Publications: *Newsletter* (1989–. Annual. En. Fr.)

457 International Committee for Education and Cultural Action (CECA)
Objectives: to exchange information and ideas about museum education at an international level; to ensure the representation of museum education in the policy, decisions and programmes of ICOM; to advocate the educational purpose of museums worldwide; and to promote high professional standards in museum education.

Organizes annual conferences and meetings at the ICOM triennial general conferences. Organizes regional and national groups in different countries. Organizes Working Parties on specific themes and issues. Sponsors regional meetings.

Publications: *ICOM Education* [68]; *ICOM/CECA Newsletter* (1988–. Twice a year); *Proceedings of the Annual Meetings*.

458 International Committee of Egyptology (CIPEG)
Concerned with museums and collections with objects from ancient Egypt. Annual meetings are held.

Publications: internal newsletter (1980–. Annual).

459 International Committee of Museums of Ethnography (ICME)
Promotes the interests of museums of ethnography and folk art museums. Organizes meetings and conferences.

Publications: *ICME News/Nouvelles de l'ICME/CIME* (twice a year).

460 International Committee on Exhibition Exchange
Aims: to exchange information and procedures related to the scholarly, technical and administrative aspects of exhibition exchange in order to promote the highest standards; to collect and disseminate information on exhibitions available for international circulation.

Publications: *Directory of sources for international travelling exhibitions*; *Bibliography: organizing travelling exhibitions*.

461 International Committee for Museums of Fine Art (ICFA)
Annual meetings; discussions; papers; excursions.

Publications: various brief reports and papers circulated internally.

462 International Committee of Glass Museums and Glass Collections
Various working parties and projects. Annual meeting.

463 International Committee for Literary Museums (ICLM)
Organizes meetings, conferences and discussions in the fields of literature, literary museums and archives, and museology.

Publications: *Information Bulletin* (1977–88); *International handbook of literary museums* I and II (1983 and 1987), continued in *Information Bulletin* X/XI (1987–8);

Proceedings of annual conferences/meetings (1978–90); *Literary memorial museums* (1986); *Newsletter* (1991–); other monographs.

464 International Committee on Management (INTERCOM)

Founded in 1989. Concerned with sound museum management worldwide. Main interests are the managerial aspects of policy formulation; the law; resource management, including human, financial and real property; governance. Meets on a triennial basis in conjunction with the ICOM General Conference.

Publications: internal newsletter (twice a year; En. Fr.)

465 International Committee for Museums and Collections of Modern Art (CIMAM)

Founded in 1963. Membership comprises directors and curators of museums of modern art worldwide.

466 International Committee for Museology (ICOFOM)

Concerned with the theoretical basis of museums and museum practice.

Publications: *Museological News* (twice a year; En. Fr.); *MuWop – Museological Working Papers* (1980–. Irregular; En. Fr.); *ICOFOM Study Series* (ISS) (each issue contains the basic papers and comments produced for the annual symposium); *ICOFOM LAM* (regional bulletin for Latin America and the Caribbean; three times a year; Es. Pt.).

467 International Committee for Museum Public Relations (MPR)

Founded 1974. Aims to study and promote the role played by public relations in museums of every kind and in all parts of the world, both in heightening the visitor's experience within the museum and in fostering recognition of the significance of museums in society. Meets every year. Four Working Groups study the following areas: temporary and travelling exhibitions; museum services; press, advertising and events; patronage.

Publications: *Public view* [327]; *MPR News* (twice a year).

468 *International Committee for Museum Security (ICMS)

Activities: serves as a source of information and technical services in the field of museum security, i.e. the protection of museum buildings, collections and other assets from threats such as wilful damage, theft and fire, the protection of museum staff members in respect of occupational safety hazards, and the protection of the visiting public from accidents. Membership (1986): 78 member countries. Meetings are held annually, and also on a triennial basis in conjunction with the ICOM General Conference.

Publications: *A manual of basic museum security* [211]; *Museum security survey* [230]; *Museum security* [276]; *ICMS Newsletter* (three/four times a year; En. Fr.).

469 International Committee of Musical Instrument Museums and Collections (CIMCIM)

Founded in 1960. Concerned with the display and maintenance of musical instruments. Special working sessions. General meeting almost every year, in different countries.

Publications: *International directory of musical instrument collections* [382]; *Recommendations for regulating the access to musical instruments in public collections* (1985; En. Fr. De. Es.); *CIMCIM Bulletin* (quarterly; articles on musical instruments, new exhibitions, etc.).

470 International Committee for Natural History Museums

Annual meeting held. The triennial programme for 1987–9 covered biological diversity and our natural heritage.

Publications: *Newsletter* (twice a year).

471 International Committee for Regional Museums (ICR)

Current interests: regional museums and eco-museums; relationships between big provincial museums and small local regional ones; and museums and tourism.

Publications: *ICR Information*.

472 International Committee of Museums of Science and Technology (CIMUSET)

Promotes international co-operation in the field, along with exchange of ideas and experience, and holds annual meetings.

Publications: *CIMUSET Newsletter* (twice a year; developments in science and technology museums, news about personnel, notes of meetings).

473 International Committee for the Training of Personnel (ICTOP)

Concerned with training of museum personnel.

Publications: *Museum studies international* [369]; *It: Newsletter/Bulletin d'Information* (1983–. Irregular; reports of meetings, details of new courses, short papers); *The professional training of museum personnel: a review of the activities and policies of ICOM, 1947–1980*; occasional conference proceedings.

International organizations affiliated to ICOM

474 International Association of Agricultural Museums (AIMA)

Established in 1966. Activities: promotes co-operation between agricultural museums by aiding the exchange of exhibitions and exhibits, by promoting exchange of information relating to exhibition techniques and didactics, and by making detailed recommendations for collecting and documentation. Membership (1992): *c.* 300 members from 35 countries. The General Assembly meets every 3 years.

Publications: *Acta Museorum Agriculturae* (information bulletin; 1966–. Twice a year; Fr. En. De. Ru.).

475 International Confederation of Architectural Museums (ICAM)

Founded in 1979. Dedicated to fostering links between all those institutions which collect, conserve and display architectural documents for the purposes of study, education and enjoyment. In 1985 over 60 institutions representing 23 countries were members.

Aims: to raise the quality of the built environment; to stimulate and receive public response in the appreciation and understanding of architecture and its allied fields in the creation of the human environment; to foster a critical attitude towards architecture and its allied fields; to act to protect the quality of the built environment when it is threatened; to monitor and record the whereabouts of architectural records and aid in their preservation, and to share this information; to expand understanding of cultural continuity and its environment context through the knowledge of history as a source of information and inspiration in the field of architectural practice; to exchange information by means of publications, exhibitions, films and other media, on matters concerning the whole history and practice of architecture and allied fields; to support and encourage the exchange of scholars, architects and members of allied professions with the intent of fostering a mutual understanding of common issues; and to seek the co-operation of all interested groups in the effort to achieve these objectives.

An international congress is held at least every 3 years.

Publications: *ICAM News* (twice a year).

476 International Association of Museums of Arms and Military History (IAMAM)

Established in 1957. Aims to establish and maintain contact between museums and similar institutions within the field and to promote the study of objects within the range of interests. Holds triennial congresses.

Publications: *Directory of museums of arms and military history* (Copenhagen, 1970); congress proceedings.

477 Museums Association of the Caribbean (MAC)

Founded 1989. Acts as adviser to governments and public and private institutions to promote museum development in Caribbean countries. Strives to develop a common policy of operations and research for museums and curators in accordance with cultural property regulations. Assists museums in: identifying financial and technical resources; defining areas in need of training; developing associations with international organizations and agencies; promoting awareness, appreciation and understanding of cultural heritages. Serves as a forum for information exchanges among museums.

Publications: *Newsletter* (1989–. Quarterly; En. Fr.; information on current

Caribbean museum activities, training programmes, exhibitions, museum development, MAC policies and related matters, meetings, symposia).

478 International Congress of Maritime Museums

Aims: to establish, maintain and promote close liaison between museums and other permanent institutions concerned with matters of maritime history, including the identification, recovery, study, collection, preservation, interpretation and exhibition of preservation objects and material, and the identification, study, excavation and display of places connected with the history and development of all navigation in or upon water.

Publications: conference proceedings (1972–); *Historic Ship Register* vols. I–II (Mystic (Connecticut), 1981–4); *Sources of information for maritime history: a directory of member libraries of the International Congress of Maritime Museums* (ed. by M. Patrick; London, 1984. 37 pp.).

479 International Movement for a New Museology (MINOM)

Aims: to establish a forum for new museology on a theoretical and practical basis; to organize international and regional meetings; to publish articles, reports, etc. on new museology.

Publications: reports, essays and bibliographies developed intermittently and responsive to specific interests and activities of membership.

480 Association of European Open Air Museums

Exchange of scientific, practical, technical and organization experiences. Promotion and discussion of new developments in the field of open-air museums. *c.* 150 members from 18 European countries meet every 2 years for a week's conference.

Publications: reports of the biennial conferences (an important source of information for all aspects of open-air museums); Zippelius, A.: *Handbuch der europäischen Freilichtmuseen* (Cologne: Rheinland-Verlag, 1974. 327 pp.); other monographs.

481 International Association of Libraries and Museums of the Performing Arts (SIBMAS)

Founded in 1954 as a section of the International Federation of Library Associations (IFLA). Since 1976, an independent association. Aims: to promote research, practical and theoretical, in the documentation of the performing arts; to establish permanent international contacts between specialized libraries, museums and documentation centres; to co-ordinate the work of members and to facilitate international exchanges between them. Organizes biennial international congresses. Has set up standing working committees, co-operates in important international projects and has permanent contacts with IFLA, ICOM [447], IFTR (International Federation for Theatre Research), and ITI (International Theatre Institute).

Publications: *SIBMAS/IFTR Information Bulletin* (three times a year); congress proceedings.

482 International Association of Transport Museums (IATM)
Established in 1968. Aims: to encourage and further co-operation and exchange of views between museums of transport and communications worldwide; to protect and promote the interests of museums and the museum profession in order to widen their influence. An annual meeting is held and visits arranged to museums of special interest to members. Membership (1985): *c*. 180 transport and communications museums, and individual members, from 34 countries. Sub-groups: Working Group of Postal and Telecommunications Museums; Aviation Sub-Committee.

Publications: *Transport Museums: Yearbook of the International Association of Transport Museums* [125]; *Guide book of railway museums: Europe* (Budapest, 1976. 464 pp.); *Directory of museums of transport and communications* (1992).

483 *Southern Africa Development Coordination Conference Association of Museums (SADCCAM)

Other international organizations

484 Association of Science–Technology Centers (ASTC)
Secretary: 1025 Vermont Avenue, Suite 500, Washington, DC 20005, USA (Tel: (202) 783–7200).
Founded in 1973. A non-profit organization of museums and affiliated institutions dedicated to furthering public understanding and appreciation of science and technology. Aims: to improve the operations of science museums and centres; to serve as a vehicle for co-operative projects of interest to its membership; to advance the role of science museums in society; to increase public understanding of science and technology; and to increase participation of women and minorities in scientific work. Activities: serves as a clearing-house for information; operates a Traveling Exhibition Service; conducts surveys; sponsors workshops and an annual conference; and operates a programme to improve science teacher education by using museum resources.

Publications: *ASTC Newsletter* [49]; ASTC Report series; *Annual Report*; *ASTC Traveling Exhibition Service Catalog* (annual); *ASTC Quarterly Calendar* (calendar of permanent and temporary exhibitions on display at science museums and centres); ASTC slide show (72 colour slides and narrative); *Update* (Traveling Exhibition Service's quarterly bulletin on exhibition development and early notice of bookings); numerous monographs; *New Science Center Support Program Information Service Bulletins*.

485 Association of Systematics Collections
Executive Director: 730 11th Street, NW, 2nd Floor, Washington, DC 20001–4521, USA (Tel: (202) 347–2850).
A non-profit association of organizations that maintain systematics collections as part of their resources. It exists to foster care, management and improvement of systematics collections and to promote their utilization. Provides

representation to governmental agencies, serves as a clearing-house for information in the systematics community, organizes meetings and workshops, and publishes and distributes books, pamphlets and newsletters for the systematics community.

Publications: *ASC Newsletter* [48]; various monographs.

486 Commonwealth Association of Museums

Objectives: to maintain and strengthen links between members of the museum profession in Commonwealth countries; to encourage and assist members to obtain additional training and to attend appropriate conferences and seminars; and to collaborate with and encourage the establishment of national and regional museums associations, etc. The major current activity is the development and implementation of a distance learning programme in basic museum studies for museum employees in Commonwealth countries.

Publications: *Newsletter* (twice a year).

487 International Centre for the Study of the Preservation and the Restoration of Cultural Property (ICCROM)

Library/Documentation Section: Via di San Michele 13, 00153 Rome, Italy (Tel: (6) 58 79 01; Telex: 613114 ICCROM I; Telefax: (6) 588 42 65).

Concerned with the preservation and conservation of cultural property in all its aspects. Founded by UNESCO in 1959 as an autonomous scientific inter-governmental organization. By 1992 had 84 member states and 120 associate members. Main aims: to assist in training personnel involved in conservation in order to raise the standards of conservation worldwide; to co-ordinate, stimulate and initiate research; to give advice and make recommendations by means of missions, meetings and publications; to collect, study and circulate information on conservation of cultural property. The library comprises over 45,000 books, offprints and periodicals, and has a computerized database on the conservation of cultural property.

Publications: *Newsletter* [72]; *List of Acquisitions* (to the ICCROM Library; 1977–. Annual; includes author index and title index); *Subject Index* (to the Library; 1977–. Annual; published in separate volumes in En. and Fr.); various monographs.

488 International Council on Monuments and Sites (ICOMOS)

Documentation Centre: 75 rue du Temple, 75003 Paris, France (Tel: 42 77 35 76; Telex: 240918 TRACE Ref. 617; Fax: 42 77 57 42).

Founded in 1965. The only international, non-governmental organization that works to promote the application of theory, methodology and scientific techniques to the conservation of architectural heritage. Aims: to bring together conservation specialists from all over the world and serve as a forum for professional dialogue and exchange; to collect, evaluate and diffuse information on conservation principles, techniques and policies; to co-operate with national

and international authorities on the establishment of documentation centres specializing in conservation; to work for the adoption and implementation of international conventions on the conservation and enhancement of architectural heritage; to participate in the organization of training programmes for conservation specialists on a worldwide scale; to put the expertise of highly qualified professionals and specialists at the service of the international community. Membership (Jan. 1992): 4,500 members in 70 countries.

The Documentation Centre, part of the UNESCO–ICOM–ICOMOS documentation network, aims to gather, study and disseminate information concerning the principles, techniques and policies for the conservation, protection, rehabilitation and enhancement of monuments, groups of buildings and sites. In 1992 the Centre was computerized, and the ICOMMOS database for the protection of the cultural heritage was created. The collection comprises c. 10,500 library units, c. 300 periodicals received and c. 10,000 slides, 1,200 maps and graphs and 5,000 photographs.

Publications: *Monumentum* (1968–84; articles on the preservation of monuments); *ICOMOS Information* (1985–90; specialized articles); *ICOMOS News* (1991–. Quarterly; details of ICOMOS current activities); numerous symposia and monographs, including thematic bibliographies.

489 International Institute for Conservation of Historic and Artistic Works (IIC)
Executive Secretary: 6 Buckingham Street, London WC2N 6BA England (Tel: 071–839 5975; Fax: 071–976 1564).
Founded in 1950. Concerned with the whole field of inanimate objects considered worthy of preservation, whether in museums and libraries or exposed externally, their structure, composition, deterioration and conservation. Has over 3,500 members in 64 countries and includes in its membership professional conservators working independently, outside the ambit of governments and institutions. Members keep abreast of technical advances and in personal contact with their colleagues at home and overseas through publications, congresses and regional groups.

The subjects of congresses have been: recent advances in conservation (Rome, 1961); textile conservation (Delft, 1964); museum climatology (London, 1967); stone and wooden objects (New York, 1970); paintings and the graphic arts (Lisbon, 1972); archaeology and the applied arts (Stockholm, 1975); wood in painting and the decorative arts (Oxford, 1978); conservation within historic buildings (Vienna, 1980); science and technology in the service of conservation (Washington, 1982); adhesives and consolidants (Paris, 1984); conservation of stone and wall paintings (Bologna, 1986); conservation of Far Eastern art (Kyoto, 1988); cleaning, retouching and coatings (Brussels, 1990); conservation of the Iberian and Latin American cultural heritage (Madrid, 1992).

Publications: *Art and Archaeology Technical Abstracts* [33]; *Studies in Conservation* [122]; *Bulletin* (bi-monthly); congress proceedings; various monographs.

490 UNESCO – Division of Cultural Heritage
 Director: 7 place de Fontenoy, 75700 Paris, France (Tel: 45 68 43 83; Telex: 204461 Paris).
Devoted to promoting cultural information and giving assistance on a worldwide level, e.g. international campaigns for the preservation of monuments and the return and restitution of cultural property, books, etc.
 Publications: *Museum International* [90]; *UNESCO List of Documents and Publications* [41]; Museums and Monuments (1952–. Irreg.; En. Fr. Es.); Protection of the Cultural Heritage: Research Papers (1984–. Irreg.; En.); Protection of the Cultural Heritage. Technical Handbooks for Museums and Monuments (1977–. Irreg.; En. Fr. Es.); Studies and Documents on Cultural Policies (1970–. Irreg.; En. Fr. Es.); Studies and Documents on the Cultural Heritage (1984–. Irreg.; En. Fr.).

491 Visitor Studies Association
 c/o Psychology Institute, Jacksonville State University, Jacksonville, Alabama 36265, USA.
An association, founded in 1990, which caters for all professionals involved in visitor studies. Sponsors Annual Visitor Studies Conference.
 Publications: *Membership Directory*.

492 World Federation of Friends of Museums (WFFM)
 Headquarters: 4 rue Auguste Dorchain, 75015 Paris, France (Tel: (1) 43 06 61 83; Fax: (1) 43 06 62 42).
Objectives: to encourage people interested in museums worldwide to become Friends of Museums; to develop an international network of information, co-operation and exchange of services among Friends of Museums and to make known the scope of these activities; to act as a representative forum for the public by helping with the establishment of national federations and by encouraging individual initiatives in favour of museums and their public; to support the initiative of young people in favour of museums and their public; to speak officially for the Friends of Museums by co-operating with international cultural organizations, especially ICOM [447]. Holds a congress every 3 years.
 Publications: regular 'WFFM chronicle' (includes details of recent activities) in *Museum International* [90]; congress proceedings.

ORGANIZATIONS BY COUNTRY

Argentina

493 *Colegio de Museólogos de la República Argentina
 Secretary: Soler 4187, Casilla de Correo 318, Sucursal 25B, 1425 Buenos Aires, Argentina (Tel: (01) 961–6102).

Professional association representing all graduates in museology. Aims: to work to promote Argentinian museums and their legislation, and to defend the rights of all professional museologists.

Publications: *Boletín Informativo* (bi-monthly; Es.)

Australia

494 Art Museums Association of Australia
Executive Officer: 159 Brunswick Street, Fitzroy, Victoria 3065, Australia (Tel: 61 3 416 3795; Fax: 61 3 419 6842).
Objectives: to encourage and facilitate the development and implementation of professional practices in Australian art museums and public galleries; to encourage and foster a greater understanding and enjoyment of the visual arts and crafts through art museums. Activities: seminars, workshops and conferences; development of professional practice in art museums through training programmes and awareness, advocacy and grants (Professional Development Grant and International Promotions – Small Grants Fund).

Publications: *Code of ethics for art, science and history museums* (30 pp.; 1985); North, I. (ed.): *Art museums and big business* (48 pp.; 1984); Lasko, P.: *The necessity of collections* (12 pp.; 1984); North, I. (ed.): *On trusteeship* (16 pp.; 1979); *The money and the means: grants, scholarships and opportunities for professional development* (39 pp.; 1992); *Australian art museums and public galleries: directory* [391]; Carroll, A.: *Independent curators: a guide for the employment of independent curators* (27 pp.; 1991).

495 Council of Australian Museum Associations
Executive Officer: 159 Brunswick Street, Fitzroy, Victoria 3065, Australia (Tel: (03) 419 7092; Fax (03) 419 6842).
Formed in 1981. A federation of the following organizations: Art Museums Association of Australia; Museums Association of Australia; International Council of Museums (Australia); Museum Education Association of Australia; Australia Heritage Parks Association; Australian Federation of Friends of Museums; Australian Institute for the Conservation of Cultural Material Inc.; Council of Australian Museum Directors; Council of Australian Art Museums Directors; Museum Shops Association. Objectives: to encourage and maintain co-operation among member organizations in the broad practice of museology, and to support them in matters of mutual concern and interest; to encourage affiliation of all bodies appropriately associated with the broad practice of museology; to encourage better understanding of the role of museums in the Australian community; to recognize the importance of education throughout museum practice; and to take all other appropriate steps to enhance the profession generally. The single major activity each year is the national conference catering for the interests of all working in the museum profession in Australia.

Publications: *Museum National* [93].

496 Museums Association of Australia Inc. (MAA)
 Executive Officer: c/o Museum of Victoria, 328 Swanston Street, Melbourne,
 Victoria 3000, Australia (Tel: (03) 669–9973; Fax: (03) 663–1490).
Founded in 1937. Has over 1,000 members in Australia and overseas. Aims: to
promote the educational, cultural, aesthetic, scientific, archival and research
value of museums; to encourage high standards within museums and those who
work in them; to increase and disseminate knowledge of museum matters; to
represent the view of museum people; and to promote museums within the
community. Has a National Council with an executive and representatives
from all states. Advises governments on the development of museums and
support services, co-ordinates activities such as International Museum Day, and
offers professional guidance and new ideas.
 Publications: national and state newsletters; various monographs.

Austria

497 Österreichischer Museumsbund
 Secretary: Burgring 5, 1010 Vienna 1, Austria (Tel: 0222 52177–300/301;
 Fax: 932770)
Publishes lists of personnel employed in museums. Co-ordinates requests of state,
provincial and other museums.
 Publications: *Neues Museum* [111].

Bangladesh

498 Department of Archaeology
 Director: 22/1 Block-B, Babar Road, Mohammadpur, Dhaka 1207,
 Bangladesh (Tel: 812715, 327608).
Responsible for overall administration of the Directorate of Archaeology and
Museums, including the planning, establishment and maintenance of govern-
ment museums.
 Publications: numerous monographs.

Belgium

499 Vlaamse Museumvereniging (Flemish Museum Association)
 Secretary: Koninklijk Museum voor Schone Kunsten, Plaatsnijdersstraat 2,
 B–2000 Antwerp, Belgium (Tel: 03 238 78 09).
Aims: to promote the museums of the Flemish community in general and their
management in particular; and to defend the professional interests of the museum
personnel. Co-ordinates the work of the different teams concerned with educa-
tion, personnel training, exhibitions, management and computerization of data.
Organizes study tours in Belgium and abroad.
 Publications: *Museumleven* [98]; *Museumbrief*.

Canada

500 Canadian Conservation Institute Library

Librarian: 1030 Innes Road, Ottawa, Ontario K1A 0C8, Canada (Tel: (613) 998-3721; Fax: (613) 998-4721).

The Canadian Conservation Institute (CCI) Library collects in the field of conservation of movable cultural property and in all aspects of collection management and practice. It has the largest collection of conservation and museological information (the Museological Resource Centre) in Canada. With its focus on museology and the conservation of museum artefacts, the CCI Library maintains a growing core of over 9,000 monographs, 400 current journals and three special collections: the Reprint Collection, the Museum Annual Report Collection and the Video Collection.

The Library primarily serves the staff of the Canadian Conservation Institute and the staff of the Department of Communications. As a national resource collection, the Library also serves the Canadian museum community. Reference, online searches and interlibrary loans are offered to conservators and museum workers in Canada. The Library has access to the Conservation Information Network (CIN).

Publications: three current awareness lists (an acquisitions list of new books; a museological index of current journals received in the Library; and a photocopied listing of up-to-date news about conferences and training opportunities in Canada and around the world).

501 Canadian Museums Association/Association des Musées Canadiens

306 Metcalfe, Ottawa, Ontario K2P 1S2, Canada (Tel: (613) 567-0099; Fax: (613) 233-5438).

Aims: to advance public museum services in Canada; to promote the welfare and better administration of museums; to foster a continuing improvement in the qualifications and practices of museum professionals. Activities: aids in the improvement of museums as institutions for the collection, preservation, research, exhibition and interpretation of the works of man and nature; acts as a clearing-house for information of interest and relevance to the museum community; promotes and supports museum training programmes; advances among museum employees the observance of high standards of ethical conduct and professional practice; extends job placement assistance to individuals and institutions; acts as a spokesman for the museum community; contributes to the public understanding of museums.

Publications: *Muse* [82]; *Bibliography* [7]; *The official directory of Canadian museums and related institutions* [401]; *Museogramme* [87]; *Museum studies programmes in Canada*; various monographs.

China

502 Chinese Society of Museums
29 May 4th Street, Beijing, China 100009 (Tel: 4015577–343).
A non-governmental academic organization. Main activities: to organize studies on museology and other academic activities; to develop international academic exchanges between museum circles in China and abroad; and to edit/translate important international publications on museology.
 Publications: *Chinese Museum* [54]; *Treatises on museology* (1983; 1986; 1992).

Czechoslovakia and its successor states

503 Národní Muzeum – Muzeologické Informační a Studijní Středisko (Museological Information and Study Centre)
Director: Malá Strana, U Lužického semináře 13, 118 34 Prague 1, Czech Republic (Tel: 533611, 532719).
Activities: documentation and information service; education and training of museum employees; consultation service; publishing.
 Publications: *Muzejní a Vlastivědná Práce* [107]; *Muzejní Práce* [108]; *Bibliografie Muzeologické Literatury* [37]; *Informace MISS*.

504 Muzeologické Informačné Centrum (Museological Information Centre)
Director: Lodná 2, 814 36 Bratislava, Slovakia (Tel: 335471).
Provides information and consulting services to the Slovak museums.
 Publications: *Múzeum* [109]; *Výberová Bibliografia Muzeologickej Literatúry* [20]; *Výročné Správy o Činnosti Slovenských Múzeí a Galérií* [128].

Denmark

505 Dansk Kulturhistorisk Museumsforening (Danish Museums Association of Cultural History)
Secretary: Nr. Madsbadvej 6, 7884 Fur, Denmark (Tel: 97593566; Fax: 97593163).
Founded in 1926. Particularly concerned with local history and folk museums. Acts as a pressure group for vigorous development of museums. Organizes training courses for museum personnel and arranges meetings and seminars discussing developments in the year gone by or professional problems in different fields.
 Publications: *Arv og Eje* (yearbook covering historical themes); *Nøgle til danske museer* (1991).

506 Skandinavisk Museumsforbund (Scandinavian Museums Association), Danish Section
Secretary: c/o Ålborg Historiske Museum, 9000 Ålborg, Denmark (Tel: 98124522).

Professional organization for staff in Scandinavian museums. Concerned with matters of common interest to Scandinavian art museums, local history/folk museums and natural history museums.

507 Statens Museumsnaevn (Danish Council of Museums)
Secretary: Nybrogade 2, 1203 Copenhagen K, Denmark (Tel: 01923370).
Functions: co-ordinates activities of museums at national level and organizes co-operation; supervises museums; recommends museums for approval for receipt of state subsidies and calculates state subsidies for museums; provides technical and other professional advice to museums; consults with the Minister of Culture and other public authorities on matters related to museums; co-ordinates international co-operation for the museums.
Publications: *Perspektiver/Oplysninger om danske museer*; various monographs.

Finland

508 Skandinavisk Museumsförbund (Scandinavian Museums Association), Finnish Section
Secretary: National Board of Antiquities, P.O. Box 913, SF–00101 Helsinki, Finland (Tel: 0–40251).
Holds the main congress of the Association every third year.

509 Suomen Museoliitto (Finnish Museums Association)
Secretariat: Annankatu 16 B50, 00120 Helsinki, Finland (Tel: 0–649–001; Fax: 608330).
Founded in 1923 and the central organization of Finnish museums. Aims: to promote the work of museums; to develop the museum activities of its members and advance their joint interests; and to make museums better known and encourage their use. Carries out planning and research, offers relevant supplementary training, archive and library services, and maintains international contacts.
Publications: *Museo* [85]; *Suomen museot* (Finnish museums) [411]; *Museoarkkitehtuuria* (Museum architecture); *Valtakunnallinen museoiden kävijätutkimus* (Study of visitors to Finnish museums; summary in En.; 1992); *Rakennuskonservointi* (Conservation of buildings; 1983); *Museologian perusteet* (Basic museology; 1988); *Tekstiilikonservointi* (Textile conservation; 1989); *Tekijänoikeus -ja kuvapalvelukysymyksiä* (Copyright questions; 1979); *Opintokäynti museoon, opas kouluille ja museoille* (Guide to teachers and museums, how schools can use museums for teaching; 1986); *Osma* (1954–63, 1983; articles on art history, history and history of culture, etc.).

France

510 Association Générale des Conservateurs des Collections Publiques de France

Secretary: 6 rue des Pyramides, 75041 Paris Cedex 01, France (Tel: 16 1 42 60 14 40).

Founded in 1922. Objectives: to establish and develop links between those responsible for the national heritage; to conserve and transmit national collections and to encourage initiatives in the field; and to represent its members.

Publications: *Musées et Collections Publiques de France* [83].

511 Direction des Musées de France

Mission de la Communication: 6 rue des Pyramides, 75041 Paris Cedex 01, France (Tel: 40 15 73 00; Fax: 40 15 36 25).

Puts forward and carries out state policy in matters of museological heritage. Organizes the co-operation of the different public authorities in this sphere.

Publications: *La Lettre des Musées de France*; numerous publications in connection with the general policy of the Ministry of National Education and Culture in the realm of museums.

512 Office de Coopération et d'Information Muséographiques (OCIM)

Enquiries: 36 rue Chabot Charny, 21000 Dijon, France (Tel: 80 58 98 50).

Founded in 1984. Activities: technical and museographic documentation in the field of natural history; training courses and technical support for all natural history museums in France.

Publications: *La Lettre de l'OCIM* (1988–; every two months); *Hors-séries à La Lettre de l'OCIM* (various themes); *Annuaire des fournisseurs des musées* (2nd ed. 1992); *Guide des musées de l'Education nationale* (1991).

Germany

513 Deutscher Museumsbund

Secretary: Erbprinzenstr. 13, Postfach 6209, D-7500 Karlsruhe 1, Germany (Tel: (0721) 175161).

Represents museums of all kinds in Germany.

Publications: *Museumskunde* [100].

514 Institut für Museumskunde, Staatliche Museen zu Berlin, Preussischer Kulturbesitz

Director: In der Halde 1, D-1000 Berlin 33, Germany (Tel: 030–8301460; Fax: 030–831 59 72).

Activities: museum studies; visitor research; research in museum technologies; documentation; statistics; legal questions about museums; history of collecting; and research, documentation and information on museums.

Publications: *Materialien aus dem Institut für Museumskunde*; *Berliner Schriften zur Museumskunde*.

Ghana

515 *Ghana Museums and Monuments Board
Director: Barnes Road, P.O. Box 3343, Accra, Ghana (Tel: 221633; Cable: 'DIRMUSMONS').
Activities: acquires cultural objects in the fields of ethnography, archaeology, science, art and contemporary paintings; is responsible for conserving and keeping safe these objects; and oversees all national monuments.
Publications: *Museum Occasional Papers*; *Museum handbook*; various monographs.

Hungary

516 Magyar Nemzeti Múzeum Mütárgyvédelmi és Információs Részlege (Hungarian National Museum, Department for Conservation and Information)
Deputy Director-General: H-1370 Budapest P.O.B. 364, Hungary (Tel: 1382-662, 1382-673; Fax: 1177-806).
The Department for Information and its Library collect museological and conservation/restoration technical literature; review relevant technical literature from foreign publications; review and abstract Hungarian technical literature for international centres covering this field; and collect and work on statistical data on Hungarian museums.
The Restoration Department trains professional restorers at elementary, advanced and higher levels; is producing a central directory for the local museum network; and organizes international meetings.
Publications *Múzeumi Hírlevél* (1979–. Monthly newsletter); *Múzeumi Mütárgyvédelem* (1970–. Annual; protection and conservation of works of art); *A magyar múzeumok kiadványainak bibliográfiája* [29]; *International Restorer Seminar* (1976–); *Dictionarium museologicum* [446].

India

517 Indian Association for the Study of Conservation of Cultural Property
Secretary: c/o National Museum Institute, Janpath, New Delhi 110011, India (Tel: 3016098, 3019538 Ext. 22).
Objectives: to provide a professional centre for the conservation and study of cultural property; to co-ordinate the efforts of various centres and improve the knowledge and the methods of conservation of material of various types: to ensure dissemination of technical knowledge and information related to conservation; to maintain high standards in conservation; to advise on technical matters; and to maintain close contact with other bodies with similar objectives abroad and in India.
Publications: *Conservation of cultural property in India*.

518 *Museums Association of India
Secretary: c/o National Museum of Natural History, FICCI Building, Barakhambra Road, New Delhi 110001, India.
Founded in 1944, to provide a forum for the development of museum activities in India. Objectives: popularization of museums in India and recognition of their role as centres of culture and educational activity; dissemination of technical knowledge about museums; organization of regular national and regional seminars, conferences, exhibitions and study tours; development of a national museum policy; maintenance of close contact between centres of academic teaching of museology, the Central Advisory Board of Museums, and working personnel and their organizations; rendering of technical assistance and professional advice to museums; devising of proper measures for protecting valuable museum objects, national monuments, etc.; and recognition of all centres of visual education (e.g. all types of museum, zoo and aquarium, botanical garden) as museums or museum-like institutions directly connected with the advancement of the knowledge and cultural attainments of the Indian people.
Publications: *Journal of Indian Museums* [77]; *Museums Newsletter; Museums in community services; Museum architecture; The Patolu of Gujarat; Brief directory of museums in India* [416].

Ireland

519 Irish Museums Association
Secretary: c/o National Archives, Bishop Street, Dublin, Ireland (Tel: 783711).
Aims: to forge links between those interested in museums in Ireland whether professional or voluntary. Supports groups seeking to ensure that professional standards for collecting, documenting and conserving collections are maintained. Runs an annual Spring Seminar and Autumn Seminar (incorporating the Annual General Meeting). Is associated with the Gulbenkian Awards for Museums and Galleries in Ireland, and also runs an annual Outreach Training Programme.
Publications: *Newsletter; Museum Ireland* [91]; *Directory of Irish museums*; seminar proceedings (for pre-*Journal* papers).

Italy

520 *Associazione Nazionale dei Musei Italiani
Secretary: Piazza San Marco 49, 00186 Rome.
Publications: *Musei e Gallerie d'Italia* [84].

Japan

521 Nihon Hakubuutsukann Kyokai (Japanese Association of Museums)
Secretary: Shoyu–Kaikan 3–3–1 Kasumigaseki, Chiyodaku, Tokyo 100, Japan (Tel: 03–3591–7190; Fax: 03–3591–7170).

Non-profit organization to promote museum activities and to contribute to the development of life-long learning for people in Japan.
Publications: *Museum Studies* [66].

Netherlands

522 Nederlandse Museumvereniging (Dutch Museums Association)
Secretary General: Postbox 3636, 1001 AK Amsterdam, Netherlands (Tel: 020–6203308; Fax: 020–6201189).
Aims: to promote, discuss and represent the interests of Dutch museums. Currently (1992) has *c*. 900 individual members and *c*. 300 museums are institutional members. Comprises 10 sections according to professional specialization: technical and transport museums; ethnological museums; museums of natural history; historical museums; museum information; educational departments; information supply; management; public relations; and art museums. Most sections have their own seminars twice a year.
Publications: *Museumvisie* [103]; annual report (1984–); proceedings of meetings; various monographs.

New Zealand

523 Art Galleries and Museums Association of New Zealand (Inc.) (AGMANZ)
Executive Officer: Museum of New Zealand, P.O. Box 467, Wellington, New Zealand (Tel: (043) 859 609; Fax: 04 3857157).
Provides a course towards a Diploma or Certificate in Museology, which consists of theory papers and practical workshops.
Publications: *New Zealand Museums Journal* [112]; *AGMANZ Newsletter* (quarterly).

Norway

524 Norsk Museumpedagogisk Forening (Association of Norwegian Museum Educators)
NMF-Sekretariatet, Vitenskapsmuseet, Erling Skakkesgt. 47, 7004 Trondheim, Norway.
Caters for all working with educational aspects of museums. Arranges seminars, courses and an annual conference.
Publications: *Pedimus* (newsletter; irreg.); reports.

525 Norske Kunst- og Kulturhistoriske Museer (Norwegian Museums of Art and Cultural History)
Senior Officer: Ullevålsvn 11, 0165 Oslo, Norway (Tel: (02) 20 14 02, (02) 20 11 22; Fax: (02) 11 23 37).
Aims: to further the importance of Norwegian museums of art and social history;

to improve contacts and co-operation between various institutions and maintain links with the government.

Publications: *Museumsnytt* [102]; *Museumshåndboka* [136]; *Film and Video Nytt* (Scandinavian co-production).

526 Norske Naturhistoriske Museers Landsforbund (Norwegian Association of Natural History Museums)

Museum of Zoology, University of Bergen, Muséplass 3, N-5007 Bergen, Norway (Tel: 47-5-212905; Fax: 47-5-321153).

Aims: to look after the interests of Norwegian natural history museums, museum departments and employees, and to improve co-operation between members. Membership (1987): 11 senior, 26 institutional, over 150 personal.

Publications: *Museumsnytt* [102]; *Informasjon* (internal newsletter); *Museumshåndboka* [136].

527 Skandinavisk Museumsforbund (Scandinavian Museums Association), Norwegian Section

Secretary: Teatermuseet i Oslo, Nedre Slottsgate 1, 0157 Oslo, Norway (Tel: 02-41 81 47).

Publications: *Nordens Museer*.

Pakistan

528 Pakistan Society of Archaeology, Archives and Museums

Secretary: c/o Lahore Museum, Shara-e-Quaid-e-Azam, Lahore 54000, Pakistan (Tel: (042) 322835).

Founded in 1989. Aims: to advance the cause of archaeology, archives and museology, improve the work of museums and archaeological institutions, and extend their usefulness by helping different branches of their disciplines; to establish close contact with universities, educational and research institutions; to advise and assist in opening new museums; to provide facilities for training and to create a general awareness.

Publications: *Museums and art galleries in Pakistan* [430].

Poland

529 Ośrodek Dokumentacji Zabytków – Dział Muzealnictwa (Historical Monuments Documentation Centre – Department of Museology)

Secretary: ul. Mazowiecka 11, 00-952 Warsaw (Tel: 267377).

Gathers information on various activities of museums in Poland.

Publications: *Muzealnictwo* [105].

530 Ministerstwo Kultury i Sztuki (Ministry of Culture and Art)

Deputy of the Minister for Museums: ul. Krakowskie Przedmieście 15/17, 00-071 Warsaw, Poland (Tel: 0-22 260869; Fax: 0-22 273958).

Department of Cultural Activity: ul. Krakowskie Przedmieście 15/17, 00–071 Warsaw, Poland (Tel: 0–22 267545; Fax: 0–22 273958).
Administers and supervises museums in Poland on behalf of the Minister of Culture and Art.
Publications: *Zdarzenia Muzealne – Biuletyn Muzealnictwo.*

State Service for the Protection of Antiquities: ul. Ksawerów 13, 02–652 Warsaw, Poland (Tel: 0–22 430973; Fax: 0–22 430960).
Publications: *Kurier Konserwatorski.*

Portugal

531 *Associação Portuguesa de Museologia
Secretary: c/o Museu de Arte Popular, Avenida de Brasília, 1400 Lisbon, Portugal (Tel: Lisbon 616707).
An association of curators, educators, conservators and other technical and professionally related staff of Portuguese museums. Aims: to develop museum studies in its various forms. Main activities: conferences, visits, publications and an annual meeting for the discussion of a major problem in museology or museography.
Publications: *Museus e Educação* (1971); *APOM – Informações* (1973–81); *Actas dos Colóquios*; *Cadernos de Museologia.*

Southern Africa

532 Southern African Museums Association
Office: P.O. Box 29294, Sunnyside 0132, Pretoria, South Africa (Tel: 012-3233128; Fax: 012-219817).
Established in 1936. Has members in Botswana, Malawi, Namibia, South Africa, Swaziland, Transkei and Zimbabwe. Objectives: to improve and extend the museum service in Southern Africa; to encourage helpful relations among museums, kindred institutions, and persons interested in the objectives of the Association; to increase and disseminate knowledge of all matters relating to museums. Responsible for technical and museological training; awards its own Technical Certificate; offers a postgraduate diploma in museology at Pretoria and Stellenbosch Universities. Has an accreditation scheme setting minimum standards for museums. Subscribes to a code of ethics. Arranges an annual conference at which the Annual General Meeting is held, and also biennial Technical and Education Conferences. Branches of the Association have been established in the 4 provinces.
Publications: *SAMAB (Southern African Museums Association Bulletin)* [116]; *SAMANTIX* (informal newsletter; three times a year); *Code of ethics of SAMA* (1979); *Professional standards–accreditation handbook for Southern Africa museums* (1989); *The making of the museum professions in Southern Africa – an historic overview of the last 50 years* (1986).

Spain

533 *Generalitat de Catalunya, Departament de Cultura – Servei de Museus (Government of Catalonia, Department of Culture – Museum Services)
Director of Museum Services: Portaferrissa 1, 08002 Barcelona, Spain (Tel: 3-3021522; Telex: 3012241).
Concerned with the management, conservation, documentation and interpretation of collections relating to the heritage of Catalonia.
Publications: *De Museus* [104]; *Informatiu Museus* (1988–. Quarterly; Ca; information on the activities undertaken by museums of Catalonia); numerous monographs.

534 Seccio de Patrimoni Cultural (Diputació de Barcelona)
Secretary: Montalegre 7, 08001 Barcelona, Spain (Tel: 3-301-00-66; Fax: 3-318-78-74).
Organization and management. Documentation and information service. Education and training. Consultation service. Support to the local heritage.
Publications: *Dossier de Patrimoni Cultural* (1989–.) Monthly; Ca. En. Fr. Es.; news about the natural and cultural heritage; documentation; opinion; legislation).

Sweden

535 Svenska Museiföreningen (Swedish Museums Association)
Box 4715, 11693 Stockholm, Sweden (Tel/Fax: 46 8643 50 41)
Chief organization for museum co-operation in Sweden. Membership: all national and regional and most municipal museums; also c. 1,100 staff members. Concerned with development, debate and information within several museum fields. Each field has its own working group or committee.
Publications: *Svenska Museer* [124]; *Museiguiden* [440]; various publications on preparatory care (climate and light, transportation and handling of museum objects) and on photography, film/video in museums.

Switzerland

536 Verband der Museen der Schweiz/Association des Musées Suisses
Secretary: Baselstrasse 7, 4500 Solothurn, Switzerland (Tel: 065/23 67 10; Fax: 065/23 67 10).
Aims: to unite museums and represent them; to assist in instructing members and to improve contacts between them.
Publications: *VMS/AMS* [127].

Taiwan

537 Chinese Association of Museums
National Palace Museum, 221 Chi-Shan Rd. Sect. 2. Shihlin, Taipei, Taiwan. Aims: to represent museums of all kinds in Taiwan; to promote co-operation and academic exchange between them; and to arrange meetings and seminars on issues concerning joint interests of its members.

Publications: *Bowu Quarterly* (Ch.; articles relating to the recent development of museums in Taiwan. Notes and news).

United Kingdom (see also Ireland)

538 Museum Documentation Association
Lincoln House, 347 Cherry Hinton Road, Cambridge CB7 5BG, England (Tel: 0223 242848; Fax: 0223 213575).
Originally established in 1977, the MDA has a new strategy in the 1990s. It is now structured into two distinct divisions: the Mission team and the Services team. The Mission team is grant-aided and promotes excellence in all aspects of documentation by the development of documentation standards, and by the provision of encouragement and advice to increase the pool of documentation knowledge, expertise and resources within the entire museum community. The Services team is self-funded and facilitates best practice by developing tools and by offering these to museums at an affordable cost.

The MDA's emphasis has shifted sharply towards promoting standards by making them relevant to the people working in museums. The Missionary team is divided into two parts: Standards and Outreach. The main project of Standards is to develop, through consultation, a UK Documentation Standard; the MDA Data Standard has recently been revised and published as part of the preliminary discussion which will take place through working parties. Other Standards projects are also being developed in collaboration with other agencies. The Outreach task encompasses the original advice and training function of the MDA, but is now more proactive and more responsive. The team's work includes producing free factsheets, a nationwide series of free roadshows, and modestly priced publications and training courses. The Services team offers affordable off-the-shelf Standards-compatible tools including the MODES computer package, a full programme of MODES training in Cambridge, and additional help on a regional basis.

The Computer Centre can offer data entry for newly computerized systems, and for existing systems the Centre can transfer, clean and harmonize records from different formats or collections. Other MDA services include the sale of books and publications as well as the MDA card systems and registers.

Publications: *Information policies for museums* [254]; *Planning the documentation of museum collections* [264]; *Practical museum documentation* [244]; *The Data Protection Act and museums: implications for collection documentation* (ed. by S.G. Jones and

D.A. Roberts (MDA Occasional Paper, 8; 1985)); *International museum data standards and experiments in data transfer* (MDA Occasional Paper, 5; 1981); *The MDA systems and services: a user's view*, by S.D. Neufeld (MDA Occasional Paper, 6; 1981); *Microcomputers in museums* (ed. by R.B. Light and D.A. Roberts (MDA Occasional Paper, 7; 1984)); the various manual components of the Museum Documentation System.

539 Museums and Galleries Commission

Secretary: 16 Queen Anne's Gate, London SW1H 9AA, England (Tel: 071-233-4200; Fax: 071-233-3686).

Established in 1931 as the Standing Commission on Museums and Galleries. Renamed and took up new functions in September 1981. Formal mandate: to advise the United Kingdom Government generally on the most effective development of museums and galleries and to advise, and take action as appropriate, on any specific matters which may be referred to them from time to time; to promote co-operation between museums and galleries and particularly between the national and provincial institutions; and to stimulate the generosity and direct the efforts of those who aspire to become public benefactors. Administers annual schemes for capital and conservation grants to English museums and provides a substantial proportion of the funding to the seven English Area Museum Councils and the Museum Documentation Association [538]. In addition the MGC directly administers a capital grant scheme for non-national museums, and various other grant schemes; it also administers the arrangements for government indemnities and the acceptance of works of art in lieu of Inheritance Tax, and it has responsibility for the two purchase-grant funds for local museums managed on its behalf by the Victoria and Albert Museum and the Science Museum. The MGC's Travelling Exhibitions Unit promotes and encourages travelling exhibitions. A Disability Adviser promotes better provision for disabled people in museums, and an Environmental Adviser is drawing up guidelines on environmental standards in museums. A registration schemes for museums in the UK is being implemented with the assistance of the Commission.

Publications: Periodic reports since 1931; *Survey of provincial museums and galleries* (1963); *Report on the Area Museum Services* (1967); *Universities and museums* (1968); *The preservation of technological material* (1971); *Report on university museums* (1977); *Framework for a system for museums* (1979); *Conservation* (1980); *Report on museums in Wales* (1981); *Countywide consultative committees* (1982); *Museum travelling exhibitions* (1983); *Review of museums in Northern Ireland* (1983); *Review of Area Museum Councils and Services* (1984); *Review of the Museum Documentation Association* (1986); *Museums in Scotland* (1986); *Museum professional training and career structure* (1987); *A history of the Commission* (1988); *The national museums: the national museums and galleries of the United Kingdom* (1988); *1992: prayer or promise?* (1990); *The museums of the armed services* (1990); *Local authorities and museums* (1991); *Conservation research in the UK* (1990); *Conservation of plastics* (1991); *Conservation sourcebook* [370]; other monographs.

540 The Museums Association
 Director: 42 Clerkenwell Close, London EC1R 0PA, England (Tel: 071–608
 2933; Fax: 071–250 1929).
Founded in 1889. The professional body for UK museums and museum staff,
with a membership of *c*. 3,000. Main programmes are in the fields of professional
training, information provision and public affairs. Activities are described in
detail in the *Museums yearbook* [399].
 Publications: *Museums Journal* [99]; *Museums yearbook* [399]; *Manual of curatorship*
[137]; *Handbooks for museum curators* (1954–65); *Information sheets* (1970–); Con-
ference proceedings; *Biological collections UK: a report on the findings of the Museums
Association Working Party on Natural Science Collections based on a study of biological
collections in the United Kingdom* (597 pp.; 1987); *Museums UK: the findings of the
Museums Data-Base Project* (325 pp.; 1987; supplemented by *Update 1* (32 pp.;
1987)).

541 Scottish Museums Council, Information Centre
 Information Officer: County House, 20–22 Torphichen Street, Edinburgh
 EH3 8JB, Scotland (Tel: 031–299 7465; Fax: 031–229 2728).
One of nine Area Museum Councils in the UK. Aim: to improve the quality of
museum and gallery provision in Scotland. Provides grant-aid to members and
a wide range of information, advisory and training services. The Information
Centre contains a comprehensive range of museological literature and infor-
mation about Scotland's museums; the Centre has over 2,000 monographs, over
200 current periodical titles; over 2,000 photographic transparencies, and also
press cuttings, photographs, brochures and catalogues.
 Publications: *Museum Abstracts* [39]; *Museum Abstracts International* [13]; *Scottish
Museum News* (1982–. Quarterly); *Planning series*; *Research series*; *Factsheet series*;
Information series; various monographs.

United States

542 American Association for State and Local History
 Director: 172 Second Avenue North, Suite 202, Nashville, Tennessee 37201,
 USA (Tel: (615) 255–2971; Fax: (615) 255–2979).
Organized in 1940 to encourage greater understanding and study of state and
local history in the United States and Canada, and to assist historical organi-
zations in improving their services to the public. Major services to individual and
institutional members include publications, seminars and workshops, consultant
service and audio-visual training.
 Publications: *History News* [67]; *History News Dispatch* (monthly); *Museum masters*
[141]; *Museums in motion* [142]; *Introduction to museum work* [152]; *Museum visitor
evaluation* [180]; *Museums and the law* [192]; *The revised nomenclature for museum
cataloging* [208]; *Museum cataloging in the computer age* [216]; *Registration methods for
the small museum* [260]; *A guide to museum computing* [278]; *Starting right* [290];

Museum public relations [306]; *Access to the past* [332]; *Making exhibit labels* [349]; other monographs.

543 American Association of Museums
Executive Director: 1225 Eye Street, NW, Washington, DC 20005, USA (Tel: (202) 289–1818).
Represents the entire US museum community. Membership (1993): *c.* 12,700. Its 6 regional conferences provide a broad base of support for the Association's work. Develops and promotes professional standards for museums and museum professionals through its Accreditation Program and its Museum Assessment Programs. The Accreditation Program sets prescribed professional criteria by which a museum's quality and performance may be judged. The Museum Assessment Program assists museums that wish to improve their operations and services. Its Government Affairs Program seeks to educate legislators and policy makers at the federal level about the vital role played by museums.

Annual meetings allow exchange of ideas, as do the 12 standing professional committees: the Curators Committee is developing professional standards for curators and has published a code of ethics and a quarterly newsletter *Collection*; the Professional Committee on Development and Membership strengthens development and membership programme standards in museums; the Education Committee organizes programmes for the annual and regional meetings, is active in the areas of professional standards, ethics, accreditation, legislation and long-range planning, and publishes a quarterly journal of museum education *Roundtable Reports*; the Media and Technology Committee is concerned with the effective use of video, film, radio, cable and other new communications media, is establishing a clearing-house of information on what museums are doing with non-print media, and keeps members informed of national policies, new technologies, current uses and future trends; the Committee on Public Relations and Marketing strengthens public relations programmes and other museum information activities; the Registrars Committee provides educational programmes and publications to its members, promotes communication among registrars and between registrars and other museum professionals, and publishes a newsletter; the Museum Association Security Committee focuses on fire prevention, mechanical and electrical systems, personnel, visitor and employee safety awareness training and education, and publishes a quarterly newsletter; the Small Museum Administrators Committee is a forum for exchanging ideas with staff from other small institutions, helps to meet the needs of small museums, and publishes a newsletter *Cornerstone*; the other four are the Committee on Museum Professional Training, the Exhibition Committee, the Committee on Visitor Research and Evaluation, and the Committee on Administration and Finance.

Publications: *Museum News* [95]; *Aviso* [50]; *The official museum directory* [443]; *Museums for a new century* [146]; *America's museums: the Belmont report* [144]; *Museums, adults and the humanities* [315]; *Museum registration methods* [221]; *Museum trusteeship* [305]; *Personnel policies for museums* [298]; *Professional standards for museum accredita-*

tion; *Museum ethics*; *Protection of cultural properties during energy emergencies* [239]; *Museums and the environment* [340]; other monographs.

544 Smithsonian Institution, Office of Museum Programs

Museum Reference Center, Arts and Industries Building, Suite 2235, 900 Jefferson Drive, SW, Washington, DC 20560, USA (Tel: 202–357–3101; Fax: 202–357–3346; Museum Reference Center Tel: 202–786–2271).

Office of Museum Programs activities: organizes museum training workshops, seminars and colloquia for Smithsonian staff; organizes museum training courses and internships for people who work with American Indian tribal museums and cultural centres; co-ordinates a central internship application referral service to all internship programmes at the Smithsonian; provides educational and enrichment programmes and career guidance seminars for interns; arranges for short-term residencies at the Smithsonian for visiting museum personnel; co-ordinates the Fellowships in Museum Practices Program which enable professionals from museums and allied fields to study methods, techniques and technologies for strengthening and expanding the educational role of museums; investigates emergent issues relating to cultural resource management in community-based museums, heritage centres and cultural organizations; and distributes videotape programmes on conservation, security, museum education and historic site administration.

The Museum Reference Centre (established 1974), a branch of the Smithsonian Institution Libraries, located in the Office of Museum Programs, is a unique working collection of resources on all aspects of museum operations. Maintains a comprehensive collection of technical literature relating to museum management, curatorial functions, preventive care of collections, education, research and exhibitions. Includes over 2,000 books, over 1,000 periodical titles, educational programmes, volunteer training manuals, membership and fund-raising promotions, annual reports, museum guidebooks, research reports including evaluation and studies on the behaviour of museum visitors, and law and legislation affecting museums nationally and internationally. Acts as an information centre by providing information on the current activities of museums and related organizations throughout the world. Reference and literature searches are done by request, and bibliographies prepared.

Publications: Conference proceedings; *Internship opportunities at the Smithsonian Institution*; various monographs.

Yugoslavia and its successor states

545 Muzejski Dokumentacioni Centar/Museum Documentation Centre

Editor-in-Chief: Mesnička 5, 41000 Zagreb, Croatia (Tel: (041) 426–534; Fax: (041) 430–851).

Publications: *Informatica Museologica* [71]; *Muzeologija* (annual; covers specialized topics on museum theory and practice).

546 *Savez Muzejskih Društava Jugoslavije (Federation of Museums Associations of Yugoslavia)

Secretary: Istorijski Muzej Srbije, Nemanjina 24, 11000 Belgrade, Yugoslavia (Tel: (011) 643–731).

Professional organization of museum personnel. Encourages contacts and co-operation between various bodies at different levels. Holds a general conference every 4 years; organizes seminars.

Publications: *Muzeji*.

Index

The index is a single alphabetical sequence of authors, compilers, editors, titles, subjects and organizations.

Publications entered under editor or compiler are also listed under title; title entries are also included for a few other works well known by their titles.

The arrangement is word by word, with abbreviations and acronyms treated as single words.

Numbers without brackets refer to page numbers in Part I; numbers inside brackets refer to *item* numbers in Parts II and III.